Making GREAT Illustration

Derek Brazell and Jo Davies

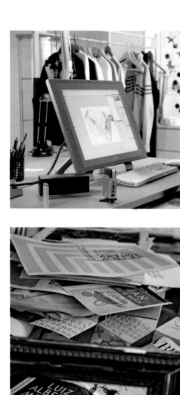
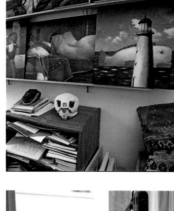
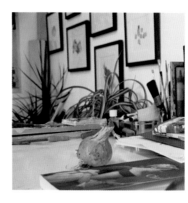
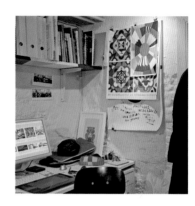

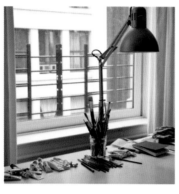

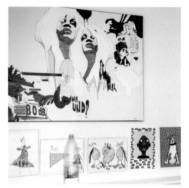

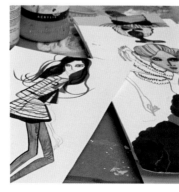
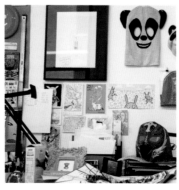
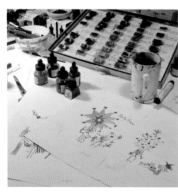

Making GREAT Illustration

Derek Brazell and Jo Davies

A&C BLACK • LONDON

First published in Great Britain in 2011
A & C Black Publishers Limited, an imprint of Bloomsbury Publishing Plc
49–51 Bedford Square
London
W1CB 3DP
www.acblack.com

ISBN 978-1-408-12453-6

Book design by Dean Owens.
Cover design by Sutchinda Thompson.

Printed and bound in China.

This book is produced using paper that is made from wood grown in managed,
sustainable forests. It is natural, renewable and recyclable. The logging
and manufacturing processes conform to the environmental regulations
of the country of origin.

FRONTISPIECE: (Illustrators studios)

Row one: Alex Trochut, Brad Holland, Emma Dibben, Hvasss&Hannibal
Row two: Jeff Fisher, Jean-Phillipe Delhomme, Matthew Richardson, Naja Conrad-Hansen
Row three: Olivier Kugler, Pete Fowler, Pete Fowler, Ralph Steadman
Row four: Ralph Steadman, Rob Ryan, Ronald Searle, Catalina Estrada
Row five: Quentin Blake, Tanya Ling, Yuko Shimizu, David Downton

Studio photographs by Andrea Liggins.

End page illustration by Laura Carlin.

Acknowledgements

The authors would like to thank:
All the illustrators who participated in *Making Great Illustration*; for sharing their time and expertise, their generosity and hospitality.
The experts who contributed to the foreword.
The commissioners of illustration who wrote the section editorials.

Jo Davies received funding from The University of Plymouth to finance part of the travel expenses incurred during the making of this book with support from *Message* research group and MADR research centre.

Thanks to the following publishers for provision of images:
L'Association (France)
Bloomsbury (UK)
Jonathan Cape (UK)
First Second (USA)
Futuropolis (France)
Fremok (Belgium)
HarperCollins Children's Books (UK)
Pastel (France)
Rizolli (New York)
Walker Books (UK)

Thanks to Dr Gisela Vetter-Liebenow at the Wilhelm-Busch Museum, Hannover, Germany and Anita O'Brien at the Cartoon Museum, London, UK for assistance with Ronald Searle images.

Thanks to:
Association of Illustrators
The Conran Shop UK
All the organisations and companies whose commissions are published in the book.

The photography was sponsored by Swansea Metropolitan University as part of two research projects, undertaken by Professor Andrea Liggins, one concerned with exploring aspects of the photographic document and the second a European-funded project looking at Spaces of/for Creativity, as part of the Creative Industries Research and Innovation Centre.

Introduction

Illustration is an incredible creative force, bringing art into our lives, performing a multitude of functions: conveying information, elucidating text, enhancing with decoration and expressing ideas. Inside *Making Great Illustration* is an impressive array of illustrators from around the world who, amongst many things, have fashioned an Olympic mascot, created characters that generations of children have loved, produced vinyl toys available across the globe, informed opinion with hard-hitting social comment, self-published books, recorded major international events and made beautified book and album covers, posters, digital hardware and furniture. Between them they have created some of the world's most compelling, enduring and recognisable images of the past 30 years in illustration. This book reveals how and why.

Being able to see sketchbooks, working drawings and work in progress in the artists' working spaces, as well as examples of finished artwork, gave a clear insight into their working methods.

With ten categories, broadly covering the main applications of illustration, *Making Great Illustration* offers a strong overview of the best of the international illustration industry, and explores its diverse range of working methods and stylistic approaches. Although the book needed categories for each section, the work of many of the artists here extends beyond any single category, so there is a concentration on that area for which they are best known.

The intention is to survey the breadth of work being created across the world. Although initial research of the artists' work was through books, exhibitions, the internet and by talking to contacts in the illustration world, ultimately the book has been based on direct, first-hand knowledge gained by visiting the artists across the world. Deciding to base the content on face-to-face research gives a distinctive perspective that makes this a unique book. Travelling to Scandinavia, America, Canada, mainland Europe and the UK to interview illustrators in their own studios provided a rich opportunity to look beyond their words and acknowledge the importance of their working environments. During these interviews the lives and personalities of the artists were witnessed for a short time. Sitting with them afforded experience of their personalities through gesture and intonation. For example, someone jumping up to show something from across the room to illuminate a point added clarity to our understanding. Being able to see sketchbooks, working drawings and work in progress in the artists' working spaces, as well as examples of finished artwork, gave a clear insight into their working methods.

The photographers were able to capture many of these moments, and their contributions offer the reader a direct and privileged access to the illustrators' personalities and the environments in which they work on a daily basis.

Most creative people are intrigued by the processes that others use in making their work. How do they do that? What materials and techniques have been used? Are they using sketchbooks? What influences and inspires this work, and how do they respond to a commissioner's brief? As Ronald Searle says, "The idea that you can look at an artist's books, or look at his sketches and so on, to me is terribly important, to discover how a person works from the beginning, from the first ideas to the finished drawing." This book allows insights into the creative process of each of the chosen artists from the perspective of two working illustrators. Genuine, informed curiosity underpins the dialogue, shapes the interviews, and influences the flavour of the book. Additional contributions in each section by esteemed commissioners of illustration offer a rare perspective from the client.

Illustrators are breaking down some of the traditional boundaries between art and design practices to work in cross-disciplinary ways.

An overview of illustration practice must place the wisdom of established creators alongside those whose careers are ascending, and *Making Great Illustration* takes the reader from editorial master Ronald Searle, in his nineties, to young illustrators such as Alex Trochut and Emma Dibben, whose work in advertising and design is placed in front of millions. As illustration is evolving to encompass duos and collectives as well as individuals who are working off the page, we aim to represent and record this flux. Alongside artists such as Jeff Fisher working within publishing, seen as a more traditional practice in illustration, the experiences of Grandpeople and Hvass&Hannibal reveal how partnerships and collectives are becoming increasingly popular, and how illustrators are breaking down some of the traditional boundaries between art and design practices to work in cross-disciplinary ways. The book shows that for many of these successful artists being an illustrator is more than just work; it's their life.

Bringing together this wide range of practitioners in one volume, displaying their amazing artwork and talking about how and why it is created, allows a uniquely focused collection of experiences and images to be put into your hands. Turn the page to find a wealth of imagery and information – and be inspired!

Derek Brazell and Jo Davies

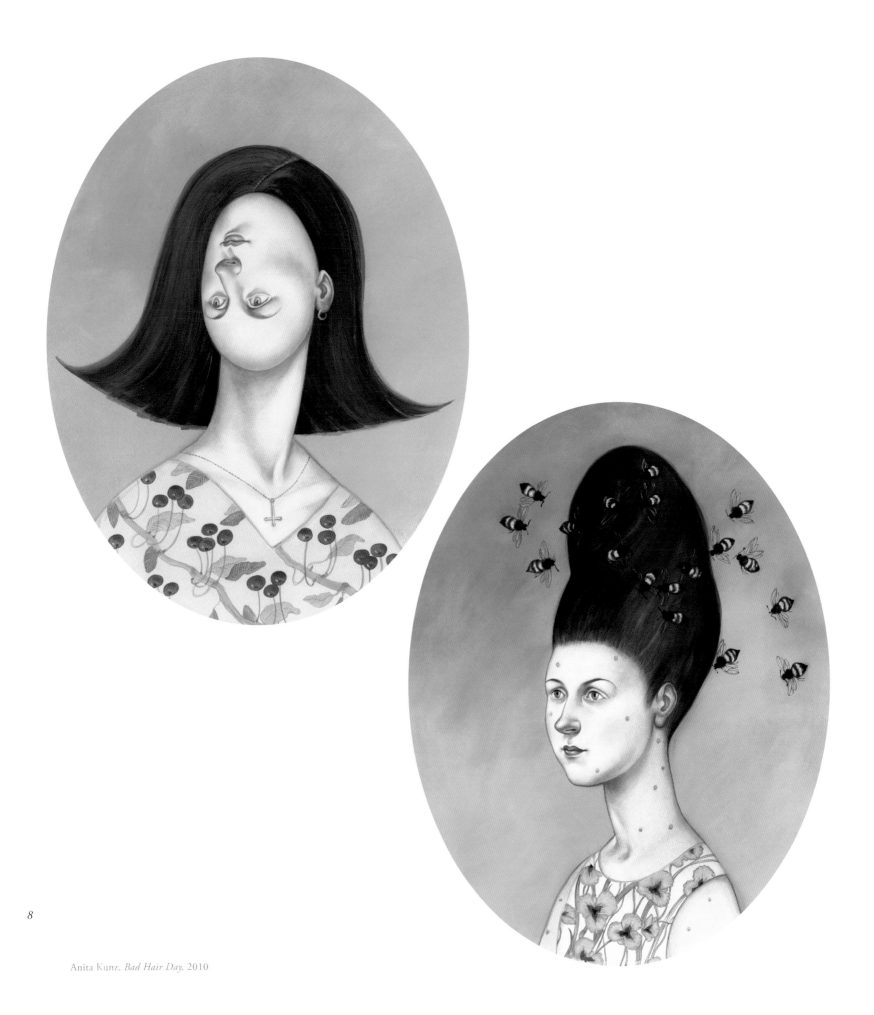

Anita Kunz, *Bad Hair Day*, 2010

Foreword
The Illustrator/Tutor's perspective - Anita Kunz

Illustration has historically held a curious place in the art world. Sometimes viewed as a less valid art form than 'fine' art, its influences are nevertheless ubiquitous, whether in magazines, books and advertising or more recently online and in films, toys and gaming.

The term 'illustration' is fairly all-encompassing. It can refer to a wide range of imagery, from the most benign, decorative pictures all the way to powerful visual statements describing political and social issues.

Arguably, illustration at its best has the power to move people emotionally and challenge them intellectually. By its very nature, it can question conventions and generate reaction. In a society such as ours this carries an unparalleled power, given the exposure of images to such a potentially wide audience. Therefore, the illustrator's goal should be to make meaningful images, and along with that comes the continual balancing act of remaining authentic to yourself, contributing to the culture and, of course, making a living!

When asked if there are any secrets to becoming a successful illustrator I often point students to the book *Outliers* by Malcolm Gladwell. From his research he concluded that most people, across a wide variety of fields, become successful after 10,000 hours' effort. That rings true to me. Hard work and tenacity are, I believe, the two key elements to a successful career as an illustrator.

Hard work and tenacity are, I believe, the two key elements to a successful career as an illustrator.

Longevity in the somewhat fickle, sometimes trend-oriented world of illustration can also be a challenge. The question is always how to remain true to your own vision. Flexibility is key, especially in these times of exponential change. Most important of all is to remain a student, constantly examining human nature. To observe requires discipline, to draw requires training, to be a participatory artist requires above all an open-mindedness and curiosity. The results will always speak for themselves.

Anita Kunz is a renowned illustrator. She was invested as an Officer of the Order of Canada, the highest civilian Canadian honour, in 2010, to recognise a lifetime of outstanding achievement, dedication to the community and service to the nation.

The Historian's perspective -
Dr Leo De Freitas

A particular alchemy has to be worked for professional illustration to succeed. A unique blend of artistic skill, commercial nous, and technical savvy is required for success. At every stage in the history of modern illustration there have been practitioners who have worked this magic deftly enough to ensure our culture is studded with visual excellences and delights.

Developments in technology, when combined with emotion and integrity, have led to brilliance in illustration. It has happened with various processes to which, after a period of learning, reflection and experimentation, have come the stages of innovation and discovery. Inspiration and imagination asserted themselves confidently through these various media and thus the distinctions that make up the exciting history of illustration emerged.

The illustrator as entrepreneur is surely a defining feature of the profession today.

What is so singularly important in our art is that it is made available to all; a democratic art. From the start, professional illustration was an international art form promoting talent not only across political and cultural boundaries, but also across a diverse range of applications. In a manner that is unique to the present time, illustration is used in the widest possible way and is to be found wherever a pictorial presence is wanted. Illustrators themselves often drive these applications of their art; the illustrator as entrepreneur is surely a defining feature of the profession today.

To witness all this as an historian is to wonder both at the stunning creativeness of the human mind when applied to illustration, and the cultural preconceptions that have stood in the way of its full celebration.

Happily, as this book demonstrates, the unfathomable depths of understanding, insight, skill and creative solutions swirling around in the minds of exceptional artists in the world of illustration are undiminished. They continue quietly to enrich our experience of existence through our visual culture.

Dr Leo De Freitas is an academic and curator and one of the UK's leading authorities on the history of illustration.

The Illustrator/Agent's perspective - Brian Grimwood

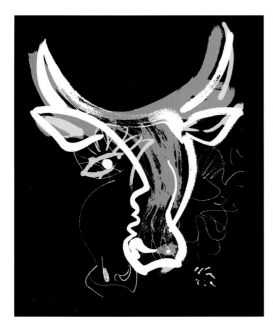

To gain an insight into how illustrators think and how they work, the development of their style and thought processes, what inspires them – that's intriguing for an established artist and also for those about to enter the fray.

It's good to be influenced. Sometimes just to get started it's beneficial to put yourself in someone else's shoes, and then as time goes by develop a distinctive visual language. It's an evolutionary thing. A good creative soul will eventually create its own benchmarks. Make its own story. As an illustrator, I try to come up with a strong original idea and put it down well. I like drama in pictures, but keep the composition simple and limit the colour.

As a young artist I was influenced by American illustration, and through my involvement in CIA (the illustration agency I set up in 1983) and its affiliation with the Bernstein & Andriulli agency in New York, I have continued to work with American creative agencies on a regular basis. The influence of the web in shrinking the world means that many of us are collaborating on an increasingly global level, absorbing cultural differences and adopting new artistic languages.

A good creative soul will eventually create its own benchmarks and make its own story.

With the constant progression of shifting visual trends it's been interesting to see craft coming back into fashion. CIA's painters and printmakers are being commissioned by new generations of art directors who didn't experience these processes first time around. As the boundaries between digital illustration, animation and interactive media become increasingly hazy, creatives are rediscovering the additional dimension that hand-made work offers – the experience of witnessing the work in progress. Illustrators could be seen as performance artists, with clients and the public as their spectators.

This wonderful variety, the diversity displayed by the artists in this book, is what makes illustration so energising.

Brian Grimwood is an acclaimed illustrator and founder of the Central Illustration Agency (UK), partnered with Bernstein&Andriulli (USA). He received an Honorary Degree of Master of Design from Nottingham Trent University in 2009 for services to illustration.

Bullhead, personal work, Brian Grimwood, 2008

Contents

Antoine+Manuel, *Jupiter-Zeus,* from Gods series, 2008.

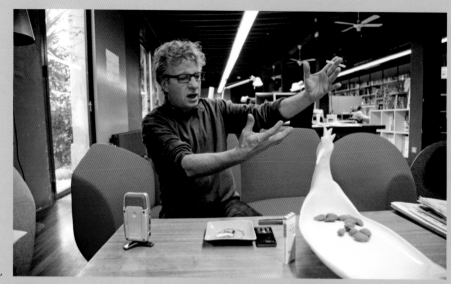

JAVIER MARISCAL

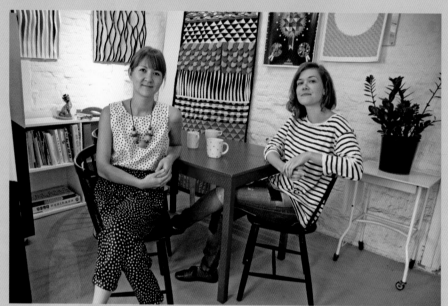

HVASS&HANNIBAL

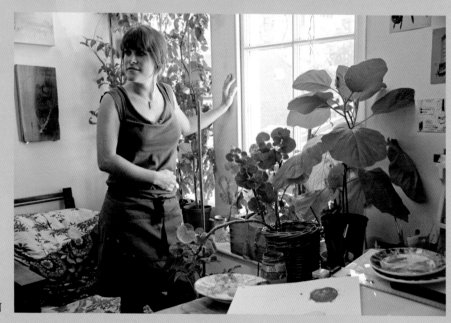

EMMA DIBBEN

Design & Advertising

Illustration is pivotal to the promotion of a range of products and services in many formats and is commissioned in all areas of graphic design. These practitioners have been influential in diminishing the boundaries between the historically distinct fields of Graphics and Illustration.

The client's perspective:
Polly Dickens,
Creative Manager,
The Conran Shop

Illustration has a special ability to bring personality into design, and this was why I commissioned Javier Mariscal to create images and logo designs for The Conran Shop's 'Well Considered' range of home products – which includes lighting, kitchenware and textiles. The shop has been regarded as classical and serious about design, but using Mariscal immediately gave us a slice of a new personality, because it's very clear what is being projected through the liveliness of his drawings.

Our intention in using illustrated packaging was to encourage a type of customer who might not previously have entered the store, by changing what might appear a basic range of products into something now excitingly enhanced.

So the use of illustration gave the products an extra dimension and successfully brought in a new audience. This is something design can do by itself, of course, but in a store like Conran, where there are so many different products to distract the customer's eye, it's very helpful and can give a wonderful peg to pin something onto. In fact, the highly packaged items from the collection were the ones which proved most popular with customers, combining the appeal of the packaging and product into something very special. The range took off in a bigger way than we had expected, and the strength of its identity looked quite compelling when we placed the collection on its own in a shopping-mall pop-up shop. Some of Mariscal's images were also successfully translated into 3D for the launch of the range, which was a good reflection of the wide scope of his design practice.

This use of illustration lifted Waitrose packaging, rapidly taking the store from being just another supermarket onto a more sophisticated level above the other UK high-street supermarkets. The medium chosen for the images was watercolour which, subtly done, made the packages quirky and interesting.

Rococo Chocolates, boutique chocolate makers, are another business who added an additional dimension to their products with pictures in the style of engravings on their packaging, creating a strong identity which for me places them over other chocolate producers. The same illustrations used on the packaging have been extended to mugs and kitchen textiles, adding to an identifiable brand.

Portrait by Derek Brazell.
Photography by Andrea Liggins.

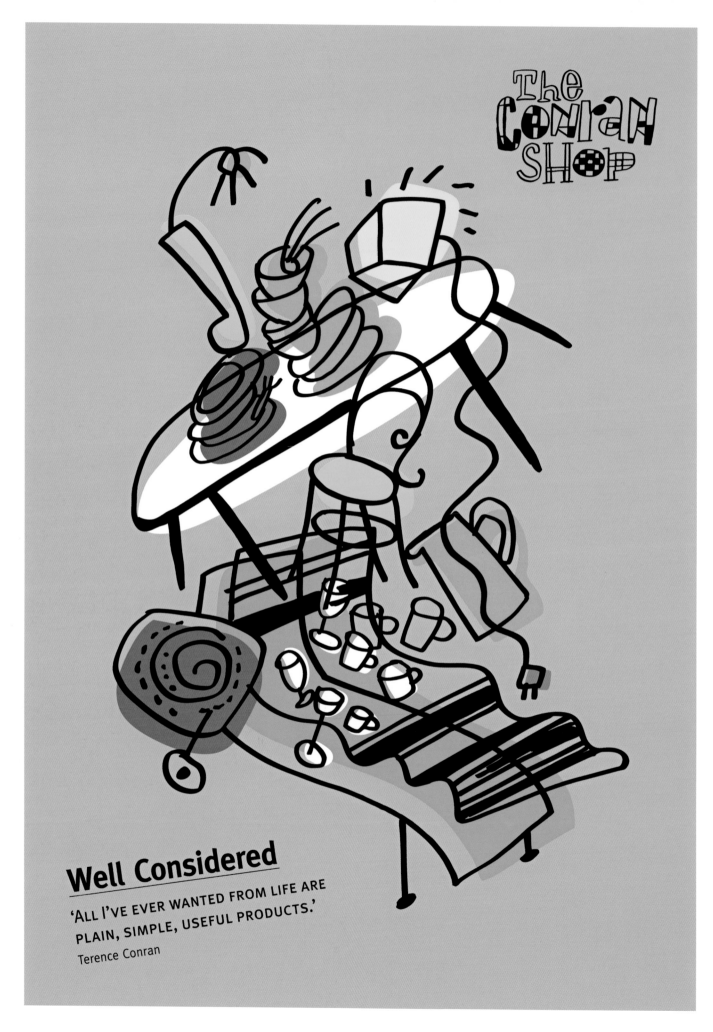

Well Considered

'ALL I'VE EVER WANTED FROM LIFE ARE PLAIN, SIMPLE, USEFUL PRODUCTS.'

Terence Conran

Javier Mariscal

BARCELONA | SPAIN

"It's very important to play, play, play. And right now people are starting to understand."

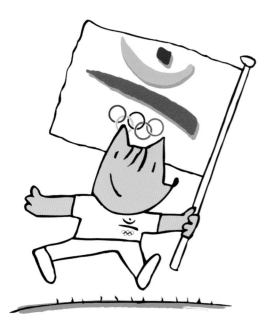

Energy, generated by movement, colour and a playful spirit, bounces off the imagery and works created by Javier Mariscal and his company Estudio Mariscal based in the Spanish city of Barcelona. As one of the country's best-known creators he works across design, illustration, interior design, furniture, architecture, television, animation and more, all of which exude his optimistic flair. In person, he reflects his work, speaking enthusiastically about his passions and stimulated by communication.

Growing up dyslexic (in a time before this would have been diagnosed), Javier struggled with reading and writing, pretending to his large family that all was fine while channelling his communication into drawing. "So my perception of my work is like everything is fake," he says, then whispering, "But don't tell anybody, please!" His difficulty with writing developed into a different approach to lettering, something which is now a strongly identifiable part of this work. "Even now when I'm writing, I draw: I draw the *e*, I draw the *a*, I draw the *t*. This *e* can be more happy," he says, curving an imaginary pencil upwards through the air. "Always it's like drawing, not automatic writing. I look again and think, 'This *t* could be longer'. Sometimes the *g* or the *c* can look angry and I think, 'Oh, I don't like this', and I try to make it more funny." As he pronounces the words or letters, stretching them out or growling in his throat, you can visualise the letter form appearing in his mind, and how it might then look as an image rather than just a letter.

Estudio Mariscal was formed in 1990 when Javier realised he'd need support to deal with the workload following the acceptance of his design for the Barcelona Olympic Games mascot, Cobi. The Studio is employed on various projects covering a wide spectrum of disciplines, and Javier can be overseeing many at one time. One uniting factor is his philosophy – think playfully, like a child. This has always been his system for approaching and developing projects, "Normally, most kids around ten they say, 'This is an aeroplane'," he comments, gliding a lighter through the air accompanied by the appropriate aircraft sound. "Adults say, 'This is a lighter'. I never stop thinking like this – 10 years, 20 years, 60 years." The

OPPOSITE PAGE:
Catalogue cover for The Conran Shop, 2009.

ABOVE:
Cobi mascot for Barcelona Olympics, 1992.

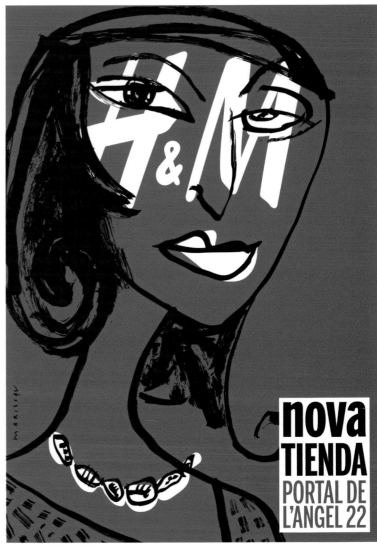

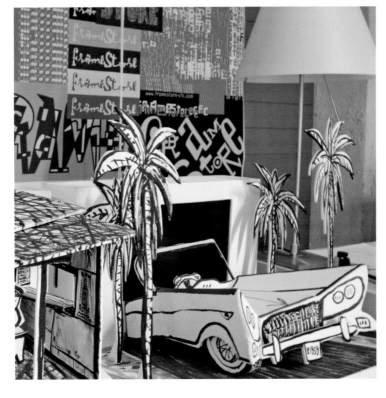

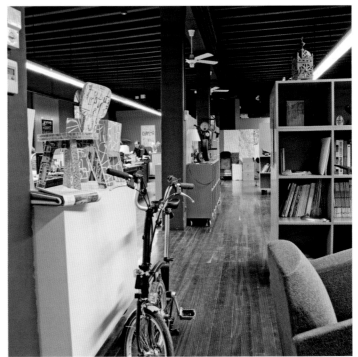

MEAT

OPPOSITE PAGE:
(top right):
Poster for H&M shop, El Portal
de l'Àngel, Barcelona, 2008.
Graphics, architecture and
interior design project for the
shop by Estudio Mariscal.

(left and below)
Mariscal in studio.
Car installation for exhibition.
Interior of Estudio Mariscal.

All portrait and studio
photographs by
Andrea Liggins.

THIS PAGE:
Drawing from *1080 Recipes* by
Simone and Inés Ortega and
Javier Mariscal, published by
Phaidon, 2007.

Julián chair/toy, designed for
the *Me Too* collection by Magis,
2004. Material: rotational-
moulded polyethylene.

lighter remains airborne. "It's proved a good system, in spite of adults usually thinking, 'This is stupid – kids! We are rational, we must think of the market'."

Javier has no time for the opinion that art should be intense and devoid of pleasure, adding, "What I do is not 'art', but it's fun. People pay me for fun, always. If not, I don't like to work." This philosophy extends to the workplace, with Estudio Mariscal avoiding the typical 9 to 5 routine, offering free calls and refreshments to the workforce, and large windows surrounded by greenery, Javier having long recognised that people work better in a supportive environment.

Javier's imagery carries a spontaneous feel, and can appear to have sprung from a first sketch, though the process often involves a lot of thought before a brush or pen is picked up. Illustration will follow the design. Design work needs an understanding of the audience and the requirements of the client, who will come to the studio with a "problem and no organisation", and the studio will take all this information and organise it with a fresh outlook, producing concepts to solve the issues. "It's not only drawing – we talk about concepts, covering architecture and interior-design projects and different visual projects. So for us it's thinking about the concept: Why this and this, how to develop this."

Working on the development of an industrial lamp for an Italian company, for example, the first question he asks is, "How is this going to work? What's happening with the technology of the light (it must reflect advances in this area)? If it's for a new hotel, why does the client want the hotel like that?" How different users or audiences will relate to a product or object is important – it must be democratic. And if he is aiming at children, he will also have to consider parents too.

Javier has a long relationship with Spanish shoe company Camper, whose Camper for Kids identity is a great example of the Mariscal touch – lively characters, vibrant colour and a zappy website, all combining to form a memorable brand. As Javier puts it,

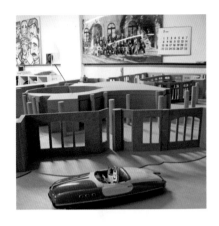

"What does the brand Camper mean? Why do they choose to make shoes for kids? What are the Camper values for the children? All the illustrations and graphic identity for the kids is thinking to help Camper communicate what is behind the shoes, what is the philosophy and what is the brand. And, of course, we are working all the time with passion," he says, patting his heart, "with feelings."

Creating identities for clients is a large part of the studio's output, and he understands the relationships we have with brands: "You like Nike or you hate it." The UK-based Conran Shop commissioned Javier to redesign the packaging for some of its homeware in 2009, successfully adding a lighter dimension to the store's high-end reputation.

Design commissions also include books, with Phaidon asking him to design a well-known Spanish cookbook, first published in the 1970s, for publication in the USA and UK. Originally it had been pocket-sized, but Javier decided that to function well in the kitchen it must open easily, lying flat, with just one recipe per page. As they are Spanish dishes, he wanted the readers to "feel the air and the light of the Mediterranean", and though surprisingly he initially resisted the editor's proposal that the book should include his illustrations, he ended up producing hundreds of drawings in crayon for inclusion. Meat, vegetables, crockery and utensils from his own home all appear, with a few objects drawn for the very first time, such as the specially purchased meat trussed in string. "Sometimes I invent it, but I try to be true – it's the way also to learn."

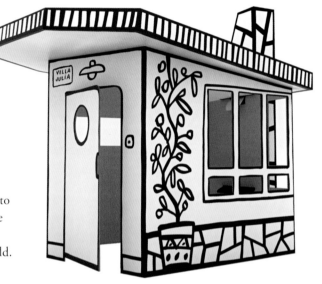

Javier relishes his work connecting with people, imagining the book's owners trying out new dishes from the Spanish repertoire, and inviting friends around to share the meal. His passion for his work comes through strongly as he discusses it, and that enthusiasm has kept him exploring new areas of creativity. Having tried out his first computer animation in the 1980s (something his young son can easily do now – "Even now we're in the Stone Age with computers"), in recent years he has embarked on a major project, first conceived around 2006, to create the feature-lengrh animation *Chico and Rita* with director Fernando Trueba. Drawing the backgrounds and designing the characters for the story, set in Havana and New York from the 1940s on, involved adapting his approach to be able to work with a team spread across the world.

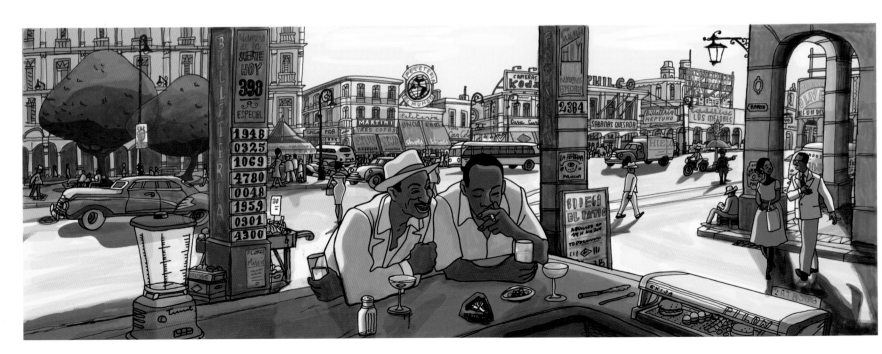

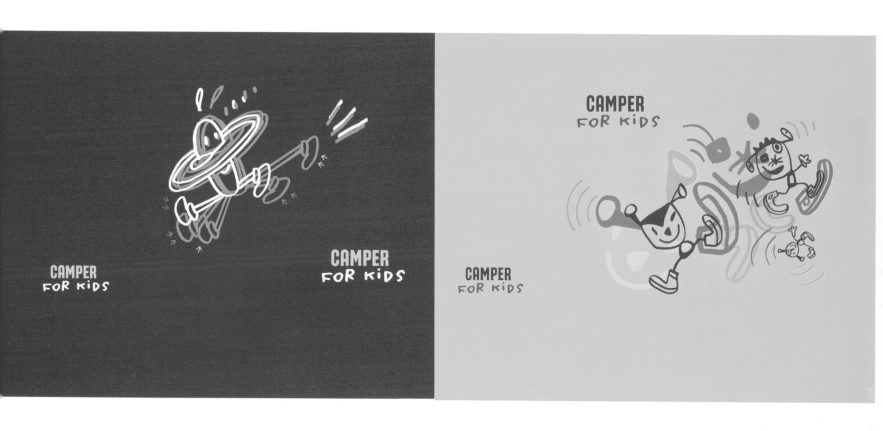

OPPOSITE PAGE:
(top)
Model for exhibition inside the studio.
(middle)
Villa Julia, self-assemble house for children,
2009. Material: cardboard.
(bottom)
Still from *Chico and Rita*, animated film, 2010.

ABOVE:
Camper for Kids, bag design, 2010.

Initially, the film's characters were realistic with a cubist edge, but the animators persuaded him to make them more standard. "This style is nice when there are just six of us. We can make more personal animations … but animation is very complicated, so it's a balance. Friends said, 'How can you change?' They're upset if any changes are made to their work. But it's not a masterpiece of the 'maestro Mariscal' – fuck Mariscal! This is something from many people, this is the style of the movie."

Still, handing over to many contributors has meant keeping an eye on how different elements are created, ensuring that they are accurately researched: a bottle drawing can't just be a bottle; it needs to be a Bacardi bottle as originally shaped in the forties. Javier acknowledges, however, that when you are working with many people, "you can't say, 'Copy the way I do it'. When I do that," – he mimes rapid pencil movements – "it's something nobody else can do." But with an undertaking of this size a balance has to be negotiated among all the parties involved, and a compromise reached between his and the film's aesthetic.

He is a busy man. "One day I was on two computers. One was a logo for a big company, for a minimum of ten years. So I changed a little line. And in the other computer was a frame of animation, and I changed a little here. This is one fraction of a second, and this is ten years. This is very much my life."

Javier refers several times to the Anglo-Saxon attitude and way of thinking compared to the Latin outlook – the direct, organised and cold versus the hotter and more flexible. He understands and uses both – "Culture is a sandwich for the brain" – but that lively Latin soul is always paramount in his imagery.

Javier Mariscal was born in Valencia, Spain, and now lives in Barcelona.

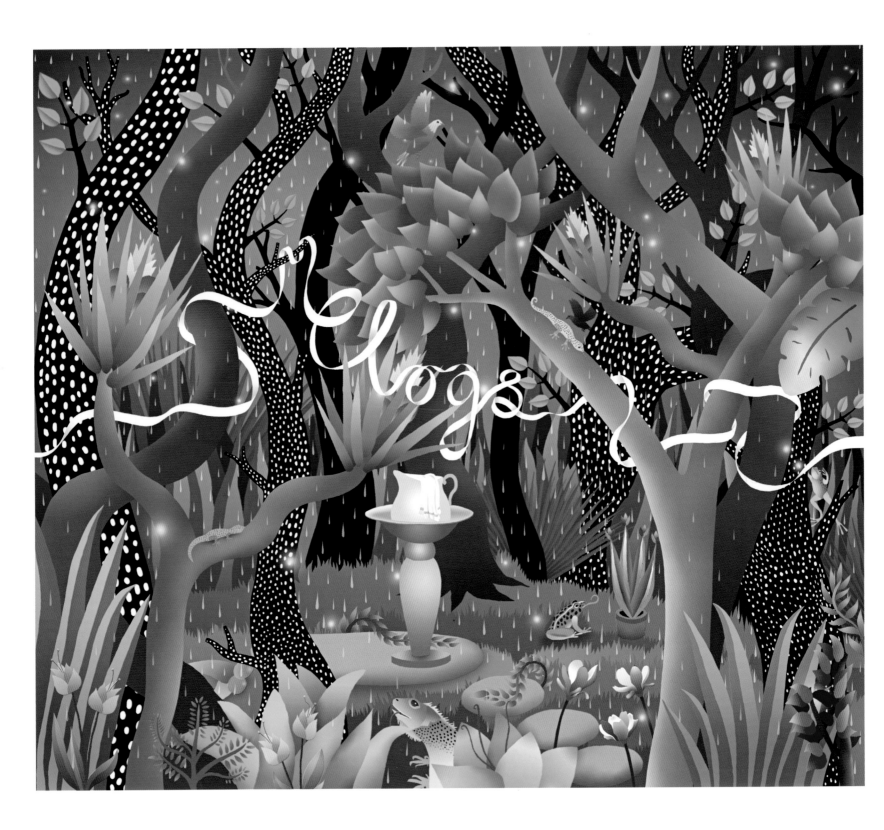

Hvass & Hannibal

COPENHAGEN | DENMARK

"I don't feel any urge to control how people experience our work. It's one of the things I like that people have different associations. How does it feel to look at things, to explore them?"
Nan Na

"In Denmark art is seen as being for itself and illustration is seen as something different. It's nice to have a foot in each camp. We don't have to feel concerned about taking commissions like someone in fine art might do. We have the freedom to explore many different medias and directions."
Sofie

OPPOSITE PAGE:
The Creatures in the Garden of Lady Walton
– album cover for the Clogs, 2010.

The Copenhagen-based duo Hvass&Hannibal decided during their studies at the Danish Design School that two minds were better than one. Since joining forces their distinctive esoteric work has made an impact globally on leading clients of design and illustration and within gallery settings.

Their collaboration is holistic: they are a fusion of individuals rather than a team. This mutual empathy exists at the core of their joint activity, and their artwork represents a synthesis that is conceptual as well as physical. Sofie reflects upon the early basis of this partnership. "In the beginning we had a super-democratic way of working where we would take it in turns, each adding a bit until we were satisfied. It's a very rewarding way of building upon illustration." Nan Na adds, "We found this worked very well. It was also fun, and we were pleased with the results."

To many solitary illustrators, relinquishing control over any aspect of the creative process would seem alien, but the transition from individual voices to a hybrid working entity has been organic and profitable for this duo, without a hint of, nor latent desire for, autocracy. Sofie explains how the principles underpinning their liaison were considered. "We talked in the beginning about establishing rules about how much you could change. Sometimes the other person would erase everything you had been working on and it would be a completely new picture. In the end you have to trust a lot."

"And not be offended!" adds Nan Na.

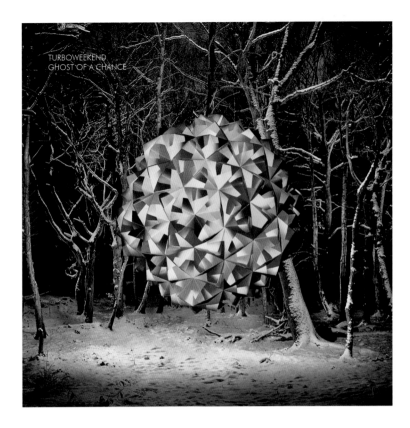

The temptation is to challenge the viability of such altruistic ideas, but both Nan Na and Sofie are relaxed and open about the other's intervention, and this attitude allows for a flourishing working relationship. Each seems to recognise at which point she should seek the other's opinion and issues of individual ownership simply don't register. An intuitive sense of when to delegate and a generosity about each other's strengths also play a large part in their success. "We don't categorise each other's personality," explains Nan Na. "One may do the biggest part of the work but the other may get it right in the end. It doesn't matter who does the idea or who finishes it."

Although their work across 2D and 3D defies clear stylistic definition, some common characteristics are clear. Whether for commercial work, or in more personal projects, there is a playful quality exuding from the exotic textured surfaces they produce. Their excursions into sundry areas of commercial art, which have included stage design, design accessories for an orchestra, CD design, posters and much more, are informed by a curiosity about the properties of different media and modes of communication. Their spectrum of ideas has resulted in work which, although manifestly eclectic, retains a distinctive visual identity. Although its exuberance seems remote from the more minimal aesthetic traditionally associated with Nordic and Scandinavian design, Nan Na agrees that its strong craft dimension can be assigned to their Danish roots. She qualifies this perspective: "I'm always in doubt about the whole idea of local styles, because for our generation everything is now international and global. It's hard to say we do things which are specifically Scandinavian, but it is hard to step back and see your work from the outside."

Both artists enjoy Op Art and value the colour theory they absorbed at the Design School, and these two influences are apparent in their work. There is also a degree of enchantment within the mix, and Sofie suggests that this fairytale oddness within their narratives could be traced back to childhood experiences in Copenhagen, especially its historic amusement park. "We were both influenced by the Tivoli Gardens as children. It's a magical place and also many of its posters are memorable. It leaves an impression."

Hvass&Hannibal enjoy interpreting briefs, large and small, from around the world as well as from their native Copenhagen, but they are determined to achieve a balance between the commercial and more

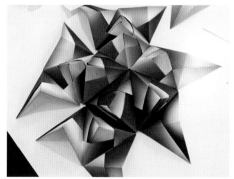

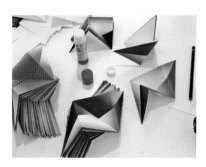

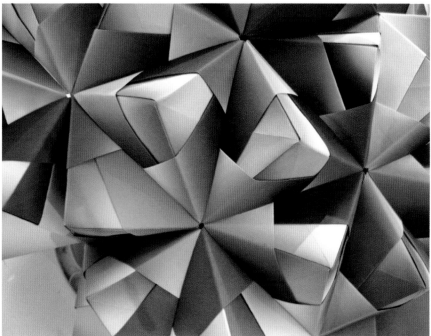

THIS PAGE:
Ghost of a Chance – album cover
for Turboweekend, and working
process.

Portrait photograph of Nan Na
(left) and Sophie (right) by
Andrea Liggins.

OPPOSITE PAGE:
Final album cover, photo by Brian
Buchard, 2009.

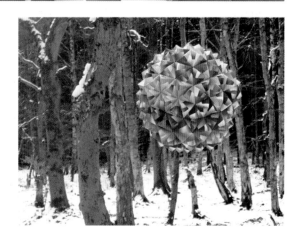

25

personal dimensions of their practice, and to keep fresh. "Because of the limits of deadlines, we sometimes pull on areas where we know we can perform and on ideas we have explored already," explains Sofie. "Our personal work is liberating. We can broaden the horizons and we return to the commercial world largely at a higher level." Nan Na explains, "I do feel that there is a much more conceptual basis to that kind of work than there might be in our day-to-day illustration work, where we are often very aesthetically based in our starting point. Later on we do, as usual, take a more intuitive approach when making aesthetic decisions."

The exploration of concepts at the beginning of their personal project *Losing the Plot* grew from an interest in the functionality of pictorial forms that convey information. They make particular reference to a book that influenced them, *The Visual Display of Quantitative Information* by Edward Tufte. The duo dismantled and re-assembled everyday visual codes and diagrams, referring to contour maps, signs, pie charts and flags. "You can see that when you collect information about any natural phenomena and attempt to present it so that it can be understood, it makes interesting patterns. We're more drawn towards the images than the data behind them." Nan Na explains.

When removed from their specific original contexts and divorced from the sometimes complex data they reveal, these visual forms are a rich source of inspiration from which Hvass&Hannibal have made surprisingly aesthetic work: wooden wall pieces, intriguing panels of subtly coloured reflective surfaces, limited-edition screenprints, and an installation of hanging wooden poles. However obscure, complicated or bewildering the original source, the interpreted forms are compelling in their colour, textural and spatial presence, with intriguing graphic patterns. Painstakingly crafted, they are also evocative. "Sometimes I think there is a conflict about how much reflection there has to be in a piece of design and how much intuition. It's not to do with the rationalising of it or its meaning. There's more of an emotional connection." Sofie adds, "We called the poster for our exhibition at London's Kemistry Gallery, in 2010, *Random Observations*. We didn't want the meanings of the works to be fixed."

Being tactile and physical pieces, this body of work is different from the more exotic, digital images for which Hvass&Hannibal are known commercially. Such personal projects are an extension rather than an alternative to commissions. As Sofie says, "In our work there's usually a narrative. Whether it's a commercial or personal project, sometimes fun or humorous, sometimes we try to give it a meaning, whether abstract or representational – we like to keep it mixed. For a

ABOVE:
Work from exhibition at Kemistry Gallery, London, 2010.

BELOW:
Efterklang – album cover for Magic Chairs.
Working process.

OPPOSITE:
Efterklang, finished album cover for Magic Chairs.
Photograph by Brian Buchard, 2010.

while we decided when we had explored one thing, that chapter was over, but now we see those things as different threads alongside each other."

Whether working upon a six-month personal project, or a quick commercial piece, the pair are diligent in their approach, aiming to bring freshness to their work, whether playing brainstorming games, "to get ideas on the table", or utilising the beauty of a piece of wood.

A latent objective is to explore the connection between ideas and the qualities inherent in the materials chosen to realise them. "We visualise on the computer, or take photos to see how something works in a particular context, but we also use sketchbooks," says Nan Na. "You can draw a lot, but when you work with materials other things happen. It can be time-consuming, but that is how discoveries are sometimes made," Sofie adds, "and there's anxiety and nervousness about the end result with new materials." To which Nan Na ventures, "But you can't stay on safe ground all the time, so it has to be like that."

In many ways Hvass&Hannibal represent a new generation and a new approach to illustration. Despite operating in Denmark, in an environment where a demarcation between art and design activity is perpetuated by a divisive educational system, for them boundaries seem invisible. Equipped with an ever-expanding range of skills and interests in sound, space and light, their two brains work successfully as one. They defy the categorisation that can halt creative evolution. Already their work has made an impressive contribution to the new forms of communication that are beginning to be defined as illustration. In that respect this inventive duo are true pioneers.

Nan Na Hvass was born in Swaziland, Africa. She moved to Denmark in 1990. Sofie Hannibal was born in Copenhagen. They founded Hvass & Hannibal in 2006.

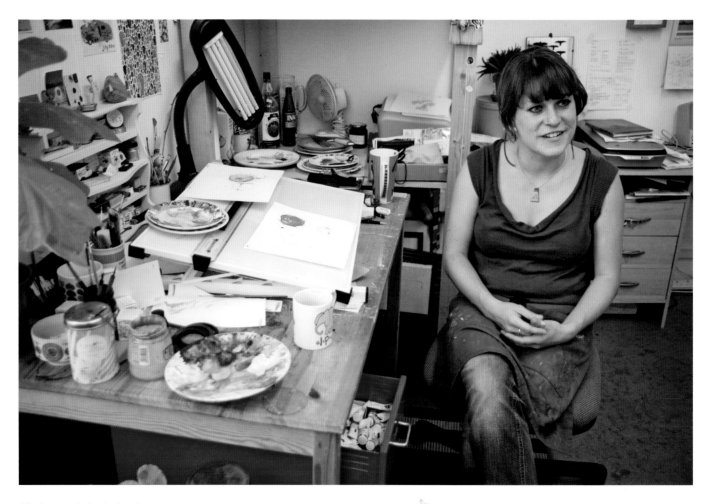

All photographs by Andrea Liggins.

THIS PAGE:
Victoria Plums, from *Waitrose Food Illustrated magazine*, 2010.

OPPOSITE PAGE:
French Breakfast Raddishes, Waitrose Food Illustrated magazine, 2009. Medium: gouache and ink on paper.

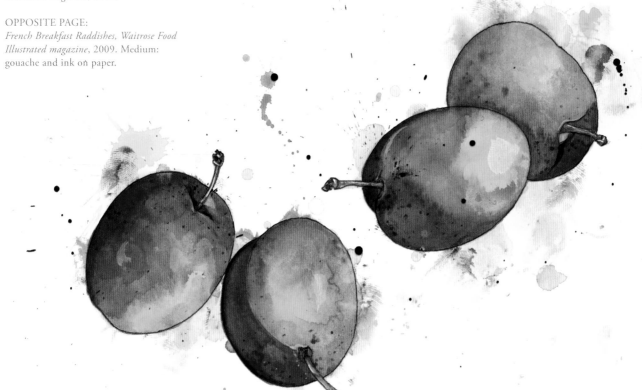

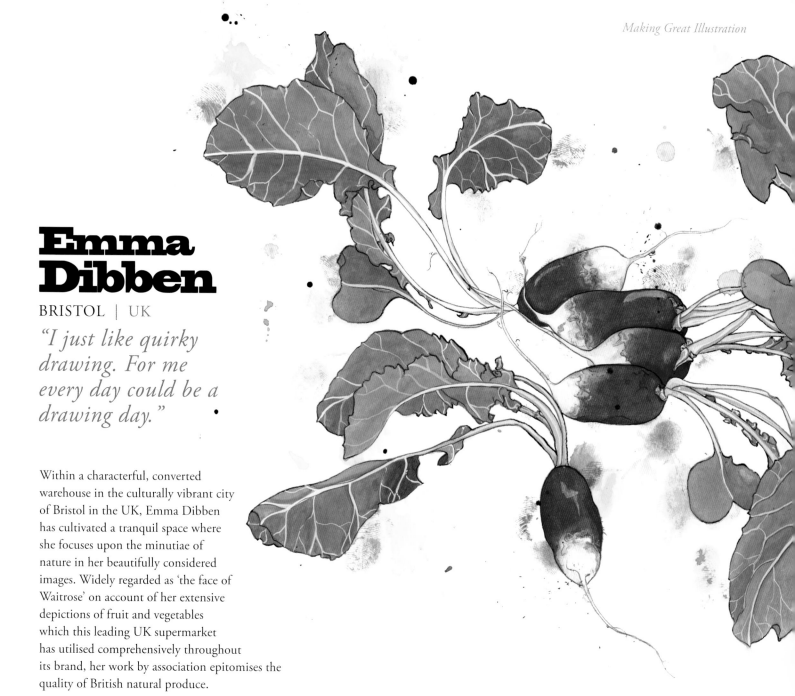

Emma Dibben

BRISTOL | UK

"I just like quirky drawing. For me every day could be a drawing day."

Within a characterful, converted warehouse in the culturally vibrant city of Bristol in the UK, Emma Dibben has cultivated a tranquil space where she focuses upon the minutiae of nature in her beautifully considered images. Widely regarded as 'the face of Waitrose' on account of her extensive depictions of fruit and vegetables which this leading UK supermarket has utilised comprehensively throughout its brand, her work by association epitomises the quality of British natural produce.

Not having specifically chosen to promote herself within this specialist area of practice, Emma is surprised that as an illustrator she is largely defined by food. Creating these often exquisite studies, however, seems like a natural vehicle for the interests and forces integral to her life. "My inspiration comes from nature. My friends gave me an allotment as a gift and I love being there. The more time I spend there the more I feel connected to nature. The allotment has become a big part of my life in the same way that drawing fruit and vegetables has become part of my life."

Emma's subjects are dictated by the cycles of nature. She only draws or paints things in season. Imbuing these subjects with a sense of life seems an intuitive aspect of her working methodology. She describes the process of direct observation which informs her imagery as follows: "My work could be arranged into two piles: those images where I've observed, and those where I've used other reference. My work is more three-dimensional and fresh when it's drawn from life – my pictures have a vitality about them."

Perhaps anachronistically within a fashion-based and heavily stylised industry, Emma's images

29

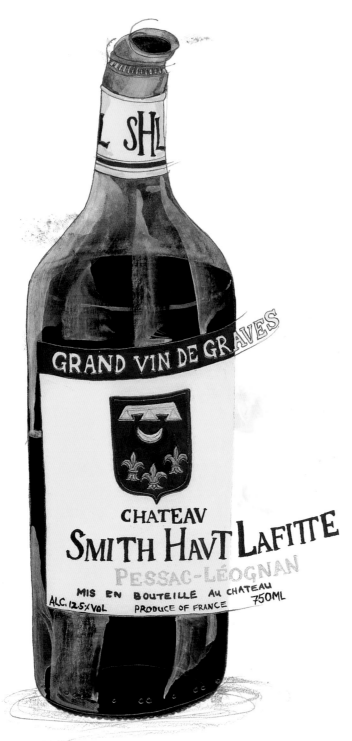

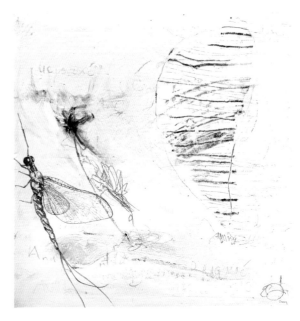

ABOVE:
Mayfly – personal work, 2009. Medium: mixed media on canvas.

LEFT:
Smith Haut Lafitte, the *Guardian Review*, 2007.
Medium: gouache and pencil on paper.

OPPOSITE:
Langoustine drawing, 2010. Medium: pencil.

Langoustine, *BBC Countryfile* magazine, 2010.
Medium: gouache and ink on paper.

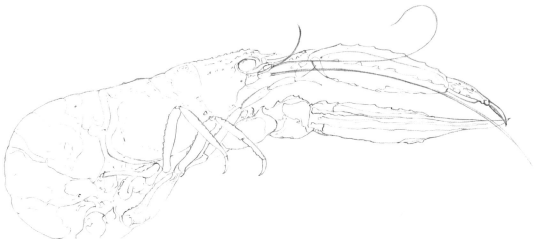

are beautifully crafted and belong to a more distant genre of carefully observed representation. Nevertheless, they retain both individual and contemporary expressiveness, perhaps facilitated by the technical processes she has evolved. There is a contradiction inherent in her process: controlled line drawing rendered in Indian ink, overflowing with energetic colour used to describe texture and define form. She notes, "I hear art directors and designers talk about my splatters and splodges – they've become part of my trademark." This has become the visual language for which she is predominantly commissioned.

Emma would like to give greater acknowledgment to the natural state of the things she paints before they undergo the process of trimming and cleaning which removes the quirks of nature to achieve the pristine state deemed essential for the supermarket shelf.

Distressed by fingerprints and smudges, the clean white backgrounds to the fruit and vegetables of her illustrations possess marks reminiscent of the randomness of nature, and indeed are a by-product of them. "I often use juices in my work. I chop fruit and vegetables up and print with them to create a surface. I also finger-paint – it's tactile. My drawing is the strong point – it holds it all together."

Many principles, permeating all dimensions of her practice, stem from a respect for nature. Whilst she recognises that she is prey to commercial forces, and to personal circumstances that dictate the viability and availability of briefs, she also identifies an ethical framework that she strives to operate within. She indicates that she has declined work from large cosmetic companies because of potential conflict with the moral grounds on which she firmly plants her professional practice. "I hope that I'll always be able to pick my work carefully. There is a line I won't cross. I've turned down food illustration work where I felt the way the food was sourced was unethical, or animal welfare was being compromised."

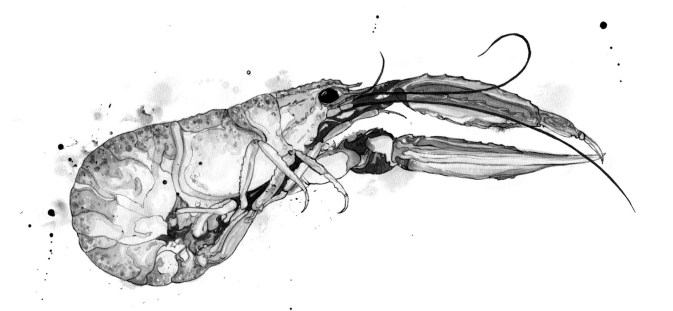

She says, "Growing is a driving force behind what I do." She means this in both contexts. Whilst grateful for the surge of commissions she has been offered since graduating in 2004, Emma is conscious of the potential pitfalls of commoditisation and perceived monopolisation by one company. The more 'personal' projects she has engineered for herself result in pieces that she exhibits in galleries and at art fairs. These are both a natural conduit for her interest in the way we interact with the environment, and a continuum of commissioned work. Drawn insects screenprinted onto pieces of rough, untreated wood appear like fossils, retaining and revealing traces of living things, a true fusion of art and nature. Unlike commissioned work the backgrounds here are solid, the texture and surface integral to the image. Nature is absorbed through osmosis into her imagery and becomes part of its constituent fabric.

Whereas in her commercial work Emma's illustrations are applied to objects, packages, bags and boxes, in her personal work the images themselves become artefacts. As an extension of her insect prints and drawings Emma is currently collecting bees. She plans to make work with a subtle commentary around her concerns over the detrimental impact we have upon the natural order of our environment. This reveals her desire to demonstrate a more authorial voice and bring more of her life into her work. There could potentially be a book documenting life on the allotment.

Whilst retaining personal integrity of direct observation, Emma relishes briefs that challenge her in other commercial and conceptual directions. Book jackets and illustrative typography, as well as projects which require her to generate personal ideas and lend themselves to further revealing her personal vision, are all part of her repertoire. Surprisingly, this work often comprises more collaged and abstract elements: lettering on bottles spilling out of the label, legible but distorted, contradicting the form; a character study that is partly abstract; a surface which employs graphic elements combining to create a surface pattern rather than a direct objective representation. As Emma says, "When clients ring to ask me to do a character-based piece, I always send them samples because I think that they may be expecting something quite different."

Whether the commission demands the drawing of a gnarled beetroot, a character observed in a café in Warsaw, or a piece of decorative packaging, there is a sincere personal energy running through the veins of Emma's work, infusing it with life.

Emma Dibben was born in Newcastle upon Tyne in the UK, and grew up in Sheffield. She lives and works in Bristol.

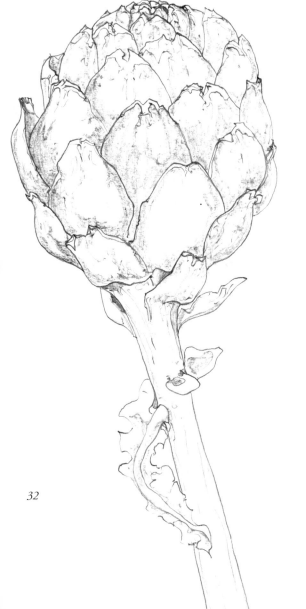

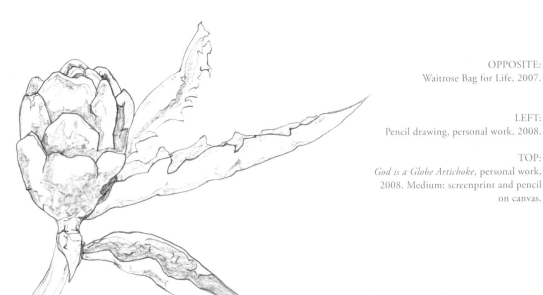

OPPOSITE:
Waitrose Bag for Life, 2007.

LEFT:
Pencil drawing, personal work, 2008.

TOP:
God is a Globe Artichoke, personal work, 2008. Medium: screenprint and pencil on canvas.

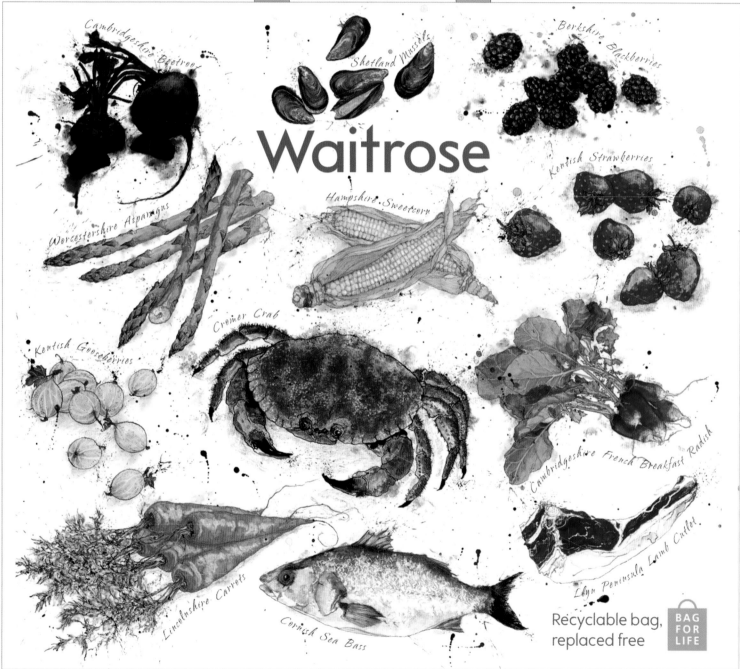

Cambridgeshire Beetroot

Shetland Mussels

Berkshire Blackberries

Kentish Strawberries

Waitrose

Worcestershire Asparagus

Hampshire Sweetcorn

Cromer Crab

Kentish Gooseberries

Cambridgeshire French Breakfast Radish

Llŷn Peninsula Lamb Cutlet

Lincolnshire Carrots

Cornish Sea Bass

Recyclable bag,
replaced free

BAG FOR LIFE

EMMA DIBBEN

JEFF FISHER

YUKO SHIMIZU

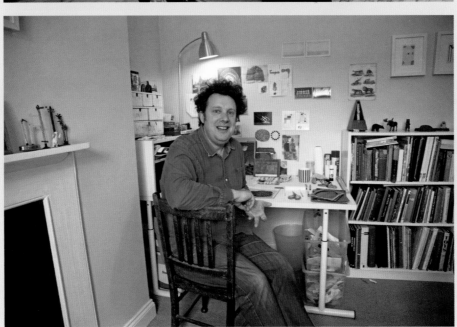

MATTHEW
RICHARDSON

Fiction

This is seen as one of the most traditional areas of illustration. The work of these illustrators has the power to sell a book with images as telling and memorable as the text.

The client's perspective: Sheri Gee, Art Director, The Folio Society

The Folio Society has been publishing illustrated adult fiction since our launch in 1947. Indeed, we seem to be one of the few firms that publish illustrated classics and modern classics.

Because it's quite a narrow field, it can sometimes be hard to find the right illustrator. I can be faced with so much excellent work – there are many talented illustrators around at the moment – but quite often there is very little that's applicable to what we do. It's difficult to imagine how an artist might be able to stretch from, say, fashion or editorial illustration to be able to illustrate a classic tale for us. I may see dozens of wonderful artists but unless I get a feel for how they'd approach adult fiction, I may not even try to make contact.

One thing I can't stress enough to potential illustrators is the importance of doing your research before sending samples out to prospective commissioners, so that the work you present them with is appropriate. This may even mean doing a project that fits the style of your prospective clients before you approach them.

When looking at an illustrator's work, I have to consider first and foremost whether they can draw people, and if so whether they can draw convincing fictional characters, which is quite a different thing from being able to sketch people in the street – the difference between observation and imagination. Next I need to consider whether they are able to convey emotion and tension, and whether their style would suit the period or genre of the book. This is not always clear, so in many cases we'll approach an artist and ask them to do a trial piece for us, and I'm glad that we do. So many amazing commissions have come from a little speculation.

It's a real privilege to work alongside our illustrators, being able to witness their imagination unfurl from rough to final piece. I'm often blown away by the creative compositions and imaginative responses to the text that they come up with.

I think adult fiction illustration requires a very different sensibility to that needed for children's fiction. In some of the best illustration I've commissioned, the illustrator has added much more than is described in the text. Through the ingenious use of composition, texture and line, an illustrator can convey so much else – a unique visualisation, a reading between the lines – turning a literary classic into a visual masterpiece.

Portrait by Jo Davies.
All photographs by Andrea Liggins.

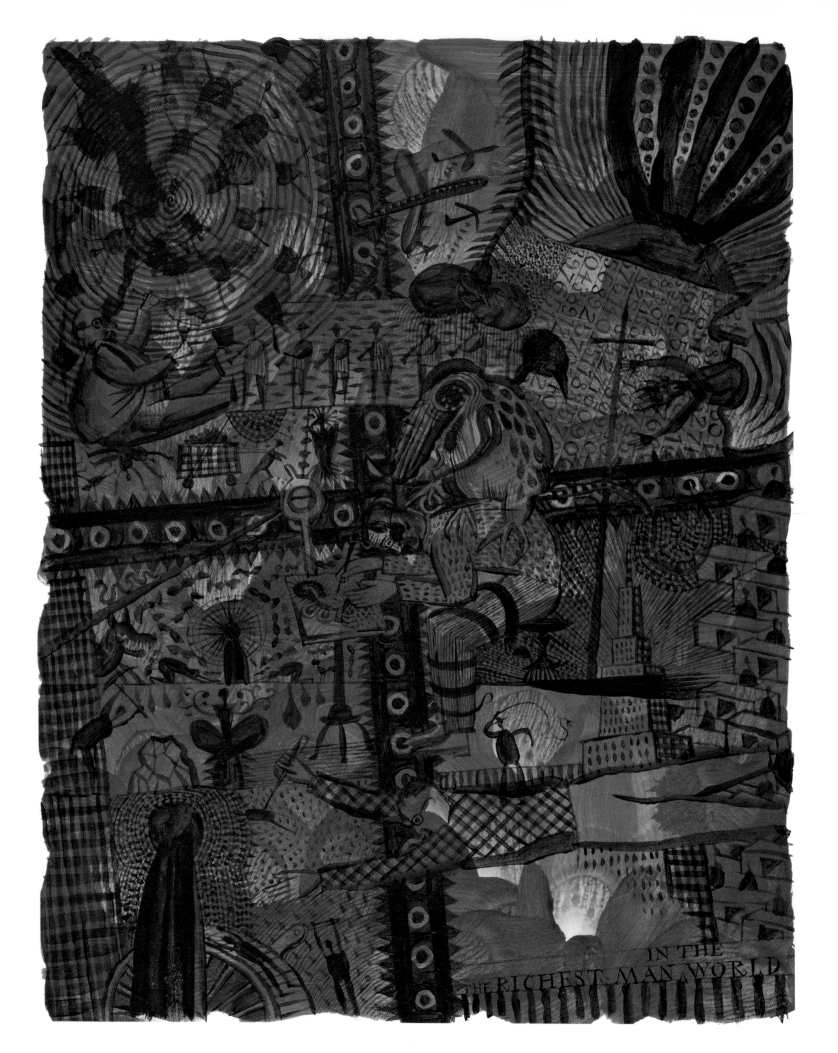

IN THE
THE RICHEST MAN WORLD

Jeff Fisher

PARIS | FRANCE

"I love print and books –
they are like gold to me."

OPPOSITE:
Drawing for *The Drawbridge* newspaper,
published by Drawbridge Publishing Ltd,
2010.

BELOW:
Cover for *Recipes from an Italian Summer,*
published by Phaidon, 2010.

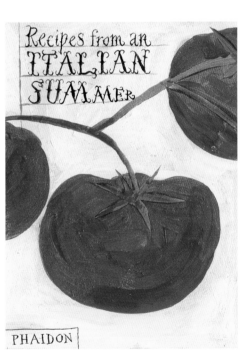

Jeff Fisher must be one of the most prolific creators of imagery for fiction alive. His memorable images grace more than a thousand books, and he has illustrated for a plethora of authors. His famous illustration for *Captain Corelli's Mandolin* is now synonymous with the story, an enduring testimony to the power of illustration to sell a book. His long career in publishing began when he was commissioned in the late 1980s to illustrate the Soho Square Covers for Bloomsbury Classics.

What is evident in both this and subsequent work is that Jeff has a distinctive way of interpreting and extending a narrative. He is effusive in his use of pattern, employing an intuitive sense of colour, creating images with refined, selective palettes and including motifs drawn from a personal visual repertoire which features distinctive characters ranging from devils to chairs. These carefully structured, subtly textured visual surfaces are often overlaid with line drawings like contours on a map, and are richly interwoven with icons, words and sentences. He stoically credits the prevalence of the hand-drawn letter forms that is characteristic of his work as a natural solution to the challenge of a new commission. "I've always loved type and have always used it. It's often helpful, graphically, and as a communicative short cut, to be able to use text." Encounters with the work of the great English illustrators, Edward Bawden and Eric Ravilious, with their strong decorative elements, distinctive design and narrative content, influenced the evolution of Jeff's visual language, and it now seems natural to position him on a chronological continuum with them.

Jeff came to the UK in 1983. "It was brilliant to arrive in England at this time. I felt I had an advantage because I was foreign and didn't go to the RCA. For years I had been enthralled by European illustration, and to be working in this environment was thrilling for me."

Although successful in this early work, with editorial clients including the respected *New Scientist* magazine and advertising for 3i, he cites a job for *Business* magazine as the commission that was pivotal to his stylistic evolution. At this time, in the mid-1980s, he built layers within his images technically, using coloured pencils, watercolours and scraperboard, but became, as he says, "sick of crosshatching". Discovering acrylic paints, with their intense colour and malleability, brought new technical freedom. He attracted commissions from clients who at that time were important in raising the profile of illustration. "The opportunity to work each year for the Trickett & Webb calendar was a great privilege and an opportunity to push myself."

Nowadays his frustrations lie with the limitations imposed by publishing clients who are constrained by market forces, rather than conceptual or aesthetic concerns. A commission by The Folio Society to illustrate *The Hunting of the Snark* by Lewis Carroll seems like one of his dream jobs, with a chance to produce more than 40 interior illustrations as well as packaging for the book. This provided a rare opportunity for Jeff to involve himself more freely in the narrative. As he says, "The book is about searching for something that doesn't exist. It seems like I'm always living with this theme and searching myself, for a drawing." He describes it as "a fascinating process going through the text endlessly. Particularly someone else's text." He laughs. "I should have been a librarian!"

Jeff immerses himself totally in his work and although he appears to possess a natural facility for many aspects of the process, such as intuitively determining a colour range, there continue to be creative challenges. "I always find coming up with the initial ideas very difficult. It's the same with book covers or editorials. It's a blank area. Usually I start to scribble in the forlorn hope that something will appear from the ether. It normally doesn't."

Jeff's final illustrations retain a freshness and vitality, but these are preceded by many rough drawings and near-finished visuals, black and white Indian ink drawings on white paper followed by re-drawings in colour, often on the same scale as the finished image. He mentally forms an idea and modifies his image at each stage, making value judgements as he goes along. "I can only do it by plunging directly into the piece. Only then can I find out what I'm doing. This can involve repeating it a number of times. It can take hours of mucking about until it's resolved. The danger with commercial work is often the short time frame, and work that I'm less than happy with going out into the world. It's not my fault."

The freedom to explore an idea seems of immense importance and the depth of his involvement with the process reveals the integrity underpinning his methodology. "There are not many jobs where you can do what you want. People always seem to want to tell you how to do things. It's ridiculous really. It takes the fun out of it and makes the end result worse. I don't see the point in clients ringing me up if they don't want what I do. Why don't they do it themselves?"

ABOVE:
Roughs for *The Hunting of the Snark* by Lewis Carroll.

OPPOSITE:
Artwork *The Hunting of the Snark*, published by The Folio Society, 2010.

All photographs by Andrea Liggins.

BELOW:
Cover illustration *The Hunting of the Snark*, The Folio Society, 2010.

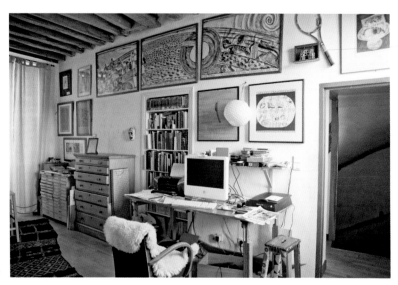

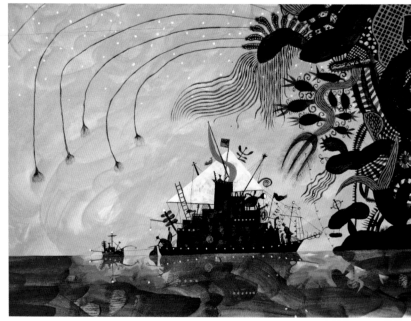

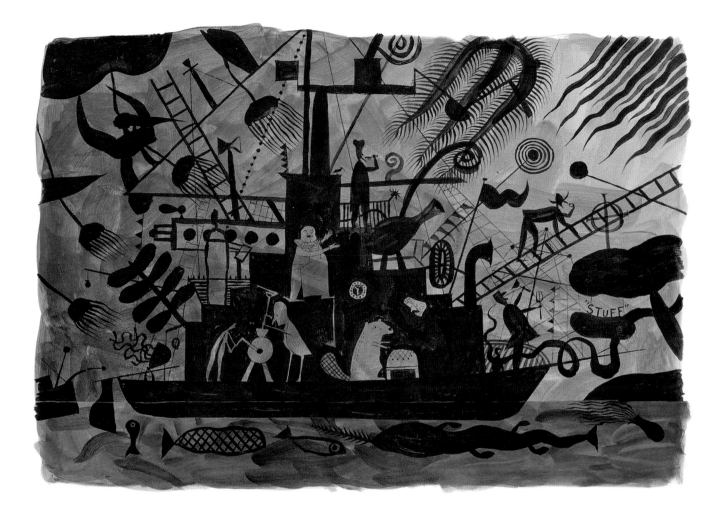

The images Jeff produces can be colouristically sumptuous, painted with acrylics to a state which he describes as "half-finished", then returning to them to refine and modify, often a few days later. He is conscious of the point at which he is comfortable with intervention from the client. It's perplexing that an artist of his vintage and calibre with such a certain and pronounced visual identity should be asked to make changes to his illustrations, but he responds with grace and humour. "I get annoyed with fussy clients. I write cross letters and emails – they calm me down. I draw over the letters and make a piece of artwork out of them then usually throw them away. It makes me feel better. On the other hand, I can totally agree with their remarks. It can produce a better result on rare occasions."

Authorship too has provided an opportunity to be immersed in projects where ideas can be explored from a multitude of directions. *How to Get Rich*, featuring a be-hatted chap in search of the filthy stuff, demonstrates the humour, irony and fun which characterises many of his pieces and pays latent homage to another of his heroes, Frans Masereel. "I love his books," says Jeff. "I love print and books – they are like gold to me. They spurred my enthusiasm for illustration. I particularly loved Arthur Rackham when I was young. It's immensely difficult to write, but I love to do that too." His successes in this area include *Pass Me The Celery Ellery* and *The Hair Scare* (Bloomsbury), both children's picture books which are equally guaranteed to make any adult reader grin.

The decades of this successful career have witnessed commissions across all areas of illustration for some of the world's most recognised clients, including postage stamps, major advertising campaigns and packaging. "I've always tried to push myself to work in other directions. Probably due to a disappointment in my own abilities." Being commissioned so prolifically, he is aware of the potential pitfall of creating images to brief. "It's easy to become trapped. You create work when you are young in the knowledge that you have no idea of what you are doing, which in retrospect is the most enjoyable

part of the whole process. This then becomes your illustration career, and then it's a small step to forgetting why it was you were doing it in the first place. It can be hard to stop censoring yourself. That's when I cease liking the job, when I am trying to second-guess what somebody wants."

Jeff's involvement with a literary festival in a small town between São Paulo and Brasilia, in Brazil, is a fascinating annual commission, which demonstrates the power an image has to impact upon an entire community. The poster he creates is deconstructed pictorially and its motifs and fragments re-rendered in eclectic contexts within the town. Enlarged to a huge scale, these new images become a stage set, his hand-drawn lettering translated into appliqué banners festooned from lampposts throughout the town. On one occasion children in the street reproduced the images in coloured sawdust on the ground. His images bring this town to life.

From his French village, in a studio overlooked by images from Edward Ardizzone, Saul Steinberg and Eric Ravilious, Jeff Fisher will undoubtedly carry on creating his own distinctive images as long as there are books to read. "My work method is a form of self-torture. It's a threat to myself. If I can't make an interesting mark with my own hand, without employing some sort of outside device or tool, I'll feel like I've failed. It's pathetic." In spite of this, his success is indisputable. Witness those overflowing plan chests and bookshelves of the world enriched by Jeff Fisher's art.

Jeff Fisher was born in Melbourne, Australia. He has lived and worked in a small village near Paris since 1994.

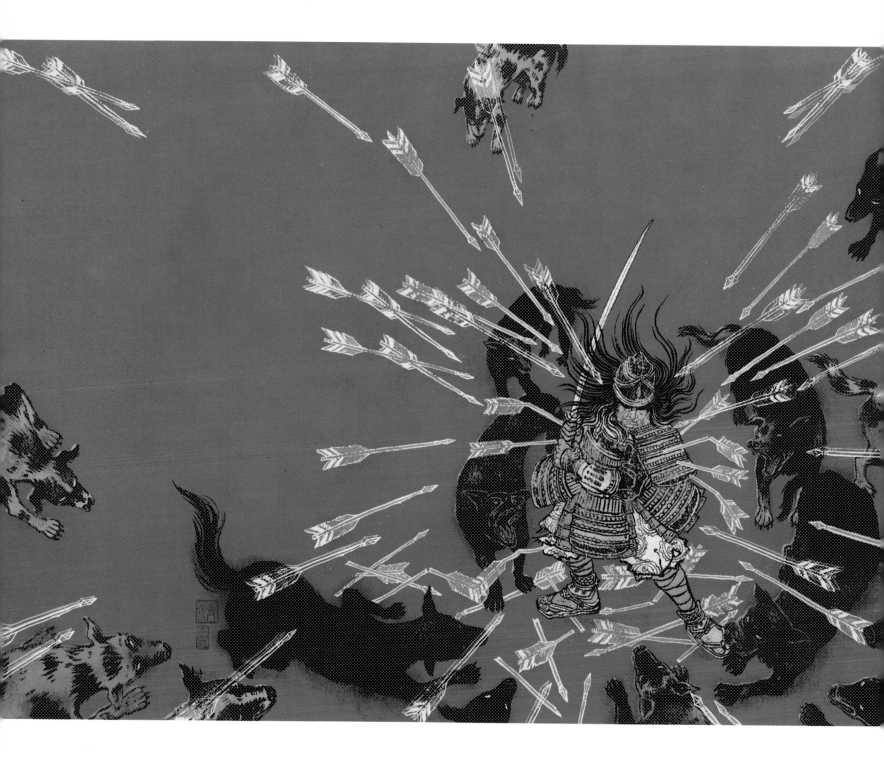

Yuko Shimizu

NEW YORK | USA

"I don't do personal work at the moment. It's not that I don't want to. I really like the marriage of art and commerce. I like being a commercial artist and making pieces for a certain purpose."

OPPOSITE PAGE:
The Beautiful and the Grotesque
by Ryunosuke Akutagawa, cover.
Published by W.W. Norton, 2010.

All photographs by Andrea Liggins.

Many children growing up in Japan spend their spare time drawing, reading comics, watching anime and dreaming of being manga artists when they grow up. This fantasy did not materialise for Manhattan-based illustrator Yuko Shimizu, but what she has managed is an extensive career and an impressive folio of work which has gained major awards such as the D&AD Yellow Pencil, Images 'Silver' award in the UK, and gold medals from the Society of Illustrators in the USA.

In 1999 the time was right for Yuko to turn her back on corporate life in PR in her native Tokyo and instead to pursue her ambition for the creative life she now enjoys. "I didn't draw much at all for about the ten years when I was working corporately. That gap made me really develop as a person. I had gained so much life experience, things I could pull upon which are outside drawing. Those years of not drawing as much were absolutely necessary for me."

The personality of Yuko's work seems to emanate from those drawings done in elementary school when she first imitated comics. It also reflects the broader historic culture of her native Japan with its traditional woodblock prints with black line and sophisticated palettes of soft colour. Although as Yuko points out she hasn't looked at comics since the mid-1980s, she observes, "I've been inking for so long it's never left me. At this point I can't do anything about it."

Her process for making illustration is contemporary. She combines the very tactile physical process of drawing with brushes and ink to produce calligraphic black lines on heavily textured watercolour paper, with digital manipulation. She deliberately seeks out broken, uneven lines, aiming to retain the traces of her process (smudges and fingerprints on the surface of the paper), which give the images a sense of life.

She is fastidious about getting things right: "I do lots and lots of sketches until I do one I like. They may be really rough. When I'm happy with one I blow it up to the size I need to draw." However, she is also careful to retain freshness: "I trace quickly because I don't want the drawing to be tight – that would also make everything in the illustration tight."

Yuko scans in these drawings, images often four times bigger than their intended reproduction size, sometimes digitally modifying the original line or changing its colour, seeking out the sophisticated tonal and colour values that are characteristic of her work. The use of colour and tone also seems to be intuitive, an extension of her personality, again shaped by early cultural influences. She recalls an important childhood experience when the realisation of this dawned. "When I was in middle school in a suburb of New York we made abstract self-portraits which were exhibited. I knew which was mine straightaway. All the American students had used vivid colours – mine were really muted. For me it was shocking because my portrait stood out in a really bad way. I wanted to blend in; I was learning how to behave like an American and wanted to be accepted."

Symbolically, the battle she has had over the identity of her work reflects the love–hate relationship she has with her Japanese background. As a student one of her objectives at the School of Visual Arts in New York was to develop alternative media and drawing skills. The professors there helped her to accept the individuality of her approach. "What most of them taught me," she recalls, "is that what I do naturally are the things I hate, but that's probably who I am and I have to be at peace with that."

Yuko hasn't returned to Japan since she left in 1999. In spite of global success she remains unknown as an illustrator in her native country. "It's a complicated thing," she reflects. "My work reminds people of where I am from. They're looking for something exotic, for work that reminds them of faraway lands."

Yuko is propelled by the dynamic multicultural forces of her current environment. How people from different places work and think feeds into her work, and New York provides that rich source of cultural nourishment. Her work has strong figurative content, and she strives to develop the ability to depict different types and reflect the human diversity she finds all around her, and says that life drawing was invaluable in helping her to gain this confidence. However, because her work would look too stiff if she used posed photographic reference, Yuko draws mostly from her imagination. This means using internet reference, a friend as a muse or her own webcam for details such as hands and fingers.

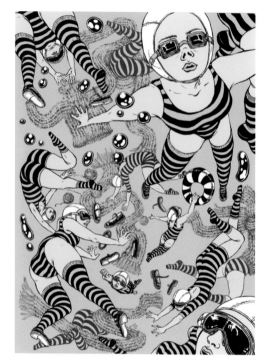

ABOVE:
The Walrus magazine (Canada), July/August, Summer Reading Issue cover, 2006.

OPPOSITE PAGE:
The Unwritten, Willowank Tales, published by Vertigo comics, 2010. Process and final artwork.

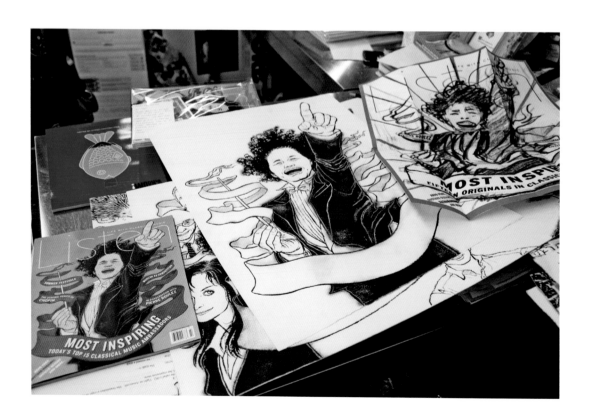

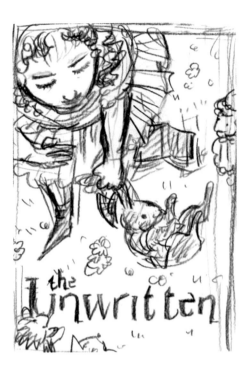
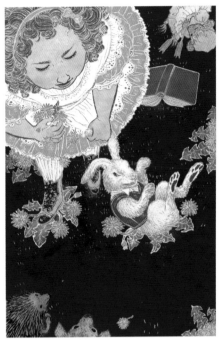
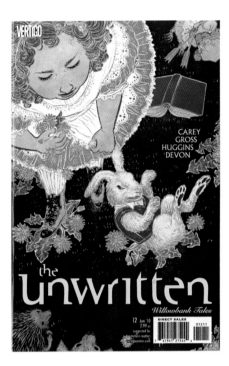

As she points out, the odd perspective and extreme viewpoints she often chooses for her work are "all fake". The illusion of distorted reality is often heightened, and her images as a consequence are very dramatic. But she clarifies: "I don't want to add drama to something that's not already dramatic. The idea comes first and the composition comes second."

It seems that this cinematic approach comes from an interest in films. Yuko laughs, insisting, "I always tell people I'm a movie fan who doesn't watch movies." She qualifies this by recalling how when working in Japan she would take her sandwiches to the cinema and stay all day watching three movies at the same sitting. "I don't know if it's cinematic," she continues, "but what is important is that I'm really into graphic design. Graphic design is distilled into concept and composition so whatever I do with the composition is to make the concept more interesting."

Although known for her high-concept editorial pieces, publishing is a dimension of Yuko's work that provides a rich source of content. "I love reading well-written books. It's amazing to come up with the psychology of different people in different environments and make them believable." When she worked in PR Yuko gained a lot of experience in editing and distilling the meaning, and she feels that this is invaluable for book-jacket illustration. "Remember your high-school English class," she laughs. "Read, underline. Can you tell the story in one sentence? If it's one sentence, what is it? How do you draw that? Basically, reading comprehension is a really important part of my illustration process."

Yuko is a flexible illustrator who respects the clients she works for, whether they are the art directors who give her the space to explore her subject matter, or those "bad art directors who look at the trees and not the wood". These are the clients who interfere unduly, making decisions that merely demonstrate they have the power to assert their opinion, rather than offering productive input. Yuko is calmly stoical about the

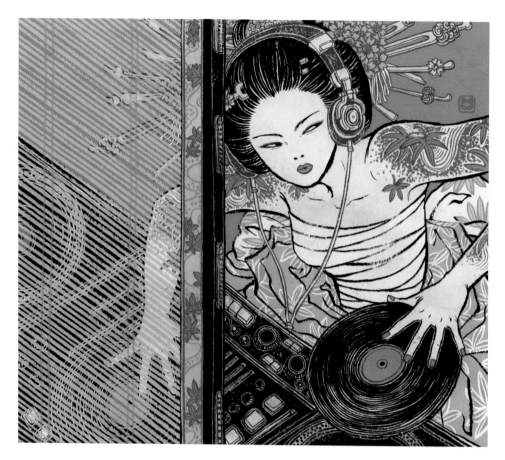

LEFT:
No Geisha, a collection of Japanese fiction by contemporary female writers. Published by Mondadori, 2008.

RIGHT:
Poster to advertise exhibition and workshop at Amarillo Centro de Diseno, Mexico, 2010. Medium: screenprint.

part they play in her process and in defining her role. "I don't care if they intervene. I'm really just an illustrator doing a job to provide a product that makes them happy. If the client is happy my job is done."

The accolades already collected confirm Yuko's position at the top of her profession. She is a highly respected artist but is both modest about this and realistic about the precarious nature of the profession. "I'm excited about having the respect from my peers, but in my everyday life it doesn't change anything. I don't feel that I need to be treated differently because I may be in higher demand. I realise how fortunate I am in this recession to still be doing this." Being in this successful position is due to the risks she has taken and the professionalism she constantly demonstrates as much as it is due to her undoubted skill as an illustrator. She works seven days a week and regulates the quality of what she does by turning down commissions that she thinks may not do well, saying, "I know my limits". Although she is known for her comic-book covers, she declines to return to her initial ambitions within this area: telling stories in panels and sequence is not her wont.

"I enjoy what I do," she says positively. "I get a range of work and there is a chance to explore and experiment with a lot of things. People think a perfect assignment for me is a story about Japan or China or sexy girls, but other assignments give me a chance to find out about a part of me I haven't really investigated before. I'm always learning through my work."

Yuko Shimizu was born in Tokyo, Japan. Since 1999 she has been based in New York, where she works as an illustrator and as an instructor at the School of Visual Arts (SVA).

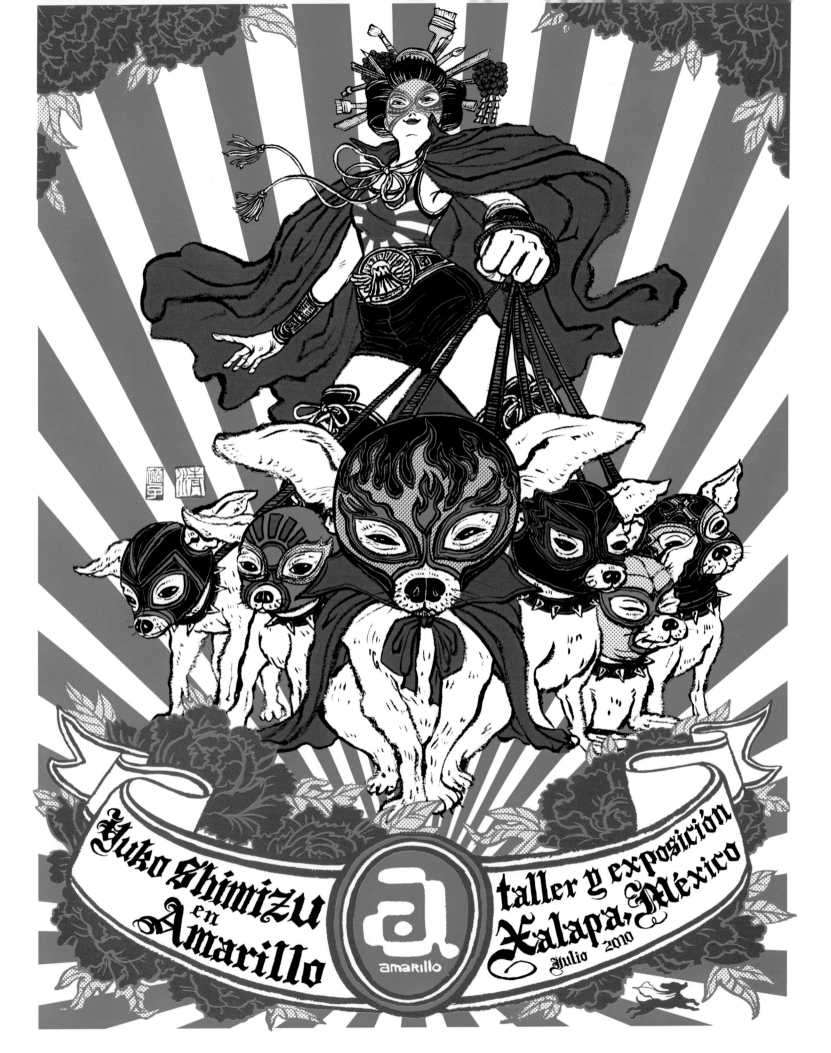

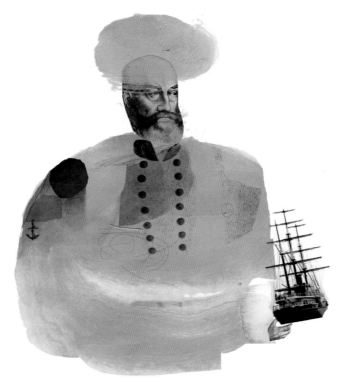

Matthew Richardson

KENT | UK

"I am always demanding of my audience and considerate of their expectations but I want them to invest something in my work. I don't want to give them everything. I provide a space for them to potentially complete the story, to bring something of themselves to whatever the image is."

THIS PAGE:
Sea Captain, personal work.

OPPOSITE:
Poster image for the Royal Parks,
commissioned by Cha Cha Design.

Matthew Richardson describes an inquisitive childhood rich in imaginative adventure where "an upturned table would always be a ship". Today being open to the freedom of creative impulses and new discoveries remains a vital dimension of his mature practice, as a storyteller, with exploration a constant factor. "Creative play is a large part of the reason I enjoy the job I do and the work I produce. With every brief I always look for a way to play within what can sometimes be quite restricting subjects. Things interest me more, and seem to work better, when the end results have an element of surprise for me, as well as the person who has commissioned the work." Editorially and in publishing generally this culminates in memorable, award-winning work.

Matthew is interested in the author's craft – how a text is constructed as well as how visual language is used to fabricate a reality. The solutions he provides to visual problems are respectful and measured. "I look at ways of finding a visual equivalent to the way an author writes," he explains. "Potentially, a novel will have been the product of many years' work. I wouldn't approach the illustration of that in a casual way."

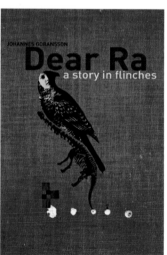

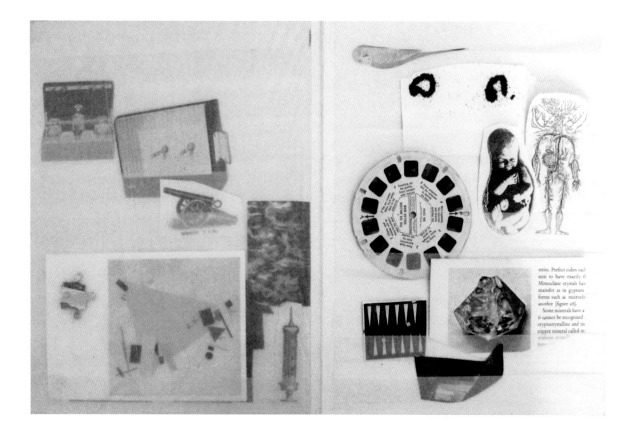

THIS PAGE:
Workbook.
Workbook image courtesy of the illustrator.

OPPOSITE (top left)
Phantom Space Storms, commissioned
by *New Scientist*, V&A Illustration
Editorial Award, 2010.

(bottom right):
Dear Ra: A Story in Flinches
Starcherone Books, 2008.

Portrait and studio photographs by Andrea Liggins.

It is likely his interpretation of a text will be rich in content, with meanings in his images beyond the first, most obvious literal description. His interest in metaphor, symbols and semiotics – the interrogation of how images reveal meaning, how they make us feel and why – became habitual during his postgraduate study. He is deliberate in employing these visual devices to engage and communicate with an audience.

In editorial pieces the meaning is more overt when compared to the more playful and open mix of symbols used in a book jacket. Matthew explains, "When I'm making an illustration, I think about how the image might be read. The images need to be strong, to catch attention, but I don't want to give absolutely everything away all at once, in a glance. So I try to allow a bit of space for the viewer to complete the story, to bring something of themselves to the image." He interprets the narrative, both facilitating the author's messages and providing his own visual comment. He encourages viewers to "inhabit the image and find their own meaning."

When commissioned to produce a book jacket Matthew uses highlighters to analyse the entire text and describes this as "a way of establishing common threads, themes, recurring places or objects – a way of identifying what might be picked up on and developed." He adds, "Of course, I also make notes and drawings of scenes and scenarios that are particularly visual or stick in the mind." Research around an identified era or place, for example, can also stimulate ideas, and to that end his vast collection of old photographs and postcards provides a valuable source of inspiration and reference. Colour is an important consideration, symbolically and pictorially, and Matthew will often focus carefully upon how it will be used in his work. "Each book appears to have its own specific colour or combination of colours. I spend quite a bit of time experimenting with different combinations and contrasts. At times, the main idea might well pivot on how one colour sits against another."

As well as drawing and sketching Matthew will often create abstract textures to reflect the fabric of a writing style, or denote the evolution of a plot. Sometimes these explorations are evident in the final image, or they may be built upon and eventually become virtually invisible.

Objects are constructed and purposefully selected as potential vessels for the ideas Matthew has chosen to develop. Here he is often playful. "What happens if I interweave elements? Change their relative scale? Take off one character's head and stick it on another? What if I turn the whole image upside down? I shuffle things around a bit like a director of a play, or a kid with his favourite toys!"

Matthew admits that he is intrigued by old artefacts and objects – the way they are inscribed by history – and unsurprisingly he draws inspiration from museums and collections, as well as cities and places he has visited. "That's why I like found images – they bring their own aura with them."

As a result there is a sense that we as viewers are witnessing a new world, a slightly surreal, fantastic place that is literally multilayered, often with the old and new co-existing. Decisions about how this is organised result in images where the audience is often left questioning compositions in which there is often a sense of imbalance, with forms about to topple over or flee the picture frame. This has the potential to animate the image, capturing a fleeting moment, which might make the viewer ask, "What's going to happen next?"

There is a cinematic approach to the way these elements are collaged together. "If I look at films it's from a very technical point of view. I'm aware of long shots, detailed panning-in shots, etc. Film has played its part in how I put images together and the way time can be collapsed."

The audience is an invisible force shaping the process. "I think about the end purpose of an image," he explains. "Ideas will be developed differently for different uses and contexts. If I do a billboard advert, I'll think of how that needs to work in a different way from an illustration that's going to be seen in a book. If I'm making work that will be experienced in a gallery, other considerations may come into play. So I'm considering what purpose an art work has in the world – if it's seen by many at once, for example, or experienced more privately and intimately."

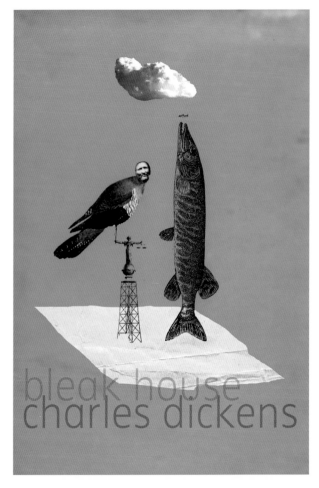

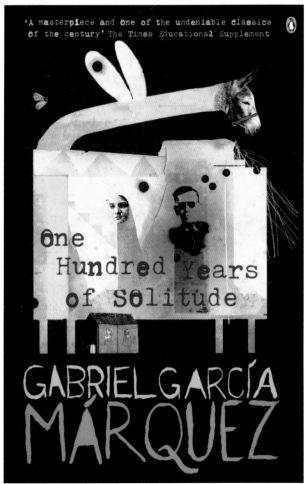

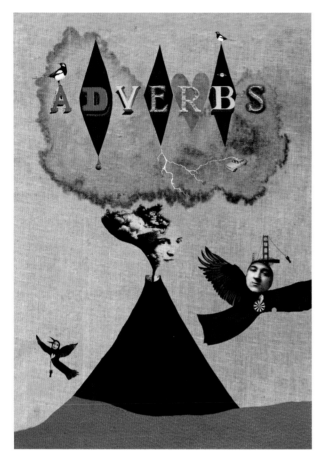

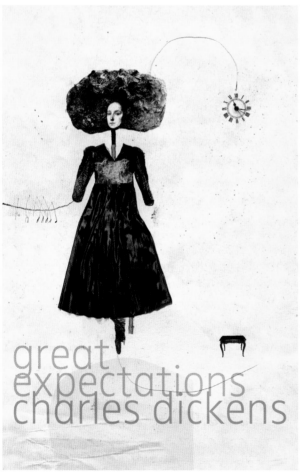

During the early days of his practice in silkscreen and etching, as well as physically cutting and collaging, Matthew established a real connection with materials. This still plays an important part in his work although the work is now largely assembled digitally. Everything commissioned for print is ultimately transposed through the inevitable scanning process, but he continues to be particular about the tactile quality of every piece of artwork. Nuances of texture and carefully applied marks can be less vital within an art work destined to become a book jacket, but are used more deliberately in work done for galleries and the personal projects running parallel to commissions. In this context the physical qualities are defining. A collage is seen as a piece of low relief and the smallest pinprick on its surface an important factor.

These self-initiated projects are important on many levels. "In my own projects I'm obviously making work around subjects and areas of personal interest. I love the aspect of commissioned work, though, where the challenge is to find your own voice and way of describing something of a subject that you may well have no prior knowledge of. This process is quite a different thing from having free reign in my own work. Authorial work is a counterpoint to commissioned illustration, which always has a purpose and a reason."

Matthew is keen to give all his work value and meaning. "As an illustrator I delight in having to sell these skills to whoever wants them," he says, before qualifying the statement. "I would hate to produce work that is just seen to decorate. There's always a potential for that as a commercial illustrator – just take the money and run."

He builds good working relationships with his clients, seeking to establish a clear understanding of their needs and ensuring that he is equally clear about what the client has recognised in his work so that he can maximise the creative potential inherent in each brief. He says that what keeps his passion for illustration alive "is never knowing what is round the next corner".

Matthew Richardson lives and works in Kent in the UK.

THIS PAGE:
Adverbs by Daniel Handler, published by HarperCollins, 2007.
Great Expectations by Charles Dickens, unpublished, 2008.

OPPOSITE:
Bleak House by Charles Dickens, unpublished.
One Hundred Years of Solitude by Gabriel García Márquez,
published by Penguin, 1996.

ANTOINE+MANUEL

CATALINA ESTRADA

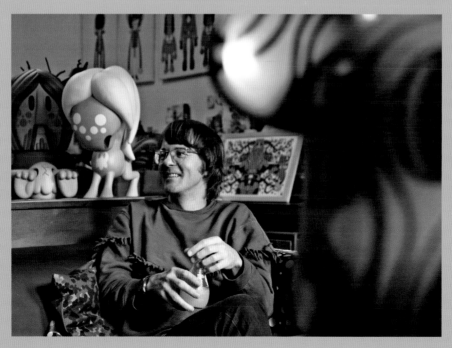

PETE FOWLER

Decorative Illustration & Merchandising

Surface pattern and decorative illustration has expanded across both 2D and 3D art and design. The genre has asserted its identity as a credible and contemporary commercial activity.

The client's perspective: Matthieu Lelièvre, Curator, Graphic Arts department - Musée des Arts Décoratifs, Paris, France

In classifying artistic genres, illustration has always held a special place typified by its dual function both to inform and to be aesthetic. While the latter relates to a wider genre, which can be successful without an explanation of content, art can be valued also from the perspective of usage, primarily as a tool for communication.

Illustration is present in museum collections in many forms, ranging from medieval illuminated manuscripts to political caricature, original lithographs accompanying books of poems, and advertising cartoons. A picture is a reflection of visual culture and the embodiment of formal information and communication, rendering it fragile and perishable. The evolution of taste, loss of knowledge and loss of ways to access its contents – in short, the ageing memory – deny successive generations these images. Deliciously vintage images from the 50s have suffered the same fate as the Art Nouveau illustrations or fashion plates of the 19th century. They are sometimes undervalued and forgotten, but can subsequently resurface charged with new emotions, to be accurate impressions of past nostalgia.

Today the image is so ever-present that the role of illustration has never been greater. The spontaneity of the designer's pencil strokes or computer work creates worlds, icons, symbols and patterns embodying anything from a company to a music band with a brand or logo. Our lives are completely invaded by these forms of communication from publications, images on walls and even objects and clothing.

One can see the multifunctional, transcendent nature of graphic language in the work of designers Antoine & Manuel when they create new realities as demonstrated in this book. Their colourful and entertaining world, as exhibited in 2009 at the Musée des Arts Décoratifs in Paris, combines vector images and hand-cut shapes together with pencil work to create a universe where dreams, sensations, sophistication and spontaneity coexist.

Diversity is what characterises the world of illustration, but this is unified by aesthetic values which perfectly reflect the era to which they belong. Omnipresence and a wealth of quality establish the image as a fantastic tool to enable us to understand our time.

ABOVE:
Portrait by Derek Brazell.

LEFT:
Photograph of Antoine & Manuel by Paul Duerinckx.
Photographs of Catalina Estrada and Pete Fowler by Andrea Liggins.

Antoine+Manuel

PARIS | FRANCE

"A graphic designer has a diversity of expressions, and a client will choose the most appropriate one, maybe bringing in other illustrators, photographers or typographers. We're not like those. We have all the expressions we want to use." Manuel

"Usually we don't know what the expressions are yet. We enjoy our work most when we have the chance to find them." Antoine

ABOVE:
Christian Lacroix, haute couture
invitation défilé 43, Autumn/Winter
2008/09.

OPPOSITE PAGE:
Centre de National Danse
Contemporaine, Angers poster, 2008.

When design historians analyse the first decades of the 21st century, and reflect on the dominant cultural factors defining that visual age, it is likely that the return of a decorative aesthetic across all areas of design will be recognised as a significant trait. Paris-based creatives Antoine and Manuel are key protagonists in this revolution in popular taste. Although as visual polymaths they defy labels, their distinctive and diverse practice puts them at the forefront of the decorative genre. Whilst this term may still hold derogatory connotations, their enduring and pioneering work has brought credibility to the use of ornament within the design spectrum. They also demonstrate the potential for successful practice dissolving the claustrophobic structures of design categorisation.

Their retrospective shows at the Musée des Arts Décoratifs in Paris (2009) and the Hong Kong Heritage Museum (2010) are testimony to the respect that a cross-disciplinary approach now merits. Around the world their wallpaper, typefaces, furniture, carpets, interiors, posters and catalogues all hold at their core the distinctive yet unpredictable language of ornament that the pair have evolved over many years.

Manuel identifies the factors that have directed their technological and personal development over the past couple of decades. "For us, working with some of the first-ever computers in the 1980s was very important. We didn't decide to be designers, we were seduced by the new processes." Antoine elaborates: "We were very impatient. We still like things that are quick. We realised that by starting as graphic designers we didn't need anyone else. People say we're egotistical because we want to do everything between ourselves."

The pair didn't begin with a prescribed philosophy or a deliberate career strategy. They began with a relationship. They became lovers at art school and their relationship organically developed into a working partnership. Manuel's education in furniture and product design and Antoine's background in fashion

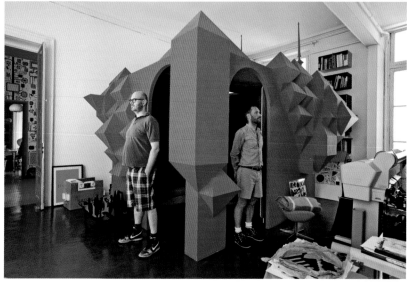

design, in pre-digital art schools, equipped them with an extensive repertoire of traditional, technical, aesthetic and intellectual skills. All of this combined with a positive realisation that the hybrid of two distinctive parts created a unique and robust new whole. "An important thing between us from the beginning was that I am optimistic and Manuel is realistic. That makes a good balance."

They continue to operate with a fluid approach to roles and responsibilities, playing to each other's strengths. This often results in Manuel taking the leading part in 3D work and Antoine being more textural and pattern-based, Manuel creating structures and Antoine being more experimental within them.

"There is no issue about who does what," Manuel explains. "We can't say we have one method – this changes every time." Antoine continues, "That's another reason why we don't want to be labelled as the guy who does this or that, it's too easy, and too commercial, to do that kind of practice."

Antoine and Manuel see the briefs that clients provide as opportunities for innovation, and enjoy long-term relationships with clients who encourage them to discover new solutions. Like most successful creatives, the calls requesting repeat versions of "what has gone successfully before" frustrate them. They are consummate professionals. "Sometimes our clients want us to be illustrators, sometimes they don't know what they want, but they are our clients," says Manuel.

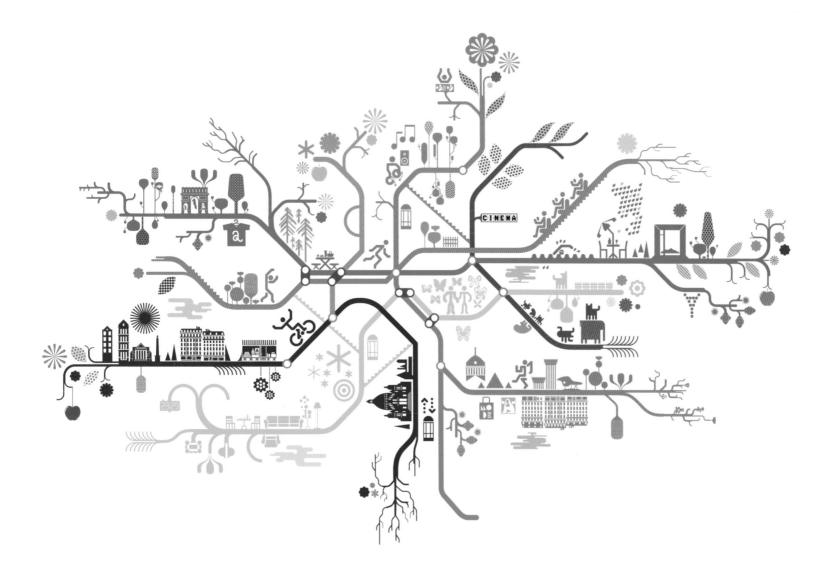

ABOVE:
RATP (Parisian Metro), Intégrale map, 2005.

OPPOSITE:
Chapelle (Chapel), evolving installation made for solo exhibition at Musée des Arts Décoratifs, Paris, 2008. Photograph by Paul Duerinckx.

Mars, from Gods series, 2008.

(top right)
Sketchbook.

They famously worked for fashion designer Christian Lacroix, creating the graphic artefacts reflecting his new collections: catalogues, show posters and invitations. "He's an example of a client who was in many ways perfect," says Manuel. "Because he's a talented creator he understands that you have to give a lot of freedom to other creatives to get a lot back from them." Antoine adds, "When he came to the studio to see the work we were doing for him, there was loads of energy and creativity. He was like, 'I love it, go further!'" The antithesis of this is clients who are afraid of the possibilities, closed to the uncertainty of new discovery and preoccupied with the duo's technique.

"At art school you learn you have a client and that's all that matters," says Manuel. "The people you work for are the most important part of the job. The best work we do is for people who respect and understand our work. It's easier to make good work for good people."

Although there is a range of repeated motifs and visual approaches that are specially requested by their clients, Antoine and Manuel tackle each project with a methodology dictated by its intrinsic needs. What emerges in final pieces is therefore eclectic. Often there is a characteristic lightness of touch, eccentricity and daring. In 2D work, loose drawing and explosive patches of fluid texture and pattern are often brought together within more controlled, designed structures. A large trestle table in the studio covered with many sheets of paper filled with abstract patterns – a work in progress – is evidence of this. Shakers filled with beautiful pigments of Indian powder contribute to ongoing experimentation for a

59

packaging job. Elsewhere walls are splattered with the memories of other explorations. Whether creating a complicated piece of furniture or a 2D commission, there is still an ambition to learn. Manuel says, "We move forward with an understanding of our limitations and abilities, but we try to polish our skills to a new level. There's no mystery – I know what works, I know what's possible." Antoine adds, "And I'm more experimental. We don't have the same confidence. Sometimes I'm less sure of something, and Manuel says go ahead. The reverse is also true. That's the point of working together."

The pair use the words 'universe' and 'worlds' repeatedly in lieu of traditional nomenclature associated with design practice. Their studio output and exhibitions testify to their conviction in the experimental nature of their work. They create their own world. While functioning as designed artefacts, brochures, posters, lamps or tables, their designs playfully encourage interaction with an audience, as well as intellectual curiosity about the content of and physical engagement with a piece. Examples are the table made from laser-cut Plexiglas, icons of distinctive French monuments (interchangeable to allow multiple permutations of a landscape), the exquisite invitations for a Christian Lacroix exhibition, with seductive multilayered embossed surfaces, or the abstract paintings without a design context, inviting the viewer's curiosity and open to interpretation. "Our universe is connected to childhood and that's why people think it's playful," explains Manuel. "When I was a child I experienced very strong sensations around pictures and wanted to share them. I always want to express feelings in my work." Antoine continues, "I enjoy being able to make things. For me the play is immediate and physical. I like to play with my hands, to learn from experimenting."

There is often something beautiful in their work, organic forms intertwining with elements such as Dutch houses, exquisite in black and white as wallpaper or as the surface of a chest of drawers reminiscent of the Fornasetti aesthetic of the 1950s. But their preoccupation is not purely with Tachist qualities of beauty or surface.

"We don't have ideas!" states Manuel contentiously. "We don't work on concepts, but behind what we do is something more than decorative art. Concepts can be a recipe, a process." Antoine elaborates, "Yes, if used over and over. We don't like that. Probably there are messages in our work but we prefer not to show them."

If there is a commonality within their work it may be the polarity of approaches, the tensions of elements and themes that contradict each other. For example, this includes the structures they created with possible latent origins in computer circuit boards, intertwined with organic forms. Antoine and Manuel's subconscious influences from the 1960s and 1970s are wedded to a futuristic vision, the natural world combining with the technologically controlled.

Manuel sheds light upon the multidimensional contradictions of their work. "There are lots of aspects of our work where we combine sharp and precise," and Antoine continues, "with organic and artistic. Hot with cold, dark with light. It's combinations we enjoy." In this respect their work may be the way it is because it is a whole single product from made by two very different men.

Antoine Audiau and Manuel Warosz have worked together since 1993. They live and work in Paris.

ABOVE:
(top)
Studio photograph of work in progress by Paul Duerinckx.

(below)
Centre de National Danse Contemporaine Anger poster, 2009.

OPPOSITE:
(top)
La France, table base and sketches, 2007.

(bottom left)
Possession, commode, Corian, prototype, 2004. Medium: silkscreen on lacquered wood. Photograph by Daniel Schweizer.

(bottom right)
Christian Lacroix, haute couture invitation 38, spring/summer 2007.

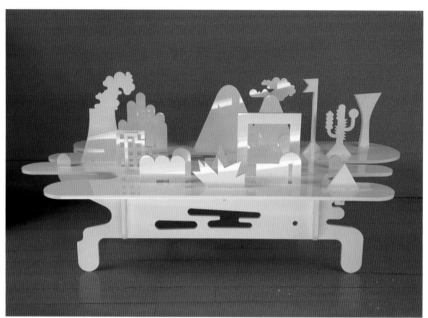

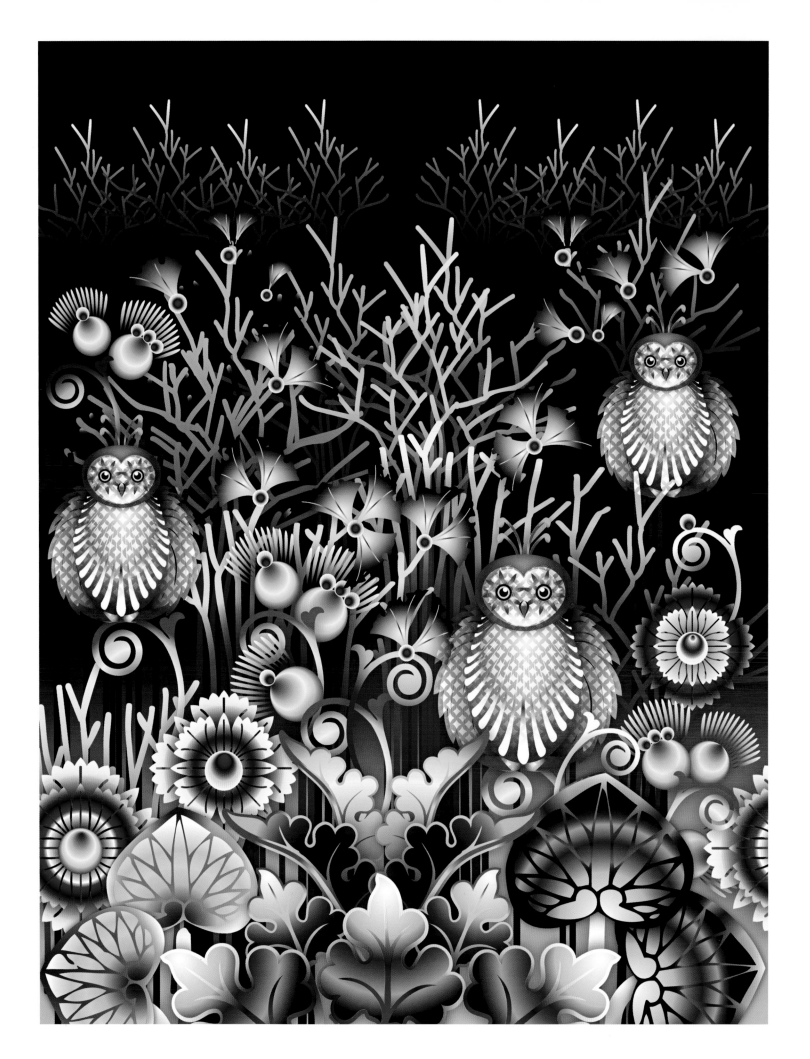

Catalina Estrada

BARCELONA | SPAIN

OPPOSITE PAGE:
Forest design for *Anunciação* fabric, 2008.

THIS PAGE:
Forest fabric for *Anunciação,* 2008.
Photograph by Pancho Tolchinsky.

HelmetDress, Catalina Blue,
motorcycle helmet cover, 2009.

"I think that's the strong part of my work – the details, the colours and the textures."

Entwining themselves across a multitude of products, Catalina Estrada's beautifully decorative, feminine images combine sweet faces, flora and fauna, pattern and shape, with an appealing empathy for colour. Her gallery images, however, whilst including all these, may also feature hand grenades and machine guns. Both these sides of her work are fed by a strongly felt connection to her homeland of Colombia.

There is a sense of warmth to her bright images, which often have a softness to them created by a glowing use of light and effective colour schemes. Commissioned to embellish MP3 players and shoes, stationery, bags and wallets, lunchboxes, crash helmets, fabrics and garments, a Kidrobot toy, and Smart cars, Catalina has also done book covers, advertising and magazine illustrations. Brought up in the Colombian countryside, she continues to be inspired by the lush plant life of her parents' garden, and the influence of her mother's love of colour. "She was always painting the house in different colours," Catalina says, "so every room was different. She is not afraid of colour, which I think is great." This stimulated her own passion for colour.

As a child, she often stayed with her nearby grandparents. Her grandmother would invent stories to entertain Catalina and her brother, and the folklore elements which surface in her work lead back to this storytelling, emphasising the enduring family ties that Catalina treasures. Her grandmother was also a collector of stamps, coins and banknotes, and they would often spend mornings soaking stamps off letters, admiring the colours and designs from around the world.

This exposure to international design was also fed by her parents' frequent visits to Japan, necessitated by her father's employment by Japanese companies, from where they would return laden with gifts, including kimono fabric, toys such as Hello Kitty, My Little Twin Star, My Melody and manga comics. "These presents had a graphic language which was so different. It was like coming from another planet," she remembers, and as prior to the internet other cultures were less accessible, these toys and textiles were all the more fascinating to the children and an abiding influence for Catalina. Now based in Spain, returning to Colombia and her mother's place continues to provide Catalina with inspiration, "because I

am very attached to memories," she says, and her mother's ongoing creative activities make her home vibrant and interesting. "I think she's a great artist, she just doesn't want to admit it." The romantic and occasionally lurid Catholic imagery prevalent in Colombia has also served to inspire her. "I think they use very beautiful colours because it's very emotional, or very dramatic, or very scary at the same time."

Contemporary influences come from travel – she carries a camera at all times to capture combinations of colour and shape – but are also available closer to her present home. Catalina loves the diversity of Barcelona's resident population. "Here many cultures arrive and they keep their own culture. Everybody has their own graphic language, and each one has their own colours and the way they pack their food, the music they listen to – I think it's a carnival. You don't get bored." She feels that the move to Barcelona subconsciously prompted an increased emphasis on colour in her work as a reaction to the more muted use of colour in Spanish interiors, along with the absence of gardens and flowers in the city.

When beginning a commission, as clients are often pressed for time Catalina will start to sketch directly into the computer. She is often working on several projects at one time and needs the flexibility that digital sketches afford, allowing her to make any changes or adjustments that the client may require. She considers her imagery to be primarily about detail and colour, and so will offer two or three similarly composed sketches to the client, already coloured up, from which a selection can be made: "I don't want to leave too much to the client's imagination."

Visual impact is essential, so Catalina will spend a great deal of time combining different details and various combinations of pattern and colour in the artwork, creating atmospheres with a strong use of light, shadow and contrast. Working in vector-based software allows her illustrations to be resized without loss of quality, though artwork may be less complex for smaller reproductions. Catalina comments that she feels more like a decorator than an illustrator sometimes, "because I am more concerned about things being

THIS PAGE:
Process design for *Anunciação*,
summer collection, 2011.

OPPOSITE PAGE:
(top)
Fabric design for Paul Smith, 2007

(bottom)
Smart For Two car series,
Milan Design Week, 2008.

beautiful, or balanced, or in harmony in terms of colour or composition, than about particular situations I have to illustrate".

Having her own distinctive graphic idiom means that clients approach her because they already like what they have previously seen and know what to expect. Occasionally, briefs will be given which include collages of her existing work, with requests for a certain colour palette, but with her own composition. "I am lucky as they always say, 'Do it in the way you would do it.' I generally know the clients already, and I know with which clients I can develop my language a little bit further." She wants her clients to be happy and will accommodate changes if she's able to. "I don't take it personally if they say, 'I don't like this, I prefer you to do it that way.' If it's in my hands and I can do it, it's my pleasure." Relationships will develop, such as with Brazilian fashion label Anunciação, so that they no longer brief her, instead offering colour schemes and names of the flowers and plants they'd like her to incorporate into her designs, often because specific plants will have a meaning for the designers.

Though commissioned to illustrate a host of products in different formats, Catalina's main query is over what kind of printing technique will be used. If it's screenprinting she's aware that the gradients she often employs will not reproduce well, and in those circumstances she will use flat colour. Her Coca-Cola bottle wrap was adapted from the main poster image she created for them, and she will let clients modify artwork, with her approval, if it removes a lot of time she would have to spend herself. "Sometimes clients drive you crazy, because they say, 'Can you move one millimetre more?' And then you get *another* email from them ..."

Even though her style appeals to a broad range of consumers, the client rather than the consumer is the focus for her work. Nevertheless, given the strong feminine slant to her artwork, when the intended audience includes men she finds that she needs to be more aware. She also enjoys new targets, "because it opens your mind. Otherwise you always stay doing the same thing." Fans of her work also send messages, and she appreciates these positive responses, noting that the illustrator's profession is mainly focused solely on the client's reaction.

Catalina's personal pieces contain interesting elements which are not seen in her commercial artwork. Most of the work for an exhibition is made by hand and can be generated over a fairly long time

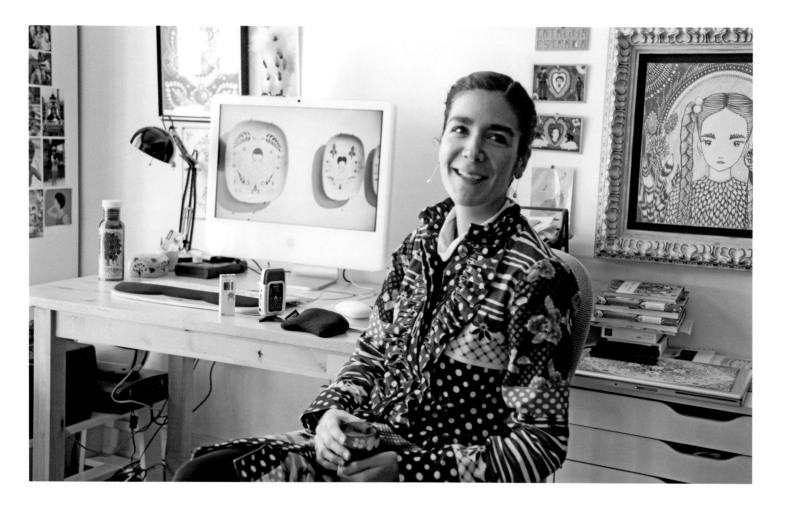

CATALINA ESTRADA

OPPOSITE PAGE:
I'm my rifle's prisoner, 2009. Personal work for Disarming Dreams exhibition themed on Colombia's civil war child combatants. Medium: digital.

I'm A Precious Stone, 2009. Disarming Dreams exhibition. Medium: hand-painted.

THIS PAGE:
Camper Locus Bcn City of Creators shoes, 2008.

All photographs by Andrea Liggins.

period, and it is usually the only personal work she will produce. Although stylistically similar to her commissions, each set of works will have a different approach, geometrics making a change from the curves and ornamentation of commissioned pieces, and colour tones possibly more muted. This, and the subject matter, allows for evolution in her work. The concept for an exhibition from 2009, for instance, was on the role of child soldiers in the Colombian civil war, and this added grenades, machine guns and knives to her more familiar motifs.

Images from some digital personal projects are available for licensing, and have appeared on jigsaw puzzles and phone skins, amongst other products. Collaborations with her photographer husband Pancho Tolchinsky, as well as ceramics and wall decals, add further dimensions to Catalina's work, and with her name branded on certain products such as clothing, recognition for her lush colourful style is expanding.

Catalina Estrada was born in Medellín in Colombia and now lives in the Spanish city of Barcelona.

Pete Fowler

LONDON | UK

"I think, in terms of illustration, there are so many places you can take that."

A unique cast of characters populate Pete Fowler's artwork and vinyl toys. Formed with a pleasingly warm palette of colour – "I like bubble-gum, psychedelic, candy colours," he says – these figures may have antlers, curiously shaped heads, and tentacles, but they have also found an international audience drawn to the individual 'Kingdom of Monsterism' he has created.

Pete became increasingly drawn to three-dimensional work towards the end of his fine-art studies. He'd had a close interest in figures since collecting the Star Wars merchandising as a child, and then at college he began creating sculptures, 3D work which would ultimately result in his own vinyl toys. "For me the character doesn't stop at 2D. When I do a character I think a little bit in 3D anyway."

Constructing figures remained a 'fine art' operation for a few years, until the first designer toys started to appear from Hong Kong and Japan in the mid to late nineties, such as Michael Lau's first few figures, Medicom's Kubricks and later James Jarvis. That showed Pete a way forward, a commercial application, "where figures are almost as easily accessible as 2D work such as screenprint or magazine illustration, rather than an expensive one-off piece".

During an exhibition of some large-scale sculptures in Japan in 2000, which took the aesthetic of plastic toys to a much larger scale, Pete was approached by Sony Creative Products and asked if he wanted to do a range of toys. "It took about a millisecond to say yes," he laughs. "I'd rather put the same amount of time and effort into something that is accessible, very instant, but at the same time disposable, without having this fine-art concept attached to it." Those initial toys were launched in Japan and the UK in 2001.

OPPOSITE PAGE:
Welcome To Monsterism Island,
adhesive digital printout,
20ft x 26ft (6 x 7.8m), 2009.

ABOVE:
Green, from Woodland
volume 3 series of
Monsterism toys, 2005.

For his early figures, it was a case of, "'Here it is from the front, what the hell does it look like from the side?' It really started to open up my mind to how these things would look if they were a real object." Before studying art, Pete discovered a strong interest in life drawing, and he believes this was one of the most important things he's done, aiding his understanding of form and shape. "To be able to do cartoon characters, or any characters that are exaggerated or mutated, it helps to know how the human body is, the weight, the shortening – those kinds of things."

At the start of the process, he'll produce drawings to design the new character. Depending on the complexity of the figure, he'll draw a front view, three quarters size, back, three quarters size; a symmetrical character will be a little easier. Considerations such as balance have to be taken into account to ensure the object will stand up. These act as rough technical drawings. Colour is thought about at this development stage before the sketches are traced in Adobe Illustrator (where the software allows for different colourways to be considered) until Pete is happy with the combination. From initial sketches to completed toy can take around six months.

Elements around the toy, including packaging, are almost as important for Pete as the toy inside – "For people who collect Monsterism, it's the toy they want, but the package is what you first see," – and though not a graphic designer, he puts the packaging together himself. Production constraints mean that packaging solutions are kept fairly simple, with Pete applying artwork and typography to the existing

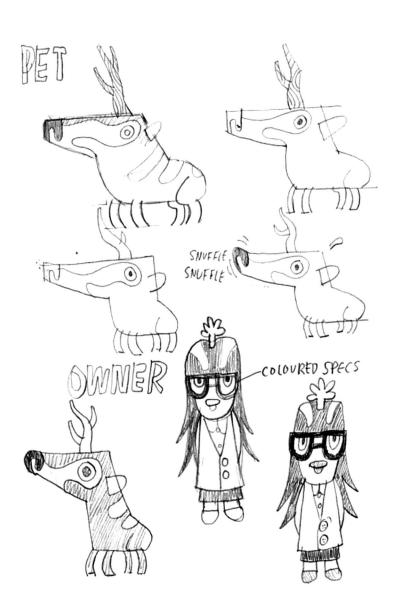

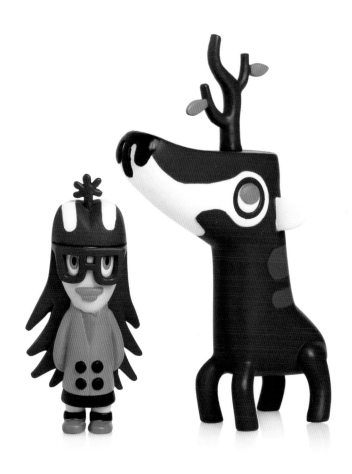

shape, and occasionally running the result past respected peers before it is sent for manufacturing in China. For his Playbeast company he produces both stand-alone figures and collections, including the *Woodland* and *Pets and Owners* series, which come as eight different figures grouped together. Other figures like TRWG! and Cam-Guin exist individually.

As a child he was interested in the supernatural and in unexplained phenomena such as the Loch Ness monster, then later on in UFOs, and as an adult in Japanese folklore – inspired by artists he admired who used it, including Shigeru Mizuki, Jim Woodring and Keiichi Tanaami. This lead to an exploration of European and other myths and stories, building influences in his work which are still apparent in his current imagery. Over time, the appeal of popular culture has waned for Pete; what resonates more strongly for him now is the timeless feel of work from the past.

His other big inspiration is the natural world: "I'll often go out and draw trees or whatever and bring that back into my work – looking at forms and cartoonifying them." He recognises the importance of observational drawing. "I think it's something that anyone who draws should do. Good for the eye. It's almost like practising scales," he says, laughing. Drawing is an activity he tries to do as often as possible: "For me drawing is all about relaxing, drawing for the sake of drawing." It's where all his ideas come from: "Wherever something ends up, that's where it starts." He has built up books and books of ideas over the years: "I've recently looked at work I did five years ago and thought, 'I'll pull that sketch out and change it, slightly modify it…'"

Pete works within a contained creative world, resisting looking at other illustrators' and artists' output: "I genuinely get disheartened, because there is some amazing talent out there." He'll try and create a feedback loop with his own work, so it can start to influence itself: "An idea starts and that'll give me an idea for another thing, and it'll all be quite self-contained. Obviously, I'll unzip the bubble to pull in other influences and inspirations from the world, but I like to think it's a quite self-contained universe."

Looking at his work, elements emerge as recurring motifs and stylistic devices. Pete has long held an interest in symmetry – "As the years have gone on I've got more and more into it," – and he'll push this further by mirroring an image one way, then another, and working with the new shapes and repetitious patterns which are then revealed. "I draw what has appeared. It's slightly magical to me, like meditative music can seem boring, but you listen to it long enough and all sorts of things can emerge. Same with symmetrical design." He'll sometimes create the impression of mirroring: "Maybe it's mirroring the composition rather than the things that are actually there. I'm sure I'd be a shrink's field day," he says, and smiles.

Skulls, people playing banjos, hats, owls and synthesizers are some of the motifs Pete returns to in his artwork: "I like to use them, but use them differently, finding something new each time by modifying and adapting them." This reuse of elements runs as a theme through the different practices of Pete's work and adds to the familiarity that makes all his productions so identifiable. Some of these are inspired by items he collects, such as guitars, banjos and electronic devices – a dusty synthesizer leans against the studio wall when we visit. "As a visual artist I like how these things look and I like how sound looks," he explains. "For me, music is quite visual – the mood or places it evokes."

OPPOSITE PAGE:
Badge & Zylphia,
Monsterism Volume 4,
Pets and Owners series,
2007.

Development sketches.

BELOW:
Troubador from *Woodland,*
volume 3 series of
Monsterism toys, 2005.

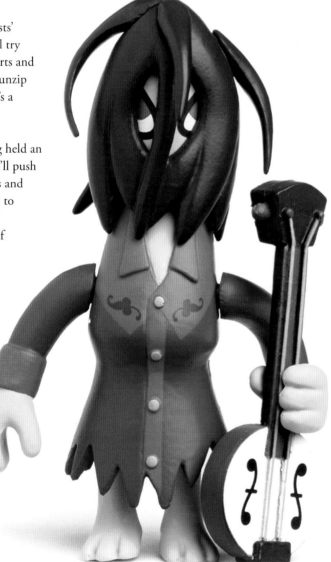

OPPOSITE PAGE:
Daily Note promotional newspaper cover, and pencil working drawing, Red Bull Music Academy, 2010.

Studio and portrait photographs by Andrea Liggins.

BELOW:
Snuggets and Snelina, Pets and Owners tin, 2007.

Psychedelic Yacht Rock Forever, billboard. Acrylic on plywood, 5ft x 20ft (1.5 x 6m), 2009.

Though originally painting all his commissions in acrylic, his style with its strong use of line and colour transferred well to computer programs, and though he'll still paint canvases, most 2D commercial work is ultimately produced digitally.

Since the time after graduation when he self-published the comic 'zine *Slouch* with two friends, which included producing T-shirts and stickers, Pete has been conscious of branding as a channel for creating interest, "so even very early on I was interested in taking things beyond just 'Here's the artwork'." He's inspired by seeing great T-shirt artwork to think, "I want some of that, I want a piece of that."

Monsterism, the environment for his own creations, is a recognisable part of the Pete Fowler brand, though he considers it a more personal one. The evolving personal work continues to appeal to commissioners. "I'm quite lucky in that I'm in a position where a client won't want to change my work too much because it's what they're interested in."

Though well-known for his creations in this area, he doesn't see himself as a toy designer, instead regarding his artwork as a springboard to multiple opportunities, encompassing paintings, large-scale wall works – inside and outdoors – apparel and animation as well as the figures designed for Sony and his own company. Experimentation in different areas has been a key element in his career, allowing for his work not to be tied down to two dimensions. Pete's open attitude to commercial applications has allowed his work to step off flat surfaces and find interested commissioners and collectors, and most recently an animated show for television, "allowing it to come alive in different ways".

Pete Fowler was born in Cardiff in Wales. He now lives and works in London in the UK.

PETE FOWLER

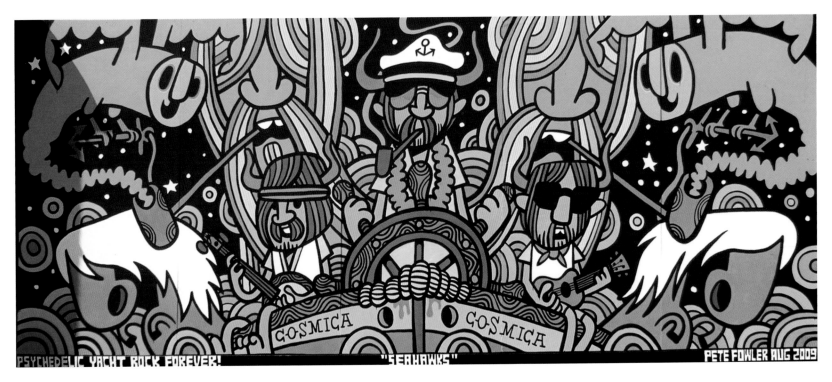

RONALD SEARLE

BRAD HOLLAND

RALPH STEADMAN

Editorial & Political Illustration

Because of the plethora of publications of all types, editorial illustration covers every possible theme within newspapers and magazines. These artists have been influential in defining the function of illustration, revealing its potential to make a cultural impact by conveying memorable ideas.

The client's perspective: Jerelle Kraus, award-winning New York Times *Art Director whose 30-year tenure included 13 years at the paper's op-ed section.*

Though editorial art direction is indispensable, it's also invisible. The art director first reads the manuscript to be illustrated. If the story is not yet written, he or she discusses the piece-in-process with its author. The next steps are to extract the argument's essence, decide on a visual direction that matches the material and, most significantly, hire an appropriate illustrator. While some artists want to read the manuscript, many others prefer an art director's detail-sparing summary. The prose's particulars can distract from its gist. Even the best artists can get too literal when illustrating a specific text.

The art director next serves as a sounding board for the artist's concepts, and reviews roughs until the best idea is clarified in a viable sketch. This is followed by the vital job of selling the image to one's editor. I try to identify any text points I can relate to tangible passages in the sketch. Certain as I am, by now, that the artist's interpretation rings true, I still need to make an airtight case.

Artists appreciate the heart, soul and spin an art director puts into a winning sales pitch. "The toughest part is selling images to the editor," says Irish illustrator Brian Cronin. It's tough on artists too. While the art director pleads their case, artists are obliged to shuffle their feet to the tune of what Danish illustrator Henrik Drescher calls the "sketch approval limbo dance".

Illustrator Brad Holland prefers to work ahead of the curve. "My most productive op-ed period was the 1980s," says Holland, "when Jerelle persuaded the editors that a considerable number of my archived images worked for the texts. It's irrelevant that they weren't commissioned." In addition to Holland's investments, my bank contains all the choice imagery I can gather from, for example, the British Ralph Steadman and Ronald Searle, the French/Polish Roland Topor, the German A. Paul Weber, and the Iranian Ardeshir Mohassess.

In cases of banked illustrations, of course, there is no sketch phase. Most highly experienced illustrators, in fact, resent doing sketches. I certainly understand that, and in order to work with them I'm quite willing to risk having a finished piece rejected by editors.

ABOVE:
Portrait by Jo Davies.

LEFT:
Photographs by Andrea Liggins.

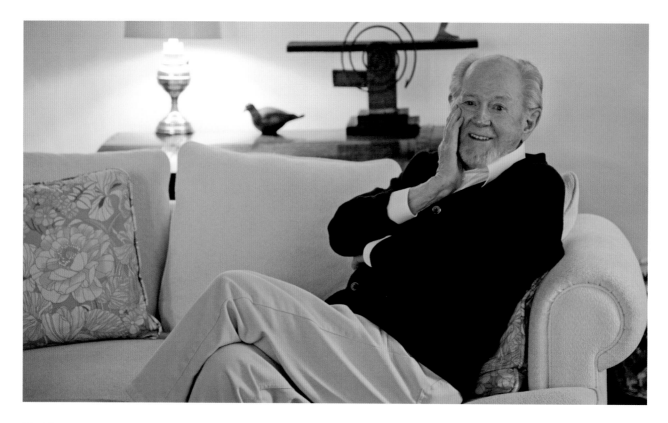

Ronald Searle

PROVENCE | FRANCE

*"For me, I can't put pen to paper
unless I know where the line is going."*

OPPOSITE PAGE:
The Dealer, Le Monde newspaper, 1995–98.

Photograph by Andrea Liggins.

Ronald Searle has been illustrating longer than most commercial artists. Commissioned by magazines since the 1940s, his editorial output has encompassed reportage drawing from the 1950s onwards, and up to 2007 included political cartoons for French newspaper *Le Monde*. His reportage work, by turns strikingly sympathetic or insightfully funny, and often both, revealed the horrors of being a prisoner of war to the world after World War II, and continued over decades of travel for American and British magazines such as *Holiday, Life* and *Punch*. He has also worked across film, animation, advertising and publishing.

Ronald's draughtsmanship and sharp humour have been an acknowledged influence on many illustrators and cartoonists for several generations. His mark-making is highly recognisable, and his edgy line – thick or thin, gentle or harsh – pulls movement and tension into every subtly composed drawing. A thicker jagged line might accentuate an outline, while softer strokes can indicate plumage or fur – "Your famous shaky line," as his wife Monica describes it.

Earlier in his career commissioners had the confidence to leave him alone once briefed, and he has always hated the idea of providing a rough visual, "because when it's actually on the drawing board, the finished version never resembles the rough." He believes most art editors don't know what they want until they get it, so he will produce what he feels is right for the particular situation, mulling the subject over to find the best way of explaining it, and then creating the best artwork possible. If they don't like the result, he expects them to justify their viewpoint. "Then I'll redo it." He laughs, adding, "There's no charge."

THIS PAGE:
Entrance to the Old Medina, Casablanca.
Morocco, *Holiday* magazine, 1965.
Wilhelm Busch Museum, Hannover.

Street scene and *Man on donkey* from Moroccan
sketchbook, 1965.
Sketchbook photographs by Matt Jones.

OPPOSITE PAGE:
Hamburg, St Pauli sketchbook, 1967.
Wilhelm Busch Museum, Hannover.

All artwork © Ronald Searle.
Reproduced by kind permission
of the artist and the Sayle Literary Agency.

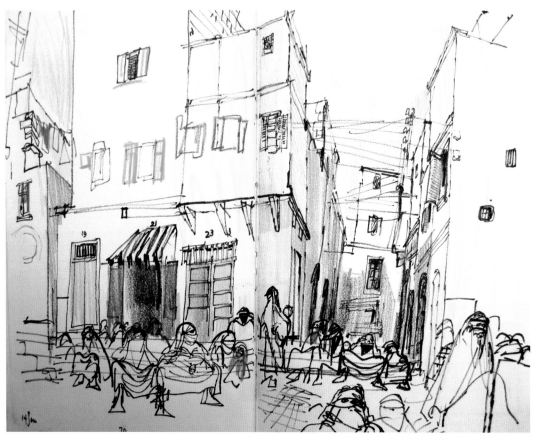

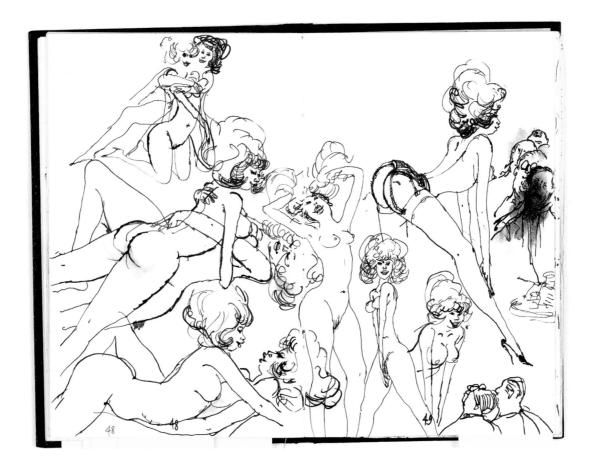

He is aware that his vision may not tie in with a writer's view of their work, believing many writers have little idea of how their words might be visually interpreted, so it "comes as a revelation to them that you can bring to life their prose or poem".

Ronald will not start an illustration without a strong sense of what he aims to achieve. "You can't doodle. In the sense that you can't just play around on the paper and hope that it will resolve something. Sometimes it can be amusing and you can play around, but basically I think that if you are positively putting something on paper you've got to have an image already formed." He'll interpret the image he has in his head onto paper, finding that as the pen or pencil begins to move across the surface, the mind adds or subtracts, changes direction, enriching the whole process. This can produce the unexpected. "You had this original image, and now you've got something which is much more interesting, and quite a surprise, actually. That's all a part of the adventure of drawing."

Being your own internal editor Ronald believes to be crucial, so he doesn't take into consideration how the external audience may react to the work. "Once you're satisfied with what you're doing, and let it go, then you know that you've achieved the job. So sometimes I find myself doing the same thing four or five times, which I then destroy before I let the final one go." Though he acknowledges that tight deadlines may occasionally mean delivering a drawing that he is not completely satisfied with, he also concedes that, "it's either that or you don't get the money!" No intervention from a commissioner is good, but sometimes editorial guidance is a positive, as the stimulation of being offered a subject can suggest a direction.

He is pragmatic about the working situation for illustrators now. "You can't escape the fact that however marvellous you want your work to be, you've still got to pay the bills, and there's always a compromise. So I have a ton of rubbish behind me, and so has every artist. But, I mean, how pure can you remain? Unless you have a nice big income behind you!"

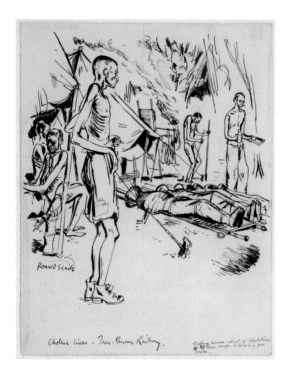

Two hundred political cartoons were created by Ronald over 12 years for the influential French newspaper *Le Monde,* commencing in 1995. This was an opportunity to change direction and move into political commentary, which he considers an important outlet, given that his interpretation of a situation may influence a reader's opinion. No editorial control was imposed, and Ronald would deliver a batch of five or six drawings for the paper to publish as and when they wanted. *Le Monde* already had a daily cartoonist, so Ronald was looking to comment on more global than immediate issues. This necessitated gathering information through newspapers and television to distil content, looking beyond the sensationalism of the headlines. "You try to finally find an image that would represent something that could indicate the savagery of a situation – that would be graphic enough, simple enough, to really hit someone who opened the paper and saw a picture of a child being eviscerated or something like that. Because when it comes down to it, there's just as much savagery now as there was a thousand years ago." The suffering he and his fellow prisoners of war had to endure at the hands of their captors means he does not consider it a problem to depict and interpret the worst side of human nature, having experienced it himself. Real political comment that is not simply a reflection of day-to-day politics can be complicated to produce, but Ronald considers this body of work to contain some of his best drawings. When asked if dealing with these issues made him cynical, he replies in the negative. "There's a certain sort of resignation with how awful people can be, whatever the veneer. The savagery is just below the skin – in any country."

THIS PAGE:
(top left) *Cholera Lines* – Thai–Burma Railway 1943. Collection of the Imperial War Museum, London.

(top right) *Kallithea Camp*, Athens, 18 November 1959. Athens, *Punch*, 1959. Wilhelm Busch Museum, Hannover.

Taxi, Georgia, from *Punch*, 1959. Wilhelm Busch Museum, Hannover.

OPPOSITE PAGE:
Angel of Paedophilia, Le Monde newspaper, 1995–98.

80

His drawing style adapts to the subject matter, with the more naturalistic approach tending to be deployed for images that are not meant to be humorous. Commissioned to draw the occupants left in refugee camps across Europe long after World War II had ended, he wanted to report it as he saw it. "I tried, in that case, to explain the person in front of me without any sort of trickery or exaggeration. Tried to get behind the sadness or the hopelessness of most of these camps – everyone abandoned." Covering the 1961 trial of Nazi war criminal Adolf Eichmann for *Life* magazine was an example of Ronald searching beyond the immediate situation, in this case a particularly static trial with the accused seated unmoving in a glass box between two guards. Realistically depicted, this could only result in static drawings, so he decided to expand the feature by trying to draw other people associated with the trial. "I went out to different kibbutzim and found the man who led the escape through the sewers of Warsaw when the Nazis destroyed the city. Also, another witness who had been dealing with the Nazis, exchanging trucks for Jews, and I found other people involved who'd had their families destroyed." Ronald felt a responsibility through his drawings to bring these witnesses to life, and this broadening out from the trial courtroom enhanced the published feature.

Ronald has often utilised animals as characters, and though they are not always recognised as such, they are there representing people. The *Le Monde* cartoon *Angel of the Paedophile* is an example of this. "Instead of picking on any particular race or person, turn the paedophile into a pig, a swine, just a bloody awful type, rather than simply *a* person." Political correctness was being imposed by some clients, which would have meant adapting the imagery to a group of people he was not allowed to offend. So he decided to use animals. "It's easier. I can say exactly the same thing with cats or dogs or pigs, whatever you want, and it doesn't pin it down to any race or human being in that way. It's worked quite well – people read the cats as cats."

The comment revealed through his drawings has remained strong over a career spanning eight decades, with acute observation enhanced by the biting wit that hovers around that famous line, creating an astounding body of work. Ronald's contemporary concern that cartoons and reportage work have been marginalised in the press is quite clear, and underlines his concern for the way that the world is presented to all of us. The Searle world view can show us a side we may have missed and for that reason is there to be cherished.

Ronald Searle was born in Cambridge in the UK and now lives in southern France.

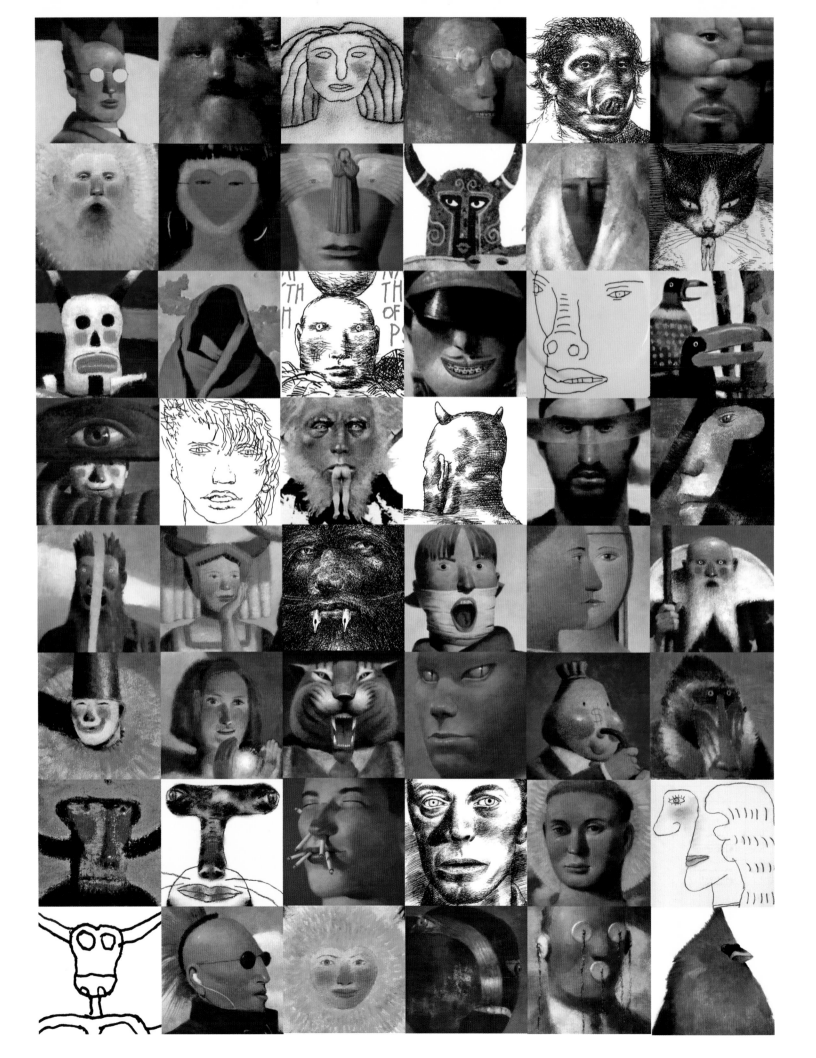

Brad Holland

NEW YORK | USA

"I established early on the kind of work I wanted to do. The effect has been that the people who call me now usually want the kind of work I'd be likely to do on my own."

OPPOSITE PAGE:
Cast of Characters, opening spread for Brad Holland's blog, *Poor Bradford's Almanac,* 2009.

ABOVE:
Point Counter Point, article on the nature of debate, *New York Times,* 2006.

The use of metaphor within illustration is now commonplace. Many complex, contentious or banal concepts are brought to life through their visual interpretation within editorial contexts where dense pages of text are supported by intelligent, sometimes challenging imagery. There are several illustrators whose work engineered a significant shift in practice, establishing the power of the image as a distinct tool for communicating ideas. Brad Holland must be recognised as one of these pioneers. When he arrived in New York in the 1970s his approach to creating imagery was radical. The notion that an illustrator was merely an instrument to technically realise an art director's idea was still prevalent.

Resilient to the resistance he encountered Brad succeeded in finding avenues for his work, helping to redefine the subject and demonstrating the right of the illustrator to retain intellectual autonomy. "One of the things I like about working in print is that you're always being confronted with new subjects; news events compel you to think about things happening in the world. If you have opinions about life and

83

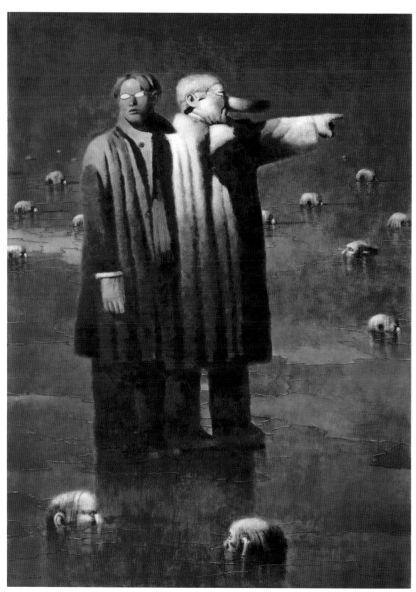

you're inclined to express yourself, either in writing or drawing or something else, I don't see why you should have to channel someone else's point of view into your work."

What is distinctive about the approach Brad brings to his work is the specific relationships and function it fulfils in relation to text. Although editors control the content of newspapers and magazines, delegating through art directors to achieve their personal dimension, Brad has steadfastly refused commissions which have diluted his own authorial power as an illustrator. Through establishing this stance early in his career he has attracted clients who have respected this position and been receptive to his conceptual intervention.

"I always work with the text I've been assigned, but my ideas don't necessarily come from it. When I first worked with Harrison Salisbury at the *New York Times*, I said, 'Imagine you've locked the writer in one room and me in another and given us both the same assignment. The writer will give you an article, I'll give you a picture; you marry the two.' Their original assumption, that the art should just reinforce the text, was an idea whose time I thought had come and gone."

Most clients require preliminary drawings before committing to an idea, but this can dull the creative process as well as forcing an image to be overly explicit to ensure the editor can access it more immediately, thus potentially impeding the evolution that happens during the process of producing artwork.

Early in his career Brad drew many visuals for himself, building the foundations before starting work on the finished piece. One of the reasons he enjoys working with acrylic is the flexibility and freedom it now affords, and because of this he has established a more organic approach, starting a piece and "messing with it" until it becomes right. "When I was young I invested a lot of energy in my preliminary sketches. They were often so completely realised as drawings that when I painted them, the finished pictures were nothing more than coloured drawings. That was fine, but coloured drawings just seemed too self-contained for the images I had in my head. They didn't pack the emotional punch I was looking for. So ever since, whenever I do a sketch, I tend to leave something unresolved about it, something unfinished. That leaves room for the colour to take over where the drawing leaves off."

He favours the clients who invest complete authority in him to create images unimpeded. In the early stages of his career he was commissioned by *Playboy*, and as he says, "They never knew what they were getting until it arrived each month." He cites a "perfect" commission to produce a series of 28 images for a casino, around the theme of 'fish'. Although specific about the scale of the pieces and the deadline, in every other respect the client gave almost complete freedom to exercise creative and intellectual integrity within the project.

ABOVE:
Portrait and studio photographs by
Andrea Liggins.

OPPOSITE PAGE:
(left, top and bottom)
Souls On Ice, sketches.

(top right)
Headhunter, Man of the Year section
focused on the terrorist Abu al-Zarqawi,
whose identity was still a source of speculation,
Time Magazine, 2004.

(bottom right)
Souls on Ice, poster for the production
Com di Com Com for Odeon Theatre,
Vienna, Austria, 2006.

ABOVE:
(top and bottom)
Catch, visual and artwork, one of 28 paintings
for installation in the seafood restaurant at Rio
Casino, Harrah's Las Vegas, 2008.

OPPOSITE:
Witness, image on the subject of torture,
Liberty magazine, 2009.

It is clear that Brad works for himself, and his methodologies are similar to those painters who may be classified as fine artists. Early in his career he was repeatedly told, despite his immediate and repeated success, that he was uncommercial. In common with many fine artists he has always been entrepreneurial in finding avenues for his ideas. "My idea is to come up with the work I want to do and then find the market for it. I've never seen the virtue of finding what the market wants and then trying to supply it. The market doesn't know what it wants. Art isn't a commodity, it's the result of a vision, and vision has to start with an artist."

For this reason he considers the definition and labelling of illustrators a constricting one. He admires Graham Greene, a literary polymath who worked fluidly within a broad literary field unfettered by boundaries. He says of his own beginnings as a 'commercial' artist, "I'd rather be a fugitive than have art directors tie me down to one thing. I've always assumed my voice would have many octaves. The business was constrained by style but I was always happiest being uncaged."

Anchored by a prodigious ability to draw and to think, Brad has been open and varied in his use of media, crosshatching with pen and ink, as well as executing gritty pastel drawings and acrylic paintings. Of the fluctuating styles in the illustration markets which have punctuated the decades of his career he says, "I've never kept up with trends. If I notice a trend, my inclination is to go in the opposite direction."

Over the course of time he has been prolific, both attracting and declining high-profile international clients across a spectrum of areas beyond editorial work, working for advertising, in publishing and even children's books. His visual language has been widely appropriated by a rash of Brad Holland clones. Clearly, some are prepared to be the conduit for an art director's idea, something Brad himself has consistently refused to do. Few if any of these imitators possess the sincerity of intention of the original. Brad, on the other hand, is clear that commercial considerations will not be allowed to impede or compromise his vision.

Brad recalls the case of a client who wanted to commission illustrations for an advertising campaign. When Brad refused to faithfully render the art director's ideas he was offered a challenge. A Brad Holland imitator was brought in to fulfil the brief as originally proposed, while Brad was given carte blanche to interpret the brief according to his own concepts. The client was given the ultimate choice. Brad's work was chosen.

"I love the work I do. Since I was 17 I've been paid to do pictures I'd have done anyway. I hate deadlines but I find them useful. They concentrate your attention. They force you not to dither. You don't always do your best work under pressure, but you can always do your best to do your best. And if a picture needs to be reworked later, you can always do that too."

As a child he developed an external self who he called upon for help. He called this persona '30-year-old Brad' and now recalls, "I always needed someone I could turn to for advice, but there was nobody around my little town I could count on. So I made somebody up. I tried to imagine myself as a 30-year-old. That seemed to do the trick. I'd always ask myself if the things that mattered to me as a teenager would matter when I was 30. As a rule the answer was no. So 30-year-old Brad kept his eye on the horizon while I navigated the bumps in the road. Then, after I turned 30, I realised that that state of mind would be as useful leaving 30 as it had been approaching it."

Recent bumps in the road have seemed to threaten the journeys of all illustrators. Brad has devoted substantial energy to fighting the changes to copyright which challenge ownership of intellectual property, undermining the fee structure for the entire profession. This crusade seems a natural extension of the work of a man who has operated within a political arena and demonstrated the value of imagery that packs a punch.

Brad Holland was born in Michigan in the USA and now lives and works in New York. He has won more awards from the New York Society of Illustrators than any other illustrator in its history. In 2005 he was elected to the NYSI Hall of Fame.

Ralph Steadman

KENT | UK

"I'm waiting for the accident to happen."

Editorial illustration responds to many things: the voice or tone of the article it's illustrating, the topic being covered, or the vision of the illustrator. Ralph Steadman, who has been drawing for commissions since the 1950s, is a unique example of the latter. Renowned for his splattered, visceral imagery, he has explored different aspects of human nature with humour and a sharp eye ever since, provoking admiration and occasional discomfort in the viewer.

At this time in his career Ralph only accepts a commission if he wants 'to die for it'. There needs to be a strong feeling generated by any text for him to want to take it on as he's always aspired to create to the best of his ability. "That's why I learned to draw. I thought, 'If I'm going to do this job properly, if I've got to be able to express myself articulately, I need to be able to draw well. And by drawing well, I can then express it so much more convincingly – whatever it is.'"

During his early career, Ralph produced 12 cartoons a week for an agent in Fleet Street – London's former newspaper district – and credits this agent's statement that, "I wouldn't get commissions without him", for his own stubborn attitude. "Bloody-mindedness is the only thing that makes it happen. And also why you do things they don't want. You want to do what you want to do. And still feel it fits in; you want to be awkward without being obstreperous."

OPPOSITE PAGE:
A Perfect Gentleman, print, 2009.

THIS PAGE:
Tunisian Violinists, sketchbook drawing.

Studio photography by Andrea Liggins.

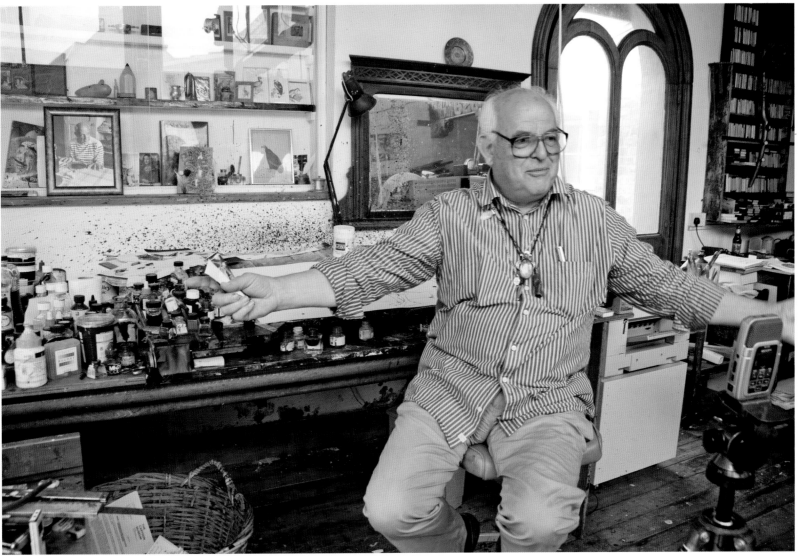

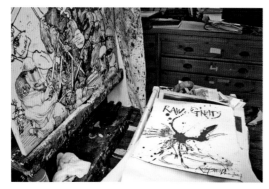

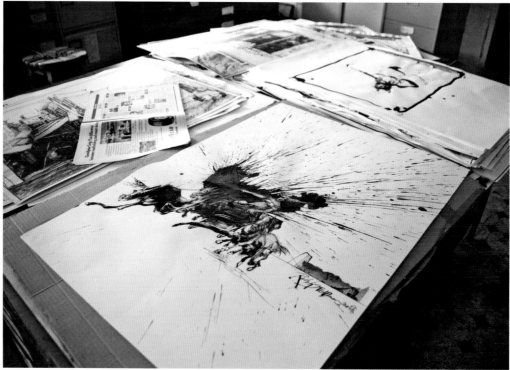

OPPOSITE PAGE:
(top left) *Houmet Souk,* sketchbook drawing,
1987.
(top right) Visual for book cover, *The Joke's
Over: Memories of Hunter S. Thompson.*

(bottom right) Ralph splatting ink, and works
in progress.

Ink, watercolour, acrylics, splatter-blowing techniques, collage and gesso may all be utilised in a Steadman image. Commencing a piece, Ralph might start with pen and ink line, or one of his famous splats – "Some people are disappointed if you don't use them" – whacking a brush dipped in ink across the paper and seeing where the resulting shape will take his imagination. Collage being a strong element of this work, he'll sometimes start with a print, old engravings, one of his own photographs or photocopies manipulated with his studio photocopier. "I love distorting things. I'll bring these images in because it's important. All these little pieces can become part and parcel of what I might want to do," he says, referring to a stack of photocopies and other papers balanced on a stool. "That's my ready pile. I'll go through that and look for something in there, then I'll add to it and change it." Elements are cut out and often changed until they are unrecognisable. "By the time I've finished with it, it looks nothing like the reference."

The studio also holds a library of books containing old drawings collected over time, and piles of papers including the richly textured protective sheets that are taped to his desk for several months at a time. These can later be cut up and incorporated into his pictures.

Inspiration comes from different directions – "I keep a lot of sketchbooks" – and he also refers to a huge book perched on a desktop crammed with notes on cigarette packets or whatever may have been at hand: "It's full of stuff." Examples include: 'This is no time to quit, it is time to reaffirm your experience and shout down those who claim superiority – what they represent is nothing more than newness'; 'A good idea runs away with itself in case of theft'; 'I am only human, and I've tried all my life not to be'; and a favourite Indian saying: 'The head understands, the heart cannot speak, follow the river.' Ralph's instantly recognisable handwritten text features on much of his work, and notes from the big book will serve as direct quotes on the image or springboards for new pieces. "That book is full of perverse sayings, and that's why they're interesting. Because they are perverse or contradictory. I'm not trying to make anything right, because I'd like to make it interesting but not necessarily right. Bit of a problem, that."

Archetypes may be employed when he is using a sketchbook for inspiration, seeing an image in there he likes and thinking how it could be utilised just as it has been drawn. "I'll try and recreate it," he says, or alternatively he may ignore it, "leave it there, and somehow it will find its way into something". Ralph's vertiginous perspectives can be prompted by a phrase or line of text, such as 'He was a damn sight taller than me,' and he cites the drawing practice done around the college he attended as beneficial for perspective drawing.

For Ralph, if something goes wrong in a picture, it becomes part of the drawing. "The drawing can evolve because of the mistake. You think that mistake is going to become something else." Besides, throwing material out isn't right, he feels. "There's good ink gone into that paper!" He never wants to feel he has practised to the point where he's confident he can pull it off every time. "An important part is I've always felt

THIS PAGE:
Songbirds, New York Times,
2010.

OPPOSITE PAGE:
Orient Disorient, 2004.
Psychogeography by Will Self
and Ralph Steadman,
published by Bloomsbury, 2007.

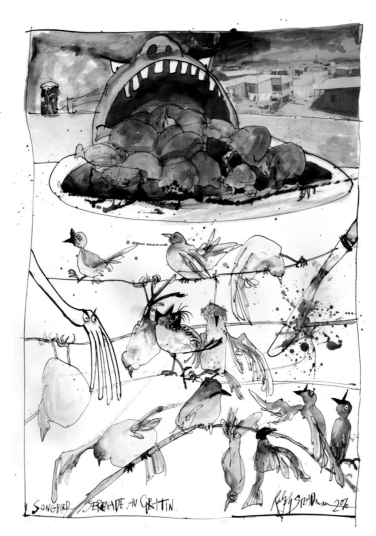

insecure, that when I come to start a drawing, I think, 'Can I do it?' If he knew for sure, "it'd be rather boring. It works out the way it works out."

For five years, from 2003, Ralph collaborated with writer Will Self on their 'Psychogeography' column, published in the UK broadsheet newspaper *The Independent*. Uniquely, Self occasionally offered to compose the text around images that Ralph had come up with, ensuring that they would have a piece prepared each week. "They were written because of the drawing. So that was kind of interesting – a weird way of going about things. Do a drawing first and find the story in the drawing." These pictures would not have to be consciously composed for the column. "I'd just draw anything, because that gives you freedom to do what you want." The pictures covered subjects from a holiday in Turkey to a fox trapped in the Steadman household's kitchen. This rare reversal of images inspiring text emphasises Ralph's concern that this art form should be accorded more respect, and no longer "wrongly assessed".

Working for other publications such as *The New Yorker* and *The New York Times* could be different. "They were forever trying to change things," he says, and as Ralph does not prepare roughs of his work, he would start the drawing, send them this initial approach to give the art director the opportunity to suggest something, but still continue working on top of the original artwork. "And they seemed to be OK then. That's what I thought the rough was all about. I don't know whether they've ever put together the idea that the rough is in fact the drawing."

It could be assumed that in commissioning Ralph you are expecting something with attitude, but this is not always the case. He considers that his pictures are "more like weapons. They're not trying to be a pretty picture of someone's back garden or something, and so it's that rampant spurt somewhere along the way" that makes it work. "I think it's that the unexpected might happen, and it's the unexpected which is really part of the interest in the drawing. 'I didn't think you'd do that.' Neither did I!"

Though Ralph has an instantly recognisable way of making images, he believes many illustrators are not concentrating on the primary element, that there is a current over-preoccupation with style. "They develop a style, thinking the bloody style's important. Style is not, content is important – something you are saying. They believe that style is the key to being recognisable. Fuck it. Content is everything, people admire that, it's like a good book." This passion for illustration to convey something essential is still plain to see, and even though he admits the desire for an image to *really* work has become less intense over time, the artist's curiosity keeps him going.

Ralph Steadman was born in Wallasey in Cheshire and brought up in Pensarn in North Wales. He now lives in Maidstone in the UK.

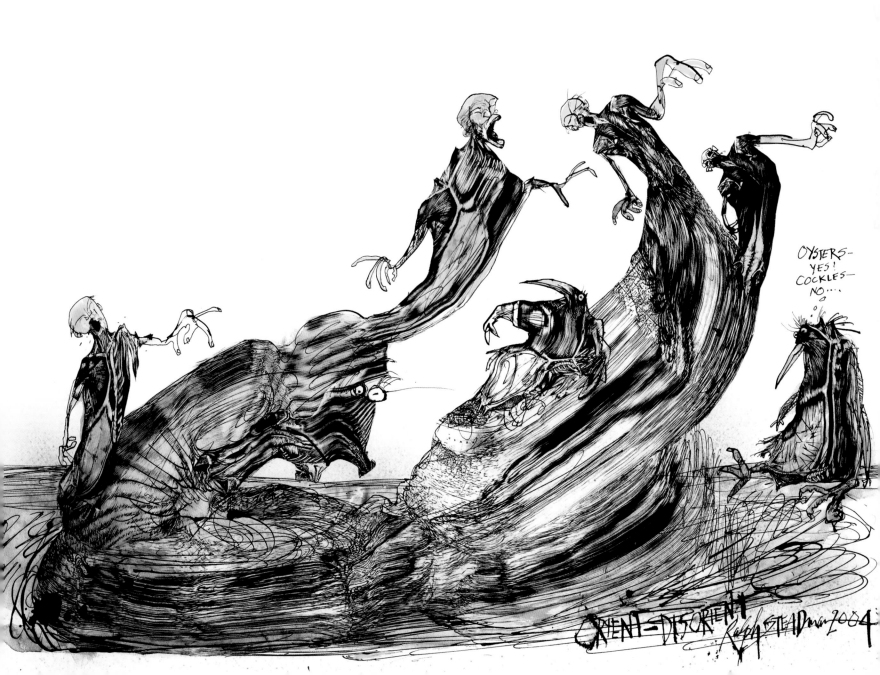

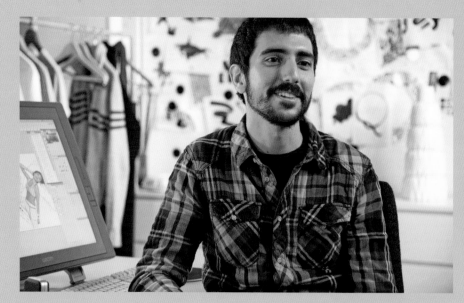

ALEX TROCHUT

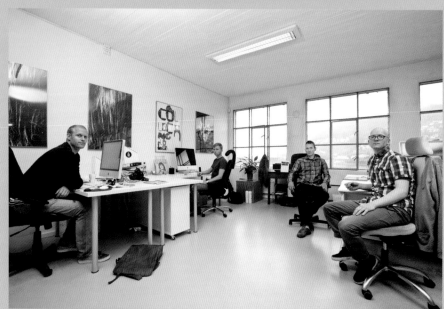

GRANDPEOPLE

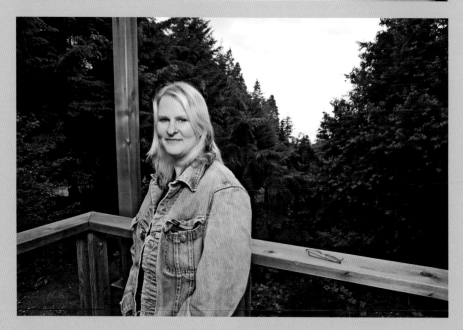

MARIAN BANTJES

Typographical Illustration

The ubiquitous nature of anonymous digital typography has provoked a return to individually created letterforms. Illustrators have extended their visual repertoire into this area with great consequence for the field of graphic design.

The client's perspective:
Terron E. Schaefer,
Group Senior Vice-President, Creative and Marketing,
Saks Fifth Avenue

We have a long tradition at Saks Fifth Avenue of commissioning art from various and sundry illustrators. I've been at Saks for more than six years, and the first artist commissioned during my tenure was Michael Roberts, the fashion and style editor of *Vanity Fair* magazine, then Mats Gustafson, celebrated fashion illustrator. They are always very talented artists.

Later Marian Bantjes was one of the illustrators we commissioned. I had seen and liked the work she did for Pentagram. We were doing a big campaign twice each year based on the fashion trends for the season. This particular campaign was called *Wanted*, for which we identified trends for both men and women. I asked Marian to create illustrations where the word looked like the item. They were very clever depictions. The high-heeled shoe for women and the tuxedo for men – both perfect solutions. I was so impressed with her work for this campaign that I then asked her to produce work for the launch of 10022, the shoe salon on the 8th floor. She then drew the Christmas snowflakes that we continue to use on catalogues, in packaging and within the store. We love Marian!

We are currently using a combination of photographic imagery and typography. It's an evolution, but illustration is easier to use than photography. It can be much looser but also allows a more specific evocation of a feeling or mood. When you talk of high-calibre illustration it's the ultimate in quality and sophistication, the simplicity of an assured mark made by the swipe of a brush or a pencil.

We are Saks Fifth Avenue, so we aspire for something sophisticated and refined.

ABOVE:
Portrait by Jo Davies.

LEFT:
Photography by Paul Duerinckx,
except Alex Trochut by Andrea Liggins.

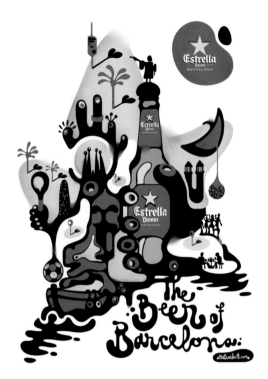

Alex Trochut

BARCELONA | SPAIN

"Every time I look at new things I discover something that maybe I would like to drop into the artwork."

ABOVE:
The Beer of Barcelona,
Estrella Damm print campaign, 2009.

OPPOSITE PAGE:
Soul Xfuns magazine, cover, 2008.

Shapes curve, flow and splatter; solid letters dissolve into running fluids which pool or wrap around further shapes; pebbles held together by driftwood form intriguing lettering – Alex Trochut's ability to create movement through his imaginative imagery, coupled with his binding of lettering into the depth of an illustration has produced a strong body of work which adapts to each commission.

Illustrative lettering was an element of image-making that Alex had been drawn to through graffiti and skateboard graphics – an area where abstract forms are often synthesised into letter shapes, and whose flexibility of structure appealed to him. He was introduced to typography by his tutors at design school, but having recognised where his real interest lay, he abandoned the more formal typographic route – "I was getting a little bored, as I do" – to work on creating more of an image than just a letter. Further influence came from Art Nouveau, Art Deco, nature, graphics annuals from the 1970s, Push Pin Studios and Surrealism, some of these appearing more obviously in his work, but more often absorbed at a deeper level. "Work that could be showing you a way to represent reality, which you can filter through your personality – it's not really conscious."

Shapes created in the natural world are clearly an inspiration, and Alex is drawn to objects transformed by water, the sea being "like an artist who has smoothed everything". A collection box of sea-smoothed pebbles, twigs and shells from the Barcelona shoreline were referenced for the poster created for American band The Decemberists. "This poster image was a good example of something that has been underwater for a long time, so all the shapes are very rounded." The liquidness of the shapes appeals to him: stones shaped like drops, and wood worn down to reflect the element which has eroded it.

The clean lines of his work are reflected in his smart expansive studio in Barcelona, where a large board displays sketches and printouts of uncompleted ideas or "accidents", elements that Alex can turn to as springboards for fresh ideas or to incorporate into new images. "If you start from scratch, it's always like the untouched white paper – it's terrible. But if you have something you've been collecting then you can just combine things, you know? Mix two things and make something different."

97

He doesn't keep sketchbooks, preferring to retain individual sheets if he likes the drawing. He sketches directly onto a Wacom screen, only occasionally scanning a drawing, and will only use a paper sketch for rough structure as opposed to indicating texture or other expression. He admires drawing: "I wish I could do that, but my hands don't allow it. I'm more of a digital guy." He smiles. "I'm in love with Mac skills."

Ideas for commissions can come straightaway if he's given freedom by the client, though he generally avoids giving them a surprise. Clients will usually refer to one of Alex's existing pieces at the start of a job, and this can set the direction the new commission will go in, either simple or more complex. Some of his artwork is very involved, so before starting work he will indicate to the client how he intends to approach the image.

Lettering may be almost hidden in his images, and though this is not an option for billboard work, Alex enjoys the play between creator and viewer on products which will capture the attention for longer, such as a CD cover, offering words within the picture which some may find and others may not. "For the time the viewer dedicates to it perhaps it will give them something back. I like that game," he says.

Occasionally, Alex will take a chance and spend time creating an almost finished piece if he believes the client may accept a different approach from what they were expecting, while remaining aware that they may still reject it. Working on commissions is always a balance, and he recognises that the client may be right about a required artwork change, even if he initially felt what he had done was correct. Though working with a good art director can be a positive journey – "You travel with them, letting it take you, and you might happen to discover many new things" – he'll also turn down a potential commission if he does not feel strongly motivated by it, or just anticipates that ultimately it would not go well. "You've got to be on the same team when you are working with someone."

He's collaborated on many campaigns, and amongst various applications the image might sometimes be required to appear on billboards. The structure of an illustration printed at this size has to deliver the message at speed. So a road constructed from words, created for an Audi car campaign, needed a lot of reworking of the inner shapes of the letters to ensure drivers would be able to read it. Large advertising campaigns have occasionally meant detaching himself emotionally from the work, as often so many changes are required, and being involved with multinational brands can add to the usual tensions of a commission, as you are just one element in a big team, "part of an engine that can fail if you fuck up". These stresses were more difficult when he started out, however. "You don't get used to it, because you always have this pressure, but you learn to not let it affect you as much."

Alex is prepared to make a stand – up to a point – if he believes the client is wrong in wanting major changes. If the job is not paying much he'll withdraw the artwork rather than spoiling what he considers to be right. With larger jobs, if the changes are less in his control, he'll display the version he likes best on his website (which may not be the published piece), at least having the opportunity to present that version to the world.

Balance is a significant element of his images, with an emphasis on beauty and elegance, though not perfection, as flexibility and spontaneity are also important. "I use geometry as my close friend when I

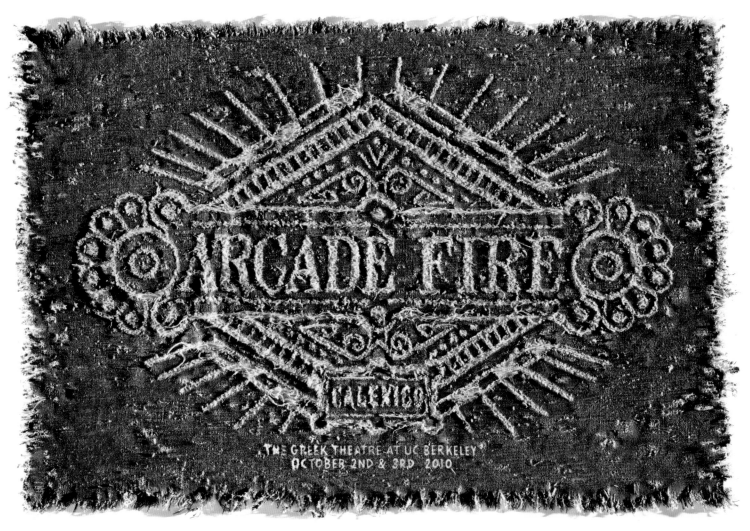

ALEX TROCHUT

OPPOSITE PAGE:
Celebrate Originality, Adidas logo treatment, 2010.

ABOVE:
Arcade Fire concert poster,
Another Planet Entertainment, 2010.
Material: denim.

Studio photographs by Andrea Liggins, except
Alex working on denim by Marc Ambros.

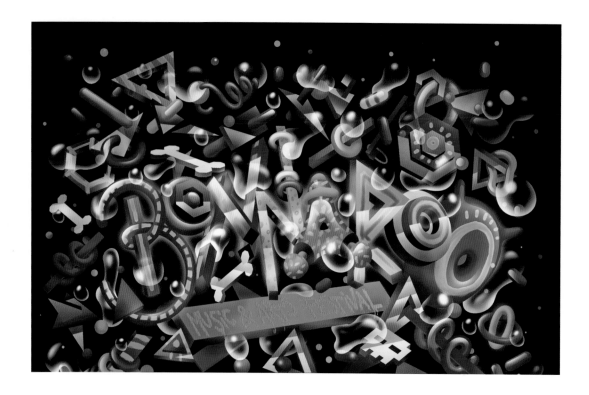

need to look for beauty." Symmetry is utilised in his work, and he greatly admires the manually created symmetrical work from previous centuries, but feels that "now with the computer it's something that's losing value". The undoubted sensuousness of many of his image forms remains subconscious, and he'll only be more literal with sexual imagery if it's intended to be amusing. Much of the imagery looks good enough to eat, with his chocolate and cream cover for an issue of illustration magazine *Varoom* inviting enough to dip your finger into. The physicality of his work is strongly present in the curious sea-inspired shapes he created for the *Drift* ceramic collaboration with Xavier Mañosa, and it's this form of work, so different from the cool angular treatment of some of his other lettering-based work, which builds on his impressive range.

Illustrators working with lettering do seem to be able to bring a larger variety of treatments to their work, and Alex recognises that dealing with letters allows for changes in structure with every typeface. He is very conscious of becoming too comfortable with a certain way of working: "It limits you, as you are thinking, 'This is a good way', but possibly if you step further beyond that you reach another place. It's trying to force yourself to open up your taste to other things." He also acknowledges that the assimilation of previously disliked things may stretch his approach in a positive way: "It's better to spend time and have that creative pain for a while to search for something new." He's open to hearing new music as he works too, feeling it may have the capacity pull his creative thinking in a new direction: "If the music makes you fly, you feel more wild."

Alex put commissions on hold for part of 2010 to learn 3D programs to expand his imagery, helping him to build structure and express more clearly what he wants to say. "Sometimes, before, I felt like I was working in medieval times without the right tools!" His commitment to finding the time to experiment with personal work keeps his artwork moving in new directions, and even though he does not consider himself a typographer, he's happy to admit, "I'm in love with type."

100

Alex Trochut was born in Barcelona in Spain and works from a studio in the Poblenou area of Barcelona.

THIS PAGE:
(top left) *Bonnaroo*,
music and arts festival
poster (detail), 2010.

The Decemberists poster roughs.

OPPOSITE PAGE:
The Decemberists concert
poster, 2009.

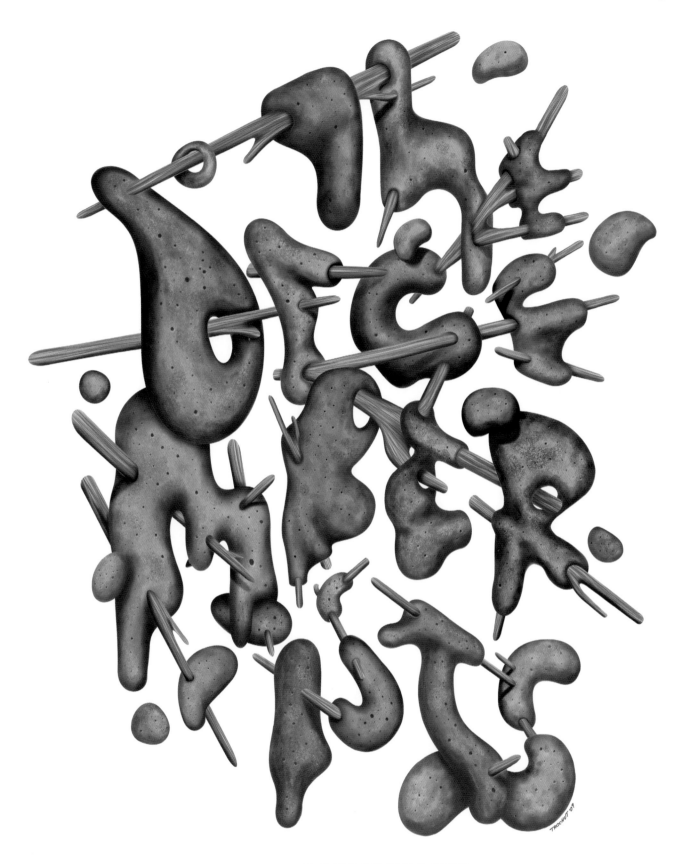

THE DECEMBERISTS
WITH BLIND PILOT

AUGUST 10, 2009 ✷ W.L. LYONS BROWN THEATRE ✷ LOUISVILLE, KY

102

Grandpeople

BERGEN | NORWAY

"If you find one angle, and then find another angle, then combine them, you come up with something that surprises you, and that's really inspiring. It doesn't have to be the obvious angle into a project."

Working across a broad area of visual communication, the Grandpeople collective has brought an open approach to a wide range of clients, producing intriguing typography for many projects which can be sharp, organic, formal or playful. Incorporating photographs of three-dimensional structures into their process has meant they can create visuals which appear to be independent of scale.

OPPOSITE PAGE:
Ekko 09, music and arts festival poster, 2009.

THIS PAGE:
Ekko 09, separate compositions for decorative uses.

Founder members, Christian Strand Bergheim and Magnus Helgesen, expanded the group in 2009 to include Gaute Tenold Aase, Jørgen Eidem and photographer Magne Sandnes. The group, though, still retains its non-hierarchical structure, so when new commissions arrive, they will be discussed by the team and allocated to various members according to a variety of factors; who may have pitched the best solution to the others, whose speciality or experience may ideally suit it, or simply who has the time. They might also consider techniques they have used in the past. An informal project leader will be assigned to each job. "But practically," says Magnus, "we all work on different projects at the same time, so it's quite an individual work process. On many projects there might be two collaborators working closely together, getting elements from other people."

Their studio space, facing Bergen old town and the fir-clad hills behind, is shared with other creatives who are also sometimes involved with Grandpeople, "so that even though there are different businesses we cooperate on a lot of projects," says Christian. "So the collective thing, I think, is brilliant." Each week Grandpeople will meet to deal with upcoming commissions and maintain an overview of ongoing projects, and to share any thoughts and ideas. Sitting at nearby desks means this exchange is a constant factor.

Expanding the group to include a photographer has allowed them to develop the use of photography in their work and freed them from using stock imagery. "It's a dream come true to have a photographer. You can just say, 'I need a picture of this. Go do it!', and not have to pay him," says Christian, laughing.

Clients come with different expectations, and Grandpeople will evaluate each individual commission, for instance by assessing whether it is commercial or more avant-garde. They will start by thinking of a concept and then select the most suitable approach for their plan. The client may have a sense of what they want, and the team can refer to previous work to determine how they wish to approach the commission, subconsciously drawing on a set of directions or 'signatures' that they use. "Some are more elaborate, one direction is cleaner, one is really hard, one is more organic," explains Magnus. Combining these elements allows them to evolve, forming new techniques, though as Christian points out, "a lot of the projects with more elaborate visual expressions tend to be for music stuff, for cultural businesses". Musicians, as well as those with only a low budget to offer, tend to be more open to alternative solutions than larger corporate clients, who will have more strictly defined requirements.

With unsure clients the team has to interpret what needs to be communicated, though if clients specify the same approach already taken with existing Grandpeople work, they will be encouraged to have their expectations 'tweaked'. "We'll try to push things forward a bit – just get them along – and usually that's fine, because they're not as into this field as we are, so they don't know what's possible or what to expect."

Even when presented with a brief, the team will also create their own version, researching and collecting various elements which they believe are relevant for their interpretation of the concept. These could be theoretical, visual or information-based, and will be included with the first roughs to add weight to their concept. "We try to make a pretty strong case every time we show visuals," confirms Magnus. "It's not only sending them screenshots or stuff. We try to wrap it up in a really good presentation in order to convince the client." The research allows them to avoid the obvious angle, thus surprising themselves with different directions which may coalesce into an unseen solution. Christian cites their *Dystopia* book cover as an example. "We came up with the broken circle, and spent quite a lot of time thinking, 'What does it symbolise?' And instead of just sending them a jpeg saying, 'It could look like this,' we sent all our thoughts on the broken circle, the historical meanings of it, the different cultures – and presented all our research." It was chosen as a metaphor for a dysfunctional society and so the title type references punk culture and DIY aesthetics.

This research will not necessarily show in the finished result, but is part of a method of working, "a way of having the project evolve into something interesting, and not just being something that you've done before, with a twist".

Type design can invite a similar approach to illustration. "An illustration needs to have an expression, a personal character," says Magnus, "and we also think each letter should have its own characteristics and personality." It is rare that an entire workable typeface will be formed – usually just the letters needed will be produced. Sometimes typography can almost become illustration, with a font derived from car-engine parts designed for *Carl's Cars* magazine, for example. "We tried to get this masculine, car-part thing – at the same time it's kind of flourished," says Christian. "It is quite ornamental, but it's made up of really simple forms, real geometric shapes, like a cross section of an engine." The internet provided all the engine reference required.

"I think type is one of the most exciting things we do," Magnus states, and they consider the way that they use it as a 'typography treatment', using type to generate the mood or expression they wish to convey in a project. "It feels more like treating an existing font to make it look like you want, to make it fit into the project," continues Christian, adding that they quite often break the classic rules of typography.

ABOVE:
Dystopia book cover, author Terje Torkildsen, published by Samlaget, 2009.

OPPOSITE PAGE:
Carl's Cars, Engine typeface sketches, 2010.

BELOW:
Portraits of Magnus Helgesen (left) and Christian Strand Bergheim (centre). Photographs by Paul Duerinckx.

(Right) *Carl's Cars* magazine, issue 27, Engine typeface and design, Grandpeople, 2010. Photograph courtesy of Grandpeople.

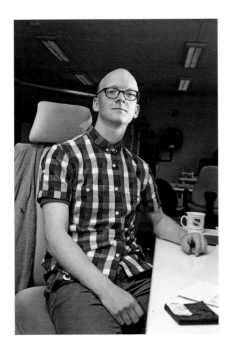
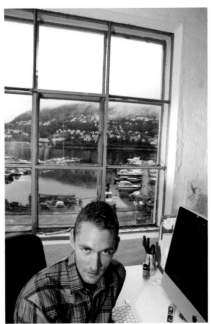

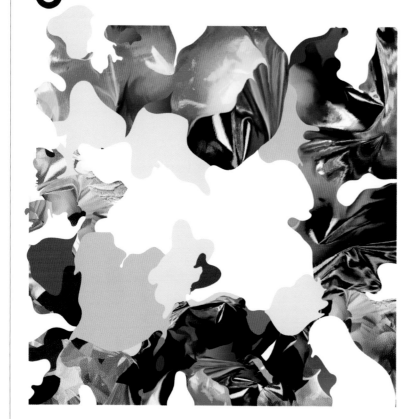

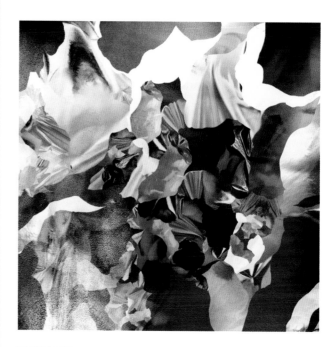

THIS PAGE:
Sketches for *Eno* cover, 2010.

Eno magazine, issue one, 2010.

Visual for *Eno* cover, 2010.

Grandpeople like to produce images that are abstract, familiar yet also strange, using 3D shapes and letters constructed from a variety of materials, which when photographed and retouched offer no clues as to their scale within the completed artwork. "We like that feeling, that you don't know what it is, but you sense that maybe you've seen something familiar before. 'Is it a landscape, or is it something up close?'" Magnus adds, "It doesn't refer to real objects, it's like a simulacrum."

A visual concept done for the Ekko electronic music festival in Bergen reveals this playing with scale – are the letters large or small? Given an open brief, Grandpeople started with the name Ekko, 'a reflection of sound', and the gig-goer's experience of standing in the dark facing a band illuminated on stage, with light reflecting off many surfaces. They had been talking about using Plexiglas for some time, and this was the perfect opportunity to use its unique surface quality. The shapes for the Ekko logo were laser-cut from Plexiglas, and as they worked with them they noticed the resemblance to piano keys and vinyl; once placed on black paper to be photographed, the glossy surface produced yet more reflections. "This could have been done using 3D graphics," comments Christian, "but we don't want that. So we have to balance between it being cleaned up and retouched after taking the pictures, but without it looking perfect. We don't want it to look like a fake," he adds, laughing. A simplified, vector-based Ekko logo, using the same font as that created in the sensuous 3D form, was done for posters and advertising.

Sketchbooks play a part in the Grandpeople work process, though not always outside of that. "I always feel guilty because I don't sketch enough, you know?" confesses Magnus, "Should be doing it in my spare time." Christian, on the other hand, emphasises the freedom that paper offers, always starting any project with sketches, as once on the computer the feeling can be that it is more finished. "But when you're doing it on paper, you just sketch freely and jump to the next idea. That's important."

As well as their ongoing experimentation, the rigorous conceptual approach Grandpeople bring to their work pays dividends in the variety of imagery they offer, even if not all of it is done in the studio. "You do a lot of your best thinking when you're not thinking about work," says Christian, "Magnus likes to make bird houses, I like to chop wood: it can be so inspiring to do something that you like – you get all kinds of ideas."

Christian Strand Bergheim and Magnus Helgesen live and work in Bergen in Norway. They founded Grand-people in 2005.

THIS PAGE:
Bergen Biennial Conference,
Bergen Kunsthall, 2009.

We make a dwelling in the evening air
In which being there together is enough

WALLACE STEVENS, from "Final Soliloquy of the Interior Paramour"

ACADEMY OF AMERICAN POETS

www.poets.org

NATIONAL POETRY MONTH

APRIL 2010

ACADEMY OF AMERICAN POETS

NATIONAL ENDOWMENT FOR THE ARTS

Merriam-Webster®

POETRY FOUNDATION POETRYFOUNDATION.ORG

The New York Times nytimes.com

Additional support for this poster was provided by the American Booksellers Association and the National Council of Teachers of English.

Paper provided by New Page and Lindenmeyr/Sappi.

Design by Marian Bantjes.

OPPOSITE PAGE:
National Poetry Month, poster artwork
and design: Marian Bantjes, The
Academy of American Poets, 2010.

THIS PAGE:
Saks Fifth Avenue, puffy vest, 2007/8.

Marian Bantjes

BOWEN ISLAND | CANADA

"I'm looking to create intrigue rather than beauty. Something that's really important to me is that people experience some kind of joy when they look at my work."

Foil, fake fur, burned wood, nail polish and the computer are just part of Marian Bantjes's kaleidoscopic practice. Unique typographic and ornamental imagery, prompted by ceaseless experimentation often injected with a subtle humour, have made her reputation, and though feted by clients such as Stefan Sagmeister, Saks Fifth Avenue and Pentagram, her commitment to high standards means she will reject a commission if the message she is asked to work with is not of a sufficient standard. From flowing lines, evolving repeat patterns and intricate interlocking shapes or objects, delicate or powerful letter forms arise or recede, offering a multilayered viewpoint. The complexity of much of her work stimulates the joy of looking, and she aims to provoke a sense of wonder in the viewer, working constantly to achieve that. "I do have an obsessive approach to it – I am obsessed. I mean, I work all the time. It's all I want to do."

Referring to herself as a graphic artist, she believes that "it's very difficult to define what my work is – because it's not really illustration and it's not really typography." She is concerned with how ornamentation and lettering is applied, feeling that the vocabulary and significance of it as an art form may be devalued and that its emotional resonance should be acknowledged.

Marian's view of the huge amount of communication sent our way is that it says nothing to us. "It goes in, it goes out, we're bombarded with this stuff all the time. We read the message, we get the message, it's not important – it's gone." Marian is trying to do the opposite, "which is to have things that people look at and take their attention, and make them look at it more. It will ideally have some unfolding of information, an unfolding of understanding." She appreciates that illustrators may turn down work for political or ethical reasons, as she may do as well, "but the problem I have is the wording of the messaging that one works with, because the words are really important to me and I have to work with them closely". A couple of potentially lucrative commissions from large organisations have been rejected, "because the wording was just shit! I just couldn't work with it," even though this has meant losing out on benefiting from advertising budgets. Admirably, she states, "Ideally, I want people to have to work at a message, and ultimately get a message that's worth reading."

109

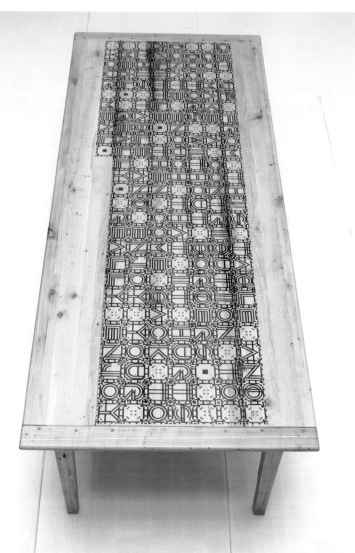

THIS PAGE:
(Above) *Design Indaba* magazine
cover, 2009.
(Right) Sketch for Typecon
poster, 2007.

(Far right) *Read Before You Eat*,
table for Dutch collaborative
company, droog, 2010.
Medium: laser-etched wood.
Etched message on table reads:
"Get up from this table and
go make a contribution to
Doctors Without Borders.
Donate enough that it hurts a
little. Then come back to this
table and enjoy your meal.
Really, really enjoy your meal."

All photographs by Paul
Duerinckx, except for table,
photograph by Stefanie Grätz.

That message is conveyed through a multitude of media, encompassing wood, metal, paper, paint, pencil, laser-cutting, flowers and computer programs. She's willing to experiment with new techniques during her increasingly rare spare time, and have them "standing by" to be utilised should the opportunity arise. Otherwise she'll turn to a text file where a long record of ideas and inspirations are logged: "I'll go to my list of ideas and think, 'Yeah, foil, this is the time to do the foil thing.' And then I'll just try it, and if it doesn't work I'll scrap it and do something else. Sometimes that happens, and that's something that I've gotten pretty good at – throwing away things that aren't working, even though I've spent a lot of time on them. It's hard to do, but I've learned that you do something once, you can do it again. It's useful to be able to do that." Embroidery and sewing on sequins are a couple of techniques she's tried which she accepts will need additional practice. "There's a reason why people are paid to do this stuff!"

Marian will rarely turn to reference material, preferring to take photographs or notes on things of interest – "Unfortunately, I do tend to put them on the hard drive and never look at them again" – accepting inspiration from wherever it may arise (a conversation, book or film) and seeking influence from museum visits or personal research.

Her constant search for new approaches flourishes best with clients open to an alternative solution, while any client sending examples of another artist's work with a brief will be rejected. They may sometimes send examples of her own artwork, although, she says, "I'd still prefer they don't do that, because I don't like to repeat myself. But it can give me a sense of what they're looking for, and if it's something I don't want to do, I'll turn the job down." At this point she will offer to look at a different option, stressing that she needs to be interested in what she's creating. She's amazed that so many commissioners want to "pick something out of a catalogue", to know in advance what they are going to receive.

Once a creative brief has been delivered, Marian will either get an idea straightaway, or find much of the work is done over time in her head, sitting staring at the fir trees surrounding her home, or wandering around, "picking things up, putting things down – really, I'm not there at all. What I'm doing is I'm working, thinking." Once the idea is present – and this often arrives during the morning shower or on first waking up – her goal is to put it down on paper, and though it doesn't usually come out exactly as envisioned in her mind, it tends to work. That sketch may be worked on, possibly with tracing paper over it to refine the drawing, and this single idea is then adapted to whichever process Marian chooses to

BELOW: *The Walrus* magazine, cover artwork, 2009.

111

OPPOSITE PAGE:
New York magazine, the "00's" issue, 2009.
Medium: tinfoil.

THIS PAGE:
The National concert poster
(Daylight version), and visual, 2010.

form the artwork. For creating a pattern, once the sketch is completed and scanned she'll go through the process of changing colours, flipping and rotating, adjusting and forming the pattern, "and getting lots of surprises along the way".

Commissions for wallpaper or fabric may be approached in a different way if there are limitations which may involve potential loss of detail, and Marian will take the opportunity to learn about industry construction materials and techniques, to explore new potential for designing patterns – for example, for upholstery fabrics.

The fee for any given commission may have an effect on Marian's work process. A decent fee will prompt a sketch from Marian, "something to give them an idea of what I'm doing", whereas clients paying less will "get what they get!" she says, smiling. Her low cost of living, on an island off the Canadian coast near Vancouver, enables her to afford to be selective in the commissions that she accepts, allowing her to maintain a varied portfolio through which clients can recognise that she will approach a job from a wide range of possibilities.

The way Marian feels about a commission is also based on a number of factors: the profile of the work, where it's going to be seen, what it's for, what kind of company or organisation the commissioner is, "and then also just the personal connection with the company itself. The friendlier they are, and the nicer they are, and the bigger they are, in terms of the audience that is going to see it, the more engaged I am with the project." It's not a conscious reaction, more one based on the excitement and size of the project. One such job was a National Poetry Month poster she was given carte blanche to create, with the subsequent 200,000 posters distributed to schools all across America. "So, it's not like it's a big Adidas campaign, but it's that same kind of feeling. Like, wow, a lot of people are going to see this – to inspire kids to get interested in poetry – how great is that?!"

Feedback from commissioners is something Marian views as important. She is happy to admit that as a creative she needs praise from her clients. "It's not OK to say, 'Great, thanks,' period." Especially when delivering artwork created in a way she's never tackled before, a positive response is significant. "Maybe it's because I'm insecure," she ponders.

The three-dimensional nature of some of her work requires artwork to be photographed, and currently this happens on the kitchen table of her open-plan home, using natural light plus occasional flash, adjusting in Photoshop where necessary. Creations such as words formed from flowers may be constructed spontaneously just as a result of being in her garden; even during a busy day, "I'll drop everything, and start making something and taking photographs".

Limitations for her artwork are something Marian resists. "I don't really like working within boundaries, so my favourite is the open brief with very few parameters: this is the size, four colours, it has to say this – that's it." But when it comes to personal work, removing the confines a brief may hold can almost leave "too many options". However, experimenting with new materials and techniques, she works towards producing pieces that contain a special quality through their actual physical presence, something that cannot be captured by a two-dimensional photograph and that may yet be encountered in a museum. "I have this desire for there to be a special experience to be held back, for some future thing."

Marian Bantjes grew up in Saskatchewan, Canada. She now lives on Bowen Island, British Columbia.

OLIVER JEFFERS

QUENTIN BLAKE

KITTY CROWTHER

Children's Publishing

Each illustrator has a unique way of creating stories and building new worlds for their cast of characters to inhabit. Their memorable stories educate, entertain and enthral children everywhere.

The client's perspective:
Christina (Chris) Paul,
Creative Director and Associate Publisher of Candlewick Press, USA.

Illustration is integral to children's picture books. The text and the artwork are thoroughly connected. That connection is everything. The illustrator of a picture book creates a world that is believable in its own right – a world unto itself, consistent and balanced, illuminating the story and bringing it alive for children. A young child reads the pictures and hears the words and learns to 'see' rather than just look. This is a very important first step into the adventure of reading.

When a picture book works well, it seems as though the text and artwork sprang up together, simultaneously, as one thing, in a seamless unity of vision. We strive for this perfect balance between art and text, such that one cannot exist without the other and together they tell the story.

Picture book-making is a collaborative art form that involves the author, the artist, the editor and the art director/book designer. Each comes to the project from a different perspective with different skills and experience. They work together through many 'sketch dummy' stages, revising and rewriting, until every turn of a page works to tell the story at the right pace – this is the heartbeat of a picture book. The process is led by the illustrator's vision, inspired by the author's story, clarified and championed by the editor, and critiqued and given its physical presence by the art director and book designer.

The artist must truly 'see' the story, have a passion and believe in it to be able to successfully work through the creative book-making process from initial sketches through to finished artwork.

The picture book's images are what stay in the mind of the child, serving as a springboard for the child's imagination. It is the pictures that are immediate; it is through the 'page turn' that the story unfolds.

The best picture books are universal, appealing to adults, as well as children.

ABOVE:
Portrait by Derek Brazell.

LEFT:
Photograph of Oliver Jeffers by Mac Premo.
Photograph of Quentin Blake by
Andrea Liggins.
Photograph of Kitty Crowther by
Paul Duerincx.

OLIVER JEFFERS

presents

the

INCREDIBLE

BOOK EATING

BOY

POP-UP Edition

Oliver Jeffers

NEW YORK | USA

"I stopped saying I write and illustrate children's books – I think of myself as a picture book maker. I make picture books happen."

OPPOSITE PAGE:
The Incredible Book Eating Boy
(pop-up edition), published by
HarperCollins Children's Books, 2009.

BELOW:
Sketchbook, 2010.

There hasn't been a time in Oliver Jeffers's career when he hasn't been successful as an artist and illustrator. Translated into 17 languages, his funny, thoughtful, aesthetic books have been acclaimed around the world. He has already made an indelible mark on this area of illustrative practice.

Oliver seems to possess an intuitive facility for storytelling. Narrative is a natural dimension of the cultural landscape of his native Northern Ireland and, coupled with a curiosity about the connection between images and words, this produces a combustive mix fuelling the creation of imagery across a range of genres. "I fell into picture books by accident really. In my early art I was concerned with what happened when I put a single word with one of my paintings – how I could change one thing by adding another." He further explains, "Often the meaning of that word changed the meaning of the picture. This potential in my art making was fully realised when I started to make picture books. It's a perfect platform for exploring how words and pictures interact."

How to Catch a Star, Oliver's first book, featuring his distinctive character Boy, was originally intended to be a single painting, but he realised that the concept of someone physically trying to catch a star provided opportunities for multiple images. "It occurred to me that this could be more than a static image – it seems like a big jump, but I've always been a big fan of picture books and collected them since childhood. The jump wasn't so big in my mind."

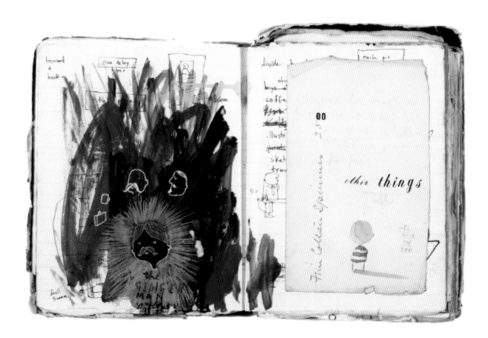

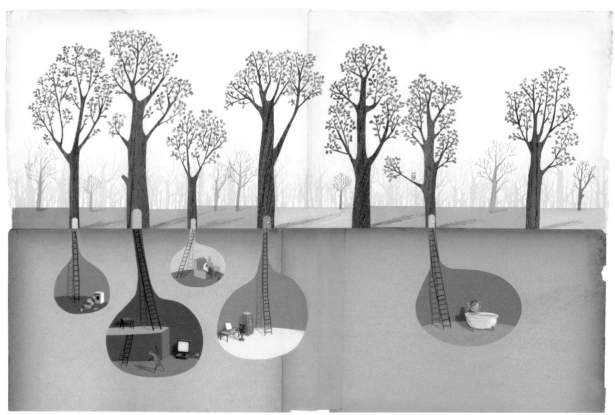

LEFT:
The Great Paper Caper, published by HarperCollins Children's Books, 2008. Medium: mixed media.

BELOW:
Artwork from *Lost and Found*, published by HarperCollins Children's Books, 2005. Medium: watercolour.

Working drawings for *Lost and Found*.

Portrait photograph of Oliver Jeffers by Mac Premo.

OPPOSITE:
Artwork from *How to Catch a Star*, published by HarperCollins Children's Books, 2004. Medium: watercolour.

The boy climbed to higher ground and called again, and waited.

The Boy character was developed by Oliver during his time at university, a visual aide-memoire to remind the conscientious student of important dates or things to do. The choice of watercolour was based on expediency, it being a quicker, more flexible medium than oils. The apparent ease with which the book came into existence belies the sheer determination to give it momentum and the meticulous approach to execution. Oliver possesses a "ferocious work drive", he says, "fundamentally, I think there are two types of people: those who talk about doing things and those who actually do them. I've always put myself in the second category." He demonstrated early in his career a proactive approach to locating avenues for his substantial creative and intellectual energies, revealing that "it never occurred to me that it was hard. I just had to make it happen."

This tenacity, curiosity and need to continually explore made Oliver consciously change direction in his work, in spite of the confirmed success of his Boy books. He describes *The Incredible Book Eating Boy* as "a gamble that paid off", recounting the reticence of his publisher to welcome his new visual approach. "I never rested on my laurels and I didn't want to get typecast." He laughs. "Neither did I want to be relegated to never having an opinion about my own work. So, because of the obstacles I had to overcome to make it happen, it's the favourite of my books so far."

The book possesses a more contemporary aesthetic, combining painting and use of collage materials with Letraset, beautiful fragments which reveal his love of vintage ephemera and his skill as an organiser of graphic elements. The humour in the work is more overt, its concept playful and fresh. He says that the process of making a good book happen has become more "solidified", and he seems now to be on an established route of evolution and discovery.

He recalls the process of making *The Great Paper Caper*, revealing clearly the steps in his methodology. "I absent-mindedly drew characters and produced written notes, seeing how they informed each other. I moved through from that to drawings, literally hundreds, to help me to confirm a direction and establish a beginning and middle, and to see how it would be resolved as a story. It's like the analogy of the iceberg." Although the figures Oliver draws are very edited, he is conscious of their physiognomy

and acts out their poses so that he is able to convey a lot of information in the subtlest of gestures and with economy of mark-making. The sketchbooks demonstrate this ability. Exploding with character and colour, each is a compendium of ideas, the chronicle of a playful and self-challenging visual journey.

Oliver enjoys considering the spatial connections between image and text, referring to words as "a tool in my image-making". Confidence with typography was fostered during his degree course, although his awareness of the fusion of picture and words extends beyond the graphic, physical properties of the work into the philosophy of their relative function and value. "The words are only a skeleton. If you remove them the images still tell the story," he insists. Thus he is selective in his choice of text, saying, "I often avoid a clunky turn of phrase by not including it – the atmosphere of the words can be almost stand-offish, almost devoid of emotion." He laughs humbly. "I'm not a writer, I know enough good writers to know I'm not one."

Oliver suggests that he himself, rather than any given child, is the target audience, his objective being to produce books that he would have wanted to read as a child. "I think children are smarter than they're given credit for." He is succinct. "If there's a magic ingredient, it's not trying to kid them or yourself." His books, which deal with profound issues, have powerful messages. He is clear in his stance: "I totally avoid forced content, thinly veiled morals, anything preachy or funny for the sake of it." He also cleverly avoids being sentimental or confrontational, by strategically making understatements. "The images convey the energy and the charm. That way I get away with content and issues which may otherwise be cheesy.

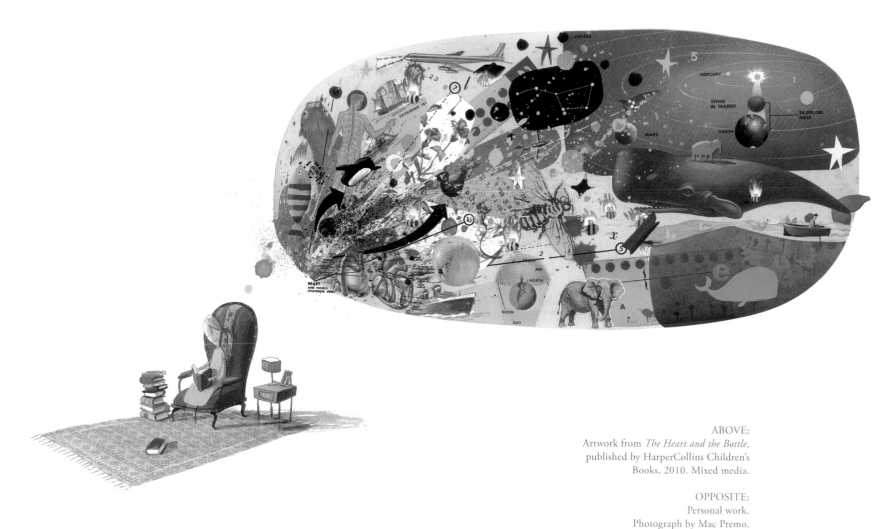

ABOVE:
Artwork from *The Heart and the Bottle*, published by HarperCollins Children's Books, 2010. Mixed media.

OPPOSITE:
Personal work.
Photograph by Mac Premo.

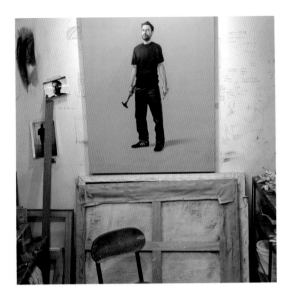

Writing the words gives me the chance to let them inform and not the other way round."

Oliver's practice is multifaceted and multi-dimensional. His is an interconnected life driven by an intelligent challenging of both meaning and process and a compulsion to make art. He is a member of OAR, a collective of artists who share a common sensibility and aesthetic and are spurred on by working together. They are a tributary of YOU AND ME THE ROYAL WE, a separate enterprise which he loosely defines as product design. He uses an analogy to clarify his ideology. "Musicians don't usually tie themselves to an instrument. They see it as a means to get some-where. That's exactly my thesis and philosophy. I have different tastes and ideas, concepts and outputs and I'm not tied by any one medium for their execution."

The outcomes from these tangents of his work are surprisingly different in their form to his children's books, but in physical manifestation only. "I actually don't see much difference between my picture books and paintings, just in my frame of mind. Sure, the form and content is immediately different, so is the process, but both begin as germs, nuggets of an idea, and I make them happen – I bring them into existence."

The dominant theme of his paintings, which are sold through galleries internationally, stems from an interest in the ideas about reality and his interrogation of the dialectic of logic and emotion. His work examines absolutes, commenting on mathematical thinking by exploring concrete notions from different viewpoints, what Oliver refers to as "the theory of duality". He elucidates further this divergent approach: "Each person's visual literacy is wide and varied, individuals are complex. That's how I feel about physically making art."

Oliver is an artist of integrity, and the visual content of his work is underpinned by a sound understanding of complex knowledge gained from extensive reading and many hours spent in dialogue with a doctor of quantum physics at Ulster University. This knowledge is coupled with an exacting command of the medium of oil paints. In parallel to the children's books, there is admirable meticulousness in this process. "There are different parts of the world as I see it, and I feel I need to make comment on them in different ways. It's the same reality in my art whatever form it takes."

An ideal year for Oliver will be divided into equal amounts of time spent on both commissioned and self-initiated work. His practices inform and compliment each other; both paintings and picture books are about quests for intelligence and an unravelling of existence and storytelling. "An important part of my process is distance and space between various levels of thinking."

Oliver's own aim is to be intriguing, fun, challenging, odd and humorous, to present a compelling mixture of ideas and notions. He is, as he says, "in a really good place". It will be really interesting to see where his endeavours lead next.

Oliver Jeffers grew up in Belfast, Northern Ireland. He now lives and works in Brooklyn, New York, USA. His books are published by HarperCollins Children's Books.

OLIVER JEFFERS

THIS PAGE:
L'hôpital Armand Trousseau, Paris: picture no. 3 in
the series. Enlarged and displayed at the hospital since
October 2008.

OPPOSITE PAGE:
Our Friends in the Circus: produced for enlargement
and display at Northwick Park Hospital, Harrow,
in 2008.

Quentin Blake

FRANCE & UK

"I always knew drawing was interesting but not how interesting, and what you could do with it. Someone said once, 'If I'd known I was going to be any good, I would have tried harder.' I think about that myself. I think I'm a late developer."

Generations within families recognise the book illustrations of Quentin Blake. His tremendous output of more than 300 titles, including *Mr Magnolia* and *Mrs Armitage* as well as the famous drawings for Roald Dahl, continue to entertain and enthral children around the world. His memorable characters and archetypes are synonymous not only with the reading of stories but also with the magic of childhood.

The energetic lines and fluid colour, the fabric of his distinctive characters and scenarios, marry with the writing of a range of seminal authors, notably Michael Rosen, Joan Aiken, Charles Dickens and lately David Walliams. Quentin says of the nature of these relationships, "The words are there. You can't change Shakespeare, but you can bring something from it that's not a contradiction. In Dahl, for example, I think some of the pictures are more introspective than the words." Roald Dahl was not a man of introspection, he was a man of action, and his books reflect that. This demonstrates the symbiotic relationship that exists between image and text, with the illustrations bringing a different complexion to the book.

Over the years he has developed a systematic working methodology. The initial stage is pure invention. Working quickly, standing at the light box Quentin visualises with a black line on layout paper using italic pens or fibre tips, which facilitate rapid, short bursts of drawing. He acts out his characters' posture and expressions, exploring composition and framing pictures on the page. "It's interesting to do the roughs very fast, because you then respond instinctively. When you come to evaluate them later you see that the person you drew was looking in a way that hadn't gone into the objective bit of your mind before you'd drawn it. I still surprise myself a bit."

When working on a book he begins with an overview, plotting the entire story. It's only when he has decided on the sequence of the pages that he begins the roughs. "There's something about not putting too much energy into the rough because you know you have to do it again later. I don't do the drawing at this stage. Things get articulated in the final drawing so there's something left to discover. That's when you do energy."

The roughs are not intended for client approval, but structurally they underpin the final illustrations. He chooses from a selection of implements – reeds, which he enjoys for their unreliable qualities, brushes, bamboo, or old-fashioned writing nibs like the Waverly – and begins his artwork by consciously choosing Arches watercolour paper because of the resistance its surface offers to his energetic marks. At the painting stage watercolour is applied with élan, and smudged and blotted with his fingers to make characteristic patches of colour with unruly edges.

Quentin is recognised for his unique distillation and interpretation of visual information. His fast, economical drawing is an individual pictorial version of reality. "I almost never draw in sketchbooks. I say, ridiculously, that I make it up. I don't, of course – it's drawn from memory. When you sit down and do a drawing you're not inventing it. You can't invent it, but you can pull it back from somewhere."

OPPOSITE PAGE:
Visual and finished art for
Mrs Armitage Queen of The Road,
published by Jonathan Cape, 2003.

BELOW:
Studio photographs and portrait (p. 126)
by Andrea Liggins.

He describes his characters as a repertory company, and it's a cast that we connect with universally because they are reminiscent, slightly exaggerated versions of people we have encountered. "Sometimes people ask if the characters are based on someone specific, and they're not. But sometimes when they are complete, I see someone I know has got incorporated. And sometimes people who know me say, 'That's you, those are your elbows!' I don't do it consciously, but it gets into the system somehow."

The processes he uses have become increasingly efficient, based on a keen visual awareness. "I believe my pictures criticise each other. Sometimes I look back to the rough and realise there's something there I've lost, a nuance of posture or facial expression. Sometimes I think that with the same number of lines there could be more engagement – some images seem more observed, not in a literal way. They could have more flavour."

Quentin's career began during his teens, when his persistent submission of images to *Punch* finally resulted in paid commissions. The editor at that time was sympathetic to the more dynamic qualities of the rough drawings and encouraged a more relaxed approach to the artwork. The work of illustrator André Francois was also an important inspiration and the philosophy behind his approach a revelation. "I like the feel of his work. He always treated what he did like fine art. The image was absolutely relevant to the situation he was working for, but he would scratch it, paint on it, cross it out, stick bits on. There wasn't a rule he'd learned from the book *How to do Commercial Art* – he demonstrably got away from that."

Reflecting on his expansive oeuvre Quentin appears tentative when asked to select the greatest from the output. "It's hard to choose," he says. "What suits me about illustration is that it's cumulative. It isn't one major thing, it's moving from one situation to another, from one book to another, and playing it slightly differently each time. That's why I enjoy working with different writers. I draw in an identifiable way,

but each one shifts you slightly, some more than others. That was particularly interesting with Dahl. The books are not the same, the tone changes. Some are darker, others more acerbic. You have to make the effort to be like him in that way."

Some of the projects Quentin takes on may appear like a departure from the children's books for which he is known. In particular the artworks produced for hospitals are notable because they are off the Quentin Blake page. They bring a sense of fun, wonder and joy to those traditionally formal environments. Like images in a book these wall prints are often seen sequentially, pieces to be encountered repeatedly by a diverse audience engaging with their subtle metaphor and underlying content. Interpretation of their visual fables encourages reflection and empathy, and maybe evokes a sense of comfort. "In a sense these are a form of pure illustration," he reflects. "The work belongs to a specific place and addresses a specific audience, although I'm working without words. There's another narrative. With the old I extended situations beyond the reality of their lives. They have to be funny, but I'm aware of the susceptibility of the audience."

For Quentin as an image-maker the sophisticated nature of inkjet printing removed constraints of size and scale. For many of the maternity scenes there was the liberation of working directly without roughs. "I like those pieces greatly. They aren't ostensibly funny but they're celebrations. Also it was interesting for me to use that kind of academic life drawing fairly directly in a freewheeling kind of way, as it would have been in the past. A chap doesn't get many chances nowadays to draw naked women in public situations. But of course these are private public places." This is an important body of work. It asserts the functionality of illustration and dismisses notions that a visual language or stylistic approach anchors a practitioner to one genre or literary association.

ABOVE:
Cover artwork from Roald Dahl's *Revolting
Rhymes*, published by Puffin Books, 2001.

QUENTIN BLAKE

The deliberate ambiguity in the title of this book, *Making Great Illustration*, applies specifically to
Quentin Blake, who is making illustration great. His exhaustive commitment to exerting the value of the
subject as a cultural force is epitomised in the foundation of the *House of Illustration*, intended jointly
as a space for illustrators to meet and fortify each other and for the general public to be able to view an
array of visual work. Over time the 'greatness of illustration' as a means of conveying emotion, accessing
experience, sharing knowledge and communicating ideas will be asserted more powerfully as a result not
only of his own work but also of his altruistic role in the foundation of this national institution.

*Quentin Blake was born in Kent in the UK. In addition to his many international awards in illustration, in
1999 he was appointed the first-ever Children's Laureate. He was bestowed with an OBE in 1988. He has
homes in the UK and France.*

Kitty Crowther

BRUSSELS | BELGIUM

"The stories you write have to be linked to things you understand on the inside. I don't do books about my life. They're about a certain stage and a certain feeling. They have their own characters and they go their own way."

OPPOSITE:
Artwork for *L'Enfant Racine*. Written and illustrated by Kitty Crowther, published by Pastel/L'École des Loisirs, 2003. Medium: coloured pencil.

THIS PAGE:
Poka & Mine: Au fond du Jardin. Written and illustrated by Kitty Crowther, published by Pastel/L'École des Loisirs, 2007. Medium: coloured pencil.

The Astrid Lindgren Memorial Award, established by the Swedish Government following the death in 2002 of the creator of the enduring Pippi Longstocking character, honours the best in children's writing and its substantial six-figure reward makes it one of the most coveted prizes in children's publishing. Its esteemed recipient in 2010, Belgian-born author–illustrator Kitty Crowther, shares with Astrid Lindgren a rare ability to create stories which touch the minds, hearts and lives of young children around the world. "I always wanted to be a storyteller," explains Kitty. "I believe in the power of children's books. You have to believe in them to share them."

In the tradition of other great storytellers Kitty shares her intensely personal vision. It is rich with the enchantment and wonder of mysterious landscapes and intriguing characters, and reveals the emotions and experiences of lives rich with discovery. It is never twee.

The books she writes and illustrates grow from seeds planted in her childhood, where the hearing difficulties she was born with impacted profoundly upon her ability to communicate. "I felt so lonely and locked out," she remembers. "It's one thing to know how to know the words but something else to know how to use them." Stories became a refuge, the stories her father told her, and her favourite books, like Beatrix Potter, which magically transported her to places where there was adventure and freedom. As she says, "Children's books were the only place where I could really hear."

THIS PAGE:
(top) *Le Petit Homme et Dieu*, written and
illustrated by Kitty Crowther, published by
Pastel/L'École des Loisirs, 2010. Medium:
coloured pencil.

(bottom) *Annie du Lac*, written and illustrated
by Kitty Crowther, published by Pastel/L'École
des Loisirs, 2009. Medium: mixed-media.

Studio photographs by Paul Duerincx.

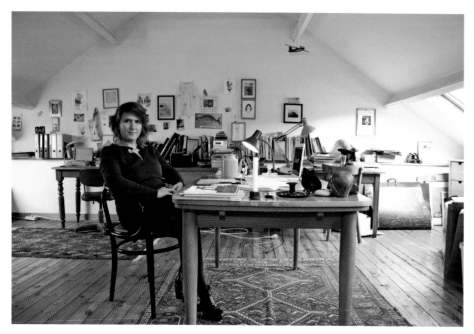

Now as author and illustrator she cherishes the opportunity to speak to children, not in a didactic or moralistic way, but to communicate the intelligence, tenderness and joy she was touched by as a young girl. "I try to respect the child I was," she says, "the little girl who liked a particular kind of books, and the first person I try to please is myself." Her stories have been applauded for their focus on characters whose weaknesses make them afraid, who overcome difficulties, who are lonely and scared of noises in the dark. Overwhelmed by the disorder of life, their triumphs and victories come from an understanding gained from new encounters and from venturing bravely into new territories.

Long before her time at art school Kitty had decided that she was going to be a storyteller and had recognised her affinity with children. She sees parallels between play and her process as a storyteller. "I don't say I'm going to make a story about separation, death or happiness. It just happens that the character leads me to those things. I tell it better if it's not obvious from the beginning. I follow the character and they will tell me what comes next." Growing up took a long time, and as an adult she recognises that her hearing difficulties helped her to develop in other ways, in particular an ability to see people clearly. "Children are more direct. I always could have fun and be honest with them," she says, laughing, "and then I had children, and I realised one day that my son Theodore thought that I was a child like him, and that I would have to go on to the other side!"

A sensitivity towards the nuances of pose and expression as shown through her characters also comes from a lifetime of curiosity and observation. Her sense of perception was heightened not through her art-school training but, again, as a consequence of her hearing problems. Her fascination with how people communicate through body language has fed into her drawing ability. "Deaf people are very good at watching," Kitty explains. "That helps a lot when you draw. I can also pretend, and that's good too. When you draw you have to feel it from the inside not the outside."

Examples such as her charming insects *Poka* and *Mine*, the frog from *Scritch scratch dip clapote!*, or the curious girl from *Annie du Lac*, Kitty's characters are, like her childhood heroes, believable. They are a subconscious melding of parts of herself, characters from other books, people she has met. She makes them seem real, like friends visiting from a faraway land. "It's a bit mysterious when you give birth to a character – it's not intellectual. I get the impression they have always been there," – she laughs – "that they just happen to come down and drop onto the paper. I just try to do my best for that character."

She admits to having a recurrent preoccupation with strong feminine characters who are not afraid of making their own way in the world. There are animals of all descriptions, and her animal stories are commercially very successful, an indication that children everywhere connect to their universal qualities. "When I was a child I would make all sorts of things talk," she remembers. "I started with animals so now it's very natural for me to do stories with them."

Kitty makes parallels between the pages she draws and the stage in theatre. Like a director bringing together a cast, she creates and enacts her narrative around one central character responding to internal questions. "Who do they meet? Are they friends? Are they in love?" She says, "I just go on and on. I can't stop myself answering questions."

ABOVE:
Hare reading, personal work.
Medium: coloured pencil.

Rainbow teeth, personal work.
Medium: mixed-media.

KITTY CROWTHER

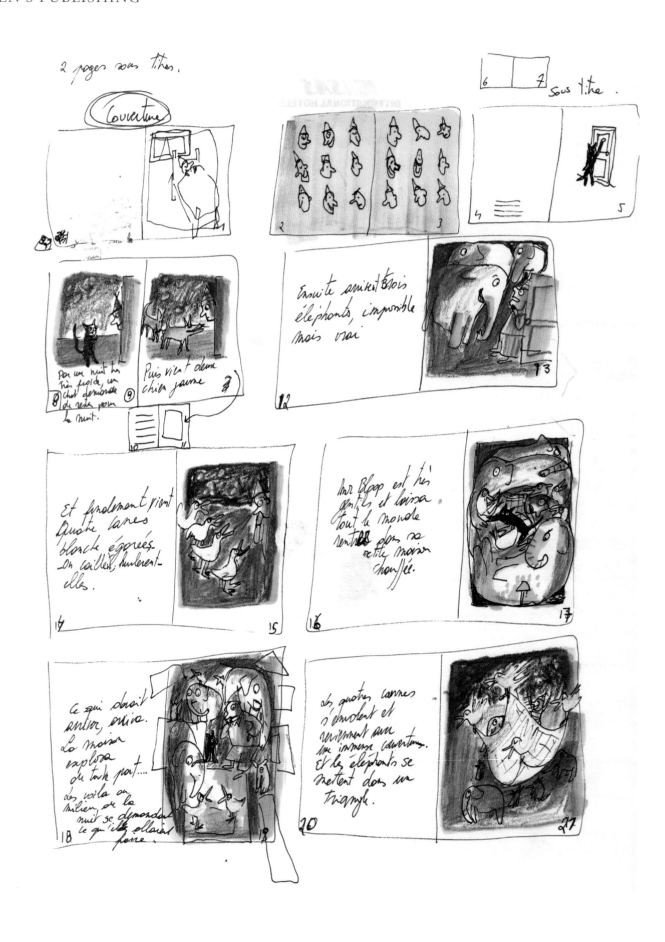

Her creative process interweaves drawing and writing circuitously, yet moves forward into a story frame by frame, with the evolution of the plot dictated by the connection of a picture to words. This synthesis is where the magic of her craft lies. Although she doesn't consider herself an author, words are vital to the chemistry of her storytelling. "When I write there's holes in the text. I can put things in, decide to ignore them or take things out."

There are few published in English, but Kitty has illustrated more than 35 books. She focuses on creating an average of two every year, consciously flipping an internal switch to cut the constant flow of story ideas so that she can focus on the quality. She alternates new ideas with her ongoing *Poka et Mine* series, sometimes bringing new technical approaches into the artwork. "I get bored when there are ticks appearing. I sometimes try new techniques just for fun. It may just happen that there is a cup of tea on my table and I'll use it instead of a watercolour. It's not really the technique that interests me, but I'm always interested in the drawing."

The drawings she makes in her small intimate sketchbooks are often quite finished. They are always in the sequence of the plot and alternate with sketches in which she explores a gesture or expression in more detail. Although she repeats them on watercolour paper, conscious of consistency of character and readability, she is careful to retain the freshness and mood of her initial drawings. "I like working in sketchbooks because it's already a book," she says. Unconventionally, it is not unusual for Kitty to then take her book to the publishers, where she will sit alongside the editor reading the story while the publisher reads the pictures.

Kitty has had many successful collaborations with other authors but is selective about which texts she will agree to illustrate. Her response when reading a story is not an intellectual one. Instead she responds intuitively, choosing only those which she believes in. "They have to give me images straightaway."

Being able to invent is what she most enjoys, and Kitty's own blood flows through the veins of her creations. Her odd dramatic landscapes reflect childhood holidays in Sweden, her mother's native country, and her continuing love of nature. The fantastic characters tap into her interest in myths and legends. She laughs and says, "I believe in God and angels, witches and fairies, gnomes and trolls. I believe in all things I do not know." Her words flow from her own lifelong love of reading and benefit from the inspiration of those illustrators "who find solutions where I don't manage to", such as Tomi Ungerer, Quentin Blake, Sempé, and the raw sincerity of expression in tribal art. Kitty's stories, like her, are full of optimism and hope and are punctuated with the good humour that enriches her conversation.

She visits the Bologna Children's Book Fair every couple of years to meet up with friends and to check out what else is happening in the illustration market. But whatever trends come and go in the vast world of children's publishing, Kitty Crowther will remain an extraordinary individual at the top of the field. She quotes her friend, the illustrator Wolf Erlbruch: "'The best thing an illustrator can do is listen to his own note of music'. I really like that. It's not a big symphony, it's not very loud, and so you don't hear it very easily. To hear your own special note you have to focus on it."

Kitty Crowther was born in Brussels in Belgium, where she continues to live and work. She writes mainly in French.

OPPOSITE:
Working drawings, *Trois Histoires Folles de Monsieur Pol*. Published by Pastel/L'École des Loisirs, 1999.

BELOW:
Scritch Scratch Dip Clapote. Written and illustrated by Kitty Crowther, published by Pastel/L'École des Loisirs, 2002. Medium: coloured pencil.

DAVE MCKEAN

EMMANUEL GUIBERT

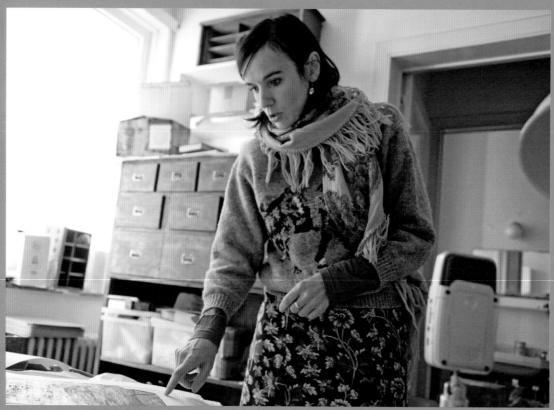

DOMINIQUE GOBLET

Graphic Literature

This form of publishing has become a global phenomenon. These storytellers use images, sometimes with words, to bring their distinctive narratives to a diverse international audience.

The client's perspective: Calista Brill, editor, First Second Books

First Second has been a home to narrative artists since our inception in 2005. Part of our mandate since that time has been to create a hospitable and nourishing environment for a significant cross section of today's great talent in the field of comics.

We work with authors and artists from all walks of life, people who write and illustrate in all sorts of genres. Some of these artists – like Emmanuel Guibert, whose great nonfiction graphic novel *The Photographer* we published in 2009 – live, work and publish in other countries; others are home-grown local talent. Because we publish a relatively small list (though it's growing all the time) and because we are committed to a long-term creative relationship with each author or illustrator on our list, we are especially thoughtful about who we bring on. The qualities that we look for in an artist are mostly pretty standard: professionalism, dedication, good technical draughtsmanship, a strong cartooning 'voice', and that less tangible quality of good chemistry. But, in addition, we look for people who have something to say.

The books that we publish at First Second are books that come from a very personal place for their creators. Although we have seen commercial success with our books, it is rare that we sign up a project with dollar signs in our eyes. What moves us to sign up a book is instead the feeling that the world needs to experience what this person has created. I don't mean to make this sound as though we only publish the Kafkas of the cartooning world. Our list is diverse: some of our books are small, funny things and some of them are great big serious things. Some are for four-year-olds who appreciate chaos and some are for grown-up readers who enjoy substantial nonfiction. But what unites the very wide variety of books published by First Second is personal engagement – on the part of the creators, the editors and the readers.

The editorial and design team at First Second is typically more involved in the creative process than at other graphic-novel publishers. For that reason, another quality we look for in our artists and authors is a willingness to enter into a creative partnership with an editor and an art director: a willingness to edit. Every now and then a project comes our way that needs very little interference from us; but in general we expect to be doing significant thinking, talking and pushing. So an openness to this sort of collaboration is crucial for a project to really take flight.

The profound difference between illustration and narrative artwork is not always obvious to the casual observer. An illustration is a self-contained entity. It stands alone, on its own merits. It often represents something larger than its literal content, but it does not generally live in the immediate context of a wealth of other material informing, complicating, subverting and reinforcing it. A panel on a page of comics, on the other hand, is a social animal. It interacts with the panels around it, with the composition of the page itself, with the text on the page and within the panel, and with the whole work, whether that work is a three-panel cartoon strip or a 500-page graphic novel. A good panel does not stand on its own, to be judged on its own merits. If every panel of a comic were an illustration in that sense, the experience of reading the comic would be disjointed indeed.

So, although some of the creators and illustrators of the comics published by First Second books come from a traditional illustration background, we are always careful to make sure that our artists understand the distinction between illustration and narrative art.

ABOVE:
Portrait by Jo Davies.

LEFT:
Photography by Paul Duerinckx, except Dominique Goblet by Andrea Liggins.

135

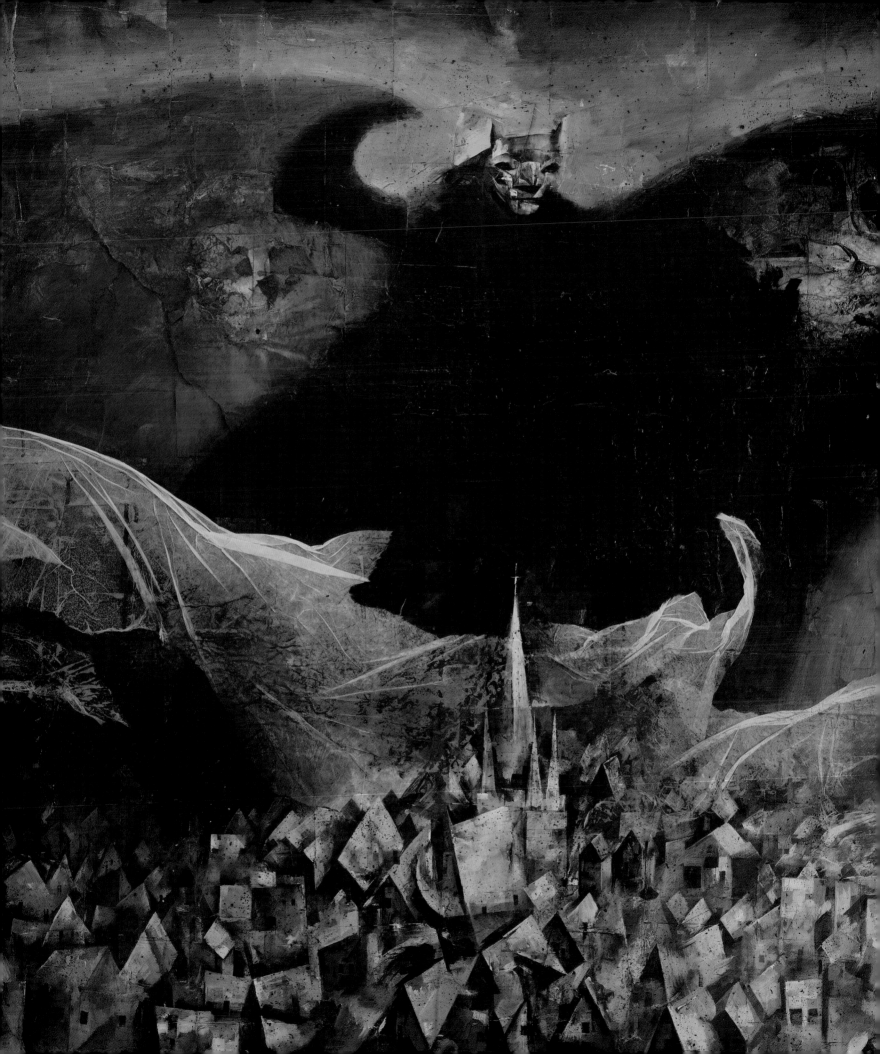

Dave McKean

KENT | UK

"I think in narratives, or at least, sequences of images, so storytelling suits me. Comics allow me complete control and freedom of the work, and I don't need a budget to initiate a project, just a pencil and paper. It's a wonderfully democratic medium."

THIS PAGE:
Mistral, from Pholk series, 2009.

OPPOSITE PAGE:
Faust (F.W. Murnau, 1926)
published by Allen Spiegel
Fine Arts, 2011.

Nitrate print from a series of paintings
and drawings inspired by silent cinema.

From the walls of a converted Kent barn curious faces from iconic Polish posters bear witness to the comings and goings of Dave McKean, "creativo", whose diverse practice across comics, books, photography, film and illustration define him as a visual polymath. Since his well-documented collaboration with writer Neil Gaiman, resulting in a diverse and acclaimed body of work with its genesis in the late 80s, Dave has produced work for clients across advertising, publishing and design as well as in a more authorial capacity. For many it as a stellar light in graphic literature that he is best known.

As a child Dave was absorbed by comics and acknowledges that their dramas and heroes taught him about sequence and framing. He still enjoys a strong connection with the medium, favouring it as a way to convey a narrative, explaining, "A narrative form like comics draws the audience into the emotions and events in stories. It is not a passive medium." This is the means of storytelling that he frequently returns to, whether in adverts for clients such as Kodak and Eurostar or books like *The Savage* by Dave Almond, reflecting, "I'm really happy when I can get comics out into the real world." He acknowledges the subculture that has evolved around the genre but is neither personally engaged in it nor drawn towards its comic superheroes. "I have no nostalgic feeling for the comics I read as a kid," he says, "I just didn't get Batman!"

Dave's own early comic-book work for DC Comics continues to be highly respected, but it was the Sandman series that propelled him away from these more traditional formats towards new audiences who wouldn't necessarily have read comics. These "books" were widely available; "they managed to get into the real world". Images such as the jackets for the *Sandman* series are often densely layered, visual patchworks with depth, not only spatially and texturally, but also conceptually. His first novel, *Cages,* was important because it was an autonomous project, but it also marked a stylistic departure. "That way of painting was slowing things down – it was getting rather lugubrious and slow and I wanted it to be lighter – a handwritten approach to the drawing."

Unlike many of his contemporaries Dave has deliberately evolved more than one distinct, singular visual language and these eclectic visual approaches are not purely about surface qualities. At the core of his work there lies an imperative to establish the essential meaning of the subject matter and to then find an appropriate way to communicate it. He elucidates that, "to an audience the technique is irrelevant – it's whether an image touches them or not." The nervousness of a character may be expressed by an agitated line drawing, a moment

137

He had no family and he had no
pals and he didn't know where he
come from and he couldn't talk and

he lived on berries and roots
and rabbits and stuff like old
pies that he pinched from the
bins at the back of Greenacres
Rest Home. He lived in a cave
under the roofed chapel. His
weapons were old kitchen knives
and forks and an ax that he
nicked from Franky Finnigin's
allotment.

which is dense emotionally, and also literally as translated through solid materials, such as clay.

The constraints and specific requirements of more commercial briefs rarely impede the integrity at the core of his work. Whether the idea is for a CD cover or a series of drawings for a narrative, Dave is genuinely engaged, enjoying the control he is able to exert within his work. Additionally, commercial briefs provide opportunities to work with other people. Unexpected challenges are welcome ones, such as the collaboration with food writer and celebrity chef Heston Blumenthal where he was "able to capture the feeling of recipes in an abstract way".

There is a density of mood in many images; his is a compelling, dark world of metaphor. Dave's thoughtful intelligence and interest in semiotics, which fashions his approach, draws upon a belief that we possess a collective understanding, not in a supernatural or religious sense but through an experiential link or connection which results in a more intuitive response from the audience. This decoding, unlike deliberate symbolic references that have historically defined certain art movements such as the Pre-Raphaelites, is a personal one based on empathy not obscurity. He explains, "I'm not interested in making symbolic images that need a key to unpick the meanings. To a degree, the images should be self-explanatory, open, not enclosed in a world of exclusive knowledge." Dave refers to the cat from the front cover of *Cages:* "The cat with a mask is an example of this. It has its antecedents in Roman and Greek statues. But I think anyone who has lived with a cat recognises that feeling of looking into a cat's eyes and expecting them to speak. There seems to be a real understanding there. A secret knowledge."

Although in his atmospheric, Gothic images it may not seem immediately apparent, drawing is vital to his work. He explains "Everything starts with a drawing, even photographs and films. There is something about putting it down on paper as a drawing or storyboard that makes it real. I can judge it then. Before that, it's just a mass of half-seen, fleeting ideas orbiting an idea, but once it's out of my head and onto paper, I can see if it works." He has worked on location to build up his drawing skills, and reflects on the benefits: "Almost all the lessons I've learned have fed directly into my other work."

138

He has consciously armed himself with a repertoire of technical skills, and final images can contain fragments of drawing, painting, photography, and 3D forms. No materials are out of bounds; he has

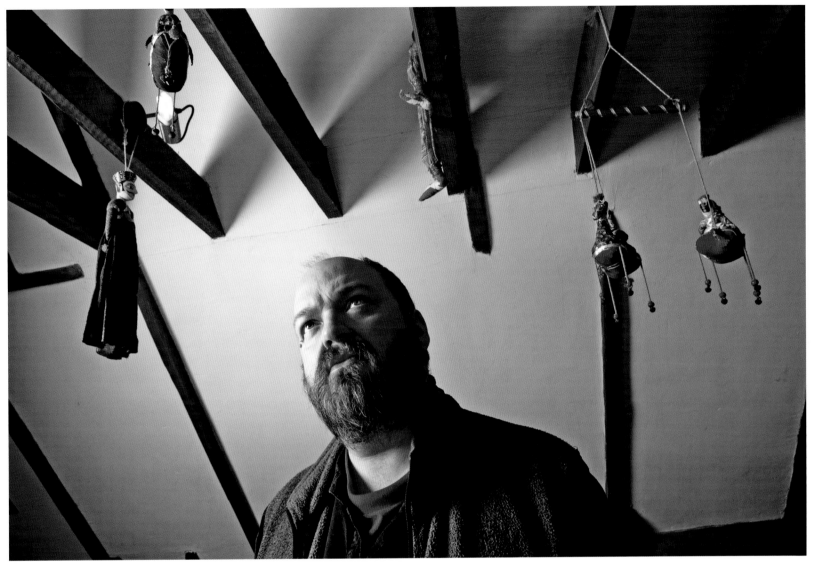

Studio photographs by Paul Duerinckx.

OPPOSITE PAGE:
(top)
Savage drawing.

The Savage, children's graphic novella written by David Almond, published by Walker Books, 2008.

(bottom right)
Final image and developmental images from *Crazy Hair,* children's picture book written by Neil Gaiman, published by Bloomsbury Press, 2009.

even used cuttings from his own beard mixed with treacle! Conscious of the tactility and substance of materials, he directs the subsequent digital process consciously to both retain and enhance key aesthetic properties. The computer as a tool has liberated his process, enabling him to get close to his own vision. "Photoshop could have been created for me," he says, "It's allowed me to get very close to the images in my head". Earlier pre-digital pieces with actual physical construction were reliant upon what he describes as, "abuse of the colour photocopier. Dave reflects on this way of experimenting and the subsequent value of the Mac. "Nothing really worked for me. The control over every aspect of image making is very powerful, and the ability to try things very quickly and save other versions is liberating. Occasionally, and for the first time, I was actually surprised by my own work."

His work resonates with the influence of the great visionaries he admires: the line work of Egon Schiele, the intensity of Marshall Arisman, the disturbing iconic characters of Stasys and filmmakers such as Tarkovsky. Music and film are his parallel interests, and Dave's own excursions into these genres have resulted in the feature films *Mirrormask* and *Luna*. Although film fuses storytelling with sound and can be seen as the ultimate opportunity to bring together his passions, his experience in this medium has affirmed his earliest ambitions and he prefers to focus on creating memorable graphic novels. "There is such a rich history of film making all over the world, I feel I could at best just add a tiny footnote to it. I'm not comfortable with the medium, and it's too difficult for someone in my position to make the kinds of films I want to make. But I do feel that comics *are* my medium. I feel I have a very strong control of the medium now, and would like to build on the books I have done that I think do add up to a strong body of work – *Mr. Punch, Signal to Noise, Cages, Pictures that Tick, Sandman* – with a much stronger collection of books for the new century."

ABOVE:
Sketch for *The Magic Of Reality*.

The Magic Of Reality, written by Richard Dawkins,
published by Transworld, 2011.

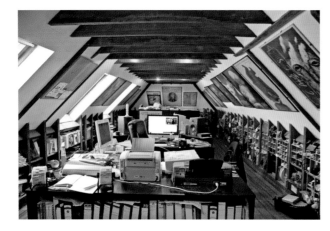

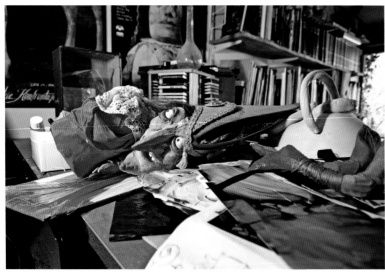

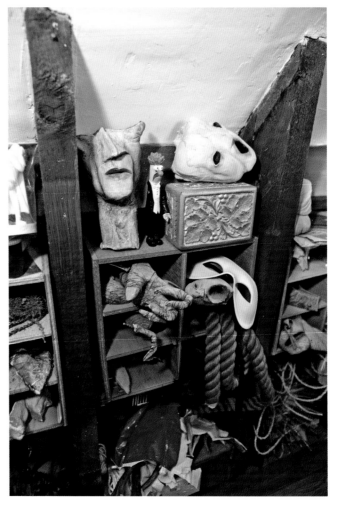

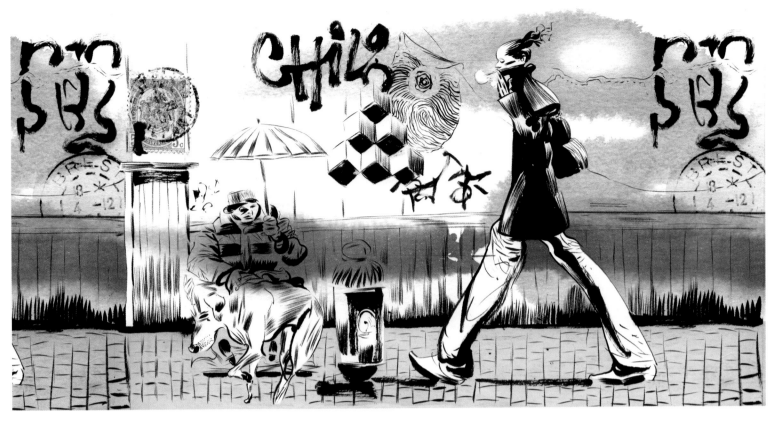

ABOVE:
Postcard from Brussels
by Dave McKean.
Published by
Hourglass, 2009.

As Dave points out, "Most of my work is just about telling stories," and for this the medium of graphic novels is compelling. In particular he describes the specific intersection of creator and audience that the genre fosters. Each reader has the potential to synergise with the content in a unique way, to bring their own pace and experience to the mix. "The reader is really engaged in the creation of the whole experience." This results in a distinct and individual interpretation of the narrative, a connection that makes experiencing the work more enduring for each person.

Although he is firmly part of its evolution, Dave sees the comic genre as being in its infancy. The current practitioners he admires, artists such as Shaun Tan "whose artful approach" in *The Arrival* has drawn in a new audience, have discovered routes into graphic novels different from his own more traditional way through comics. Dave has blazed many of the trails for these journeys.

Despite an unwillingness to define himself as a writer, Dave does have the confidence to write. Life experience has equipped him with more to say as an author-illustrator, and he chooses to draw upon his own experiences and those witnessed in the lives of other people. Sentences, words, sketches and images are fused together to create a book, and this layering and collaging of elements mirrors the visual processes he brings to each single image.

Retrospectively, he is critical of some of his output and reflects that this is indicative of his need to continue learning, evidence that he is still on a voyage of discovery that is an important dimension of his vocation. "I believe very strongly in creativity as a force to get you through life." To understand this prolific and versatile practitioner it is also worth noting that, "to do these things well there has to be an element of obsession. It has to be all-consuming."

Dave McKean was born in the UK. He lives and works in Kent.

Dominique Goblet

BRUSSELS | BELGIUM

"I try all the time to question the way I work – I must break the limit of each genre."

Dominique Goblet is a groundbreaking artist whose work not only transcends traditional boundaries of illustration, comics and art but has also contributed to a redefinition of contemporary practice in the genre of graphic literature.

One of Dominique's major endeavours has been the fascinating project published by French publisher L'Association. This is the product of a 10-year ritual of fortnightly reciprocal observations between Dominique and her daughter, which she describes as a "silent narrative". Her documentation of the metamorphosis of the growing seven-year-old and the simultaneous drawings by her child reveal the intensity and sincerity she brings to her work. She reflects upon the outcomes. "In between the intersection of this slow, parallel and opposite movement you can find time. It's an important project and I use it to question the limit of what comics are and what we consider to be painting."

Through this body of work she poses an important question that directly challenges the prejudices usually directed at the genre: "Can we see the work as a neat extension of comics?" In answer she reflects on the ramifications of this body of work for how graphic literature is defined: "We're used to the codes and principles of comics – squares and balloons – but when I ask, 'Is this a form of narration?' I have to answer, 'It is, without doubt.' We can't move any drawing – they have to be in that order. It's a sequence, not an accumulation of illustration. To me it's clearly a narration."

What Dominique refers to as the "regard" between mother and daughter was explored within her pioneering autobiographical book *Faire semblant c'est mentir* (*Pretending is Lying*) (L'Association, 2007), which explores issues of communication, the contradictions within personalities and the tensions that can thread themselves through relationships. In particular, she reflects upon the complex dynamic between

143

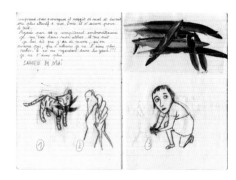
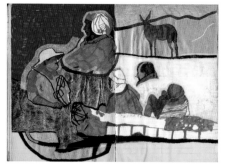

THIS PAGE:
Sketchbook drawings.

OPPOSITE:
Portraits from *Chronologie de Nikita*,
by Nikita Fossoul and Dominique Goblet,
published by L'Association, 2010.

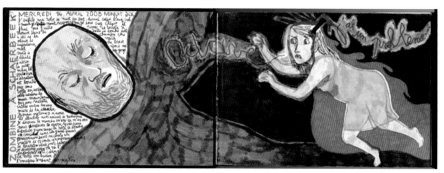

herself and her parents during the more troubled times of her childhood. "The message is that everyone is lots of things."

In this book she shows not the classic heroes or villains, archetypes who populate traditional comic books, but people who are real. Dominique puts the reality of childhood trauma and a love story on the same level, as parallel narratives. Both dimensions are autobiographical – the story of her relationship at that time, burdened by the spectre of her partner's ex-girlfriend, alongside an emotionally charged episode from her childhood. "People ask me if my work is a kind of therapy. No. In therapy you simply have to recognise what your parents mean. In an autobiography I show my mother doing some terrible things, but I ask the reader to love her." However, Dominique accepts that the process of creating the book was cathartic, reflecting, "When you have things happen to you it can be used as material. You take distance so in a certain way the result is the same."

During the 12 years spent on the book she also worked on other projects. *Souvenir d'une journée parfaite* (*Memory of a Perfect Day*) (Fréon, 2007) seminally challenges distinctions of fiction and autobiography within the comic-book genre. The brooding line drawings subtly smudged with white pastel intertwine the story of Dominique in a cemetery trying to find her father's grave, her own story, with the fictional account of an invented character, inspired by a name on a gravestone. "It's an interrogation. Can we consider autobiography to be about your own truth? Is fiction more personal and more true in another way?"

In addition to publishing these successful books Dominique exhibits artwork in many important galleries in Paris, Brussels, the Netherlands and Switzerland. The images for which she is celebrated in this domain

are rich in colour and often combine fragments of drawing and painting, as well as mixed media: monoprint drawings on carbon paper, graphite, pastel. For reference she uses photographs taken when travelling around Scandinavia, as well as those found in books and on the internet.

This compelling work with its foreboding landscapes and isolated buildings evokes a distinctive sense of place. Its recurrent motifs – crying sheep, ghostly figures, dark forests, businessmen, and shapes in the night – combine realistically handled with naively drawn elements, because, as Dominique says, "it makes them more shocking". In her project *Les Hommes-loups* (*Wolf Men*) she refers directly to a specific image of laughing businessmen shaking hands, concluding a truce. This image seems to be at the heart of this project. "Zorro says to the hyena, 'We agree you don't touch the rabbit?' And at the wolf's legs there's a rabbit looking terrified." This one of a set of independent yet interconnected pictures, the overall theme is disquiet and distrust, duplicity and deceit.

During the exhibition of *Les Hommes-loups* patrons were invited to buy two or three from the hundred or more available pieces. By deciding upon their own combination and positioning them, they too became actors in a story. The results of this process have since been turned into a book published by Frémok in 2010. This is an important publication because it represents a bridge between gallery work and comics. Based not on a single scenario, the book specifically invites multiple permutations in the order of its contents, with each one exposing new connections and complexities. "In the book you choose the order. Because it's not a linear narrative you're not obliged to follow the natural order – you can open the book wherever. I suggest some things, you make the rest. It has new significance however you mix them."

Dominique values the support and respect of her French publisher, L'Association, and although she recognises that her success has made her attractive to the mainstream, she says, "I'd rather work for someone who is also trying to find new ways of drawing and painting to be seen." She maintains a certain detachment from the genre which recognises her, admitting that she doesn't look at comics herself, finding them "too tired".

She also acknowledges the importance of membership of the Belgian collective Frigo, the force behind her Belgian publisher, Frémok. "The power of my group helped me to become experimental. Each person brings new ideas so you're always in the thinking process."

THIS PAGE:
From *Faire semblant c'est mentir,*
published by L'Association, 2006.

OPPOSITE:
Maison Bleu, Nuit from *Les Hommes-loups,*
published by Frémok, 2010.

She guards the creative freedom pivotal to her individual expression, constantly exploring and evolving an organic process not constrained by timescales or restriction of media, scale or format, and often spontaneous. "I never make drafts. I will do the same drawing ten times if necessary. After a while I know what I want."

As well as searching there is playfulness in her approach and a pleasure in the physical process of drawing. While many of the recurrent symbols she uses have direct metaphorical meaning, others such as grills and the chair derive from, "the pleasure of repetition, of making pattern". Her involvement with her work clearly satisfies on many levels.

Fuelled by new experiences Dominique enthuses over an inspiring project in which she worked collaboratively with a young man, Dominique Théâte, who was physically and mentally disabled by a motorbike accident. Together they made one of the five pieces that constitute *Match de catch à Vielsalm* (Frémok, 2009), "a simple story of love and fighting", a fusion of ideas, drawing and labour. The project, which paired four Frémok artists and the Italian cartoonist Gipi with five artists with mental disabilities from the Centre d'Expression et de Créativité La Hesse in Belgium, reveals her humility as an artist and her genuine drive to push boundaries within work practices, a desire to be open to discovery. "I took great pleasure from going. There was great energy there."

Dominique speaks about her work with passion and vitality. There is an analogy between her ongoing journey of creative discovery and the process of involvement implicit within her non-linear narrative *Les Hommes-loups*. "It's like a corridor leading to a room. That leads to new corridors and then onto new rooms. It goes on and on and there are always new things to find."

Dominque Goblet was born in Belgium. She lives and works in Brussels.

THE ASCENT BEGINS IN THE EARLY MORNING. MY WATCH SHOWS 5:10 AM. THE WEATHER IS GRAY, THE ROCKS ARE SLIPPERY. IT'S DRIZZLING. TO AVOID GIVING IN TO ANXIETY, I CAST MY MIND AROUND FOR REASONS TO BE GLAD. DON'T REALLY FIND ANY.

EACH STEP THE HORSE TAKES CAUSES MY POORLY TIED BAGGAGE TO SWAY, AND LOOSENS THE ROPES.

IT'S BARELY A QUARTER TO SIX WHEN I HAVE TO COMPLETELY UNLOAD AND RELOAD THE HORSE.

I START OVER AGAIN TWENTY MINUTES LATER.

I START OVER AGAIN FORTY-FIVE MINUTES LATER.

I START OVER AGAIN TWENTY MINUTES LATER.

I START OVER AGAIN THIRTY MINUTES LATER.

AND AGAIN.

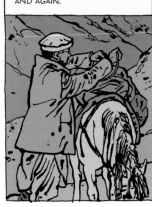

AND AGAIN.

AND AGAIN.

AND AGAIN. WITHOUT EVER GETTING THE KNACK OF IT AND GETTING IT TO HOLD IN PLACE.

Emmanuel Guibert

PARIS | FRANCE

"It's quite a solitary activity. When you throw yourself into difficulties, into jails, you have chosen to do it. If you want to have fun, you can also ask that of yourself. You can entertain yourself, scare yourself, bore yourself – it's a universal sensation for which you're responsible."

THIS PAGE:
Sketch for *The Photographer.*

OPPOSITE PAGE:
Artwork for *The Photographer,*
published by First Second, 2009.

Emmanuel Guibert was born into *bandes dessinées*, as comic books are known in France. In the 1960s, when the climate in the country was less favourable towards children reading comics, he benefited from access to a collection that his father had accumulated before he was even born. Emmanuel laughs and says, "The universe of comics was already there waiting for me. I had a complete crush from the beginning." The imaginative child made his first foray into graphic literature before he could read or write, creating his own comics with speech bubbles and pretend words. He reflects upon the compelling nature of this early engagement. "When you discover, as a child, that you are deeply attracted to an activity, you put yourself into it with a passion that is completely thoughtless, a pure appetite. When you do so, you're defenceless. You just throw yourself into the river and the feelings are very violent."

Emmanuel describes the potent, magical processes of creating images, "the sensation of power which quickly turns into frustration", and it is clear that his addiction to this excitement continues to rage and give momentum to his work today. "As a very young boy I never fulfilled my dreams or achieved what I wanted to – the mix of pleasure and frustration makes the passion survive. The scale of pleasure I now find in my work and the scale of pain and frustration I sometimes have to face are directly linked."

Emmanuel's life as an illustrator comprises long self-initiated projects combined with commissions that "come from nowhere". Critically acclaimed books such as *Alan's War* (First Second, 2008) and *The Photographer* (First Second, 2009), which between them have earned him countless international awards, are interspersed with more ephemeral commissions which he may only work on for a single day. This provides a balance, a chance to explore new approaches alongside the more arduous creation of enduring monuments of graphic literature; making *Alan's War*, for example, the celebrated documentary account of GI Alan Cope's experiences in World War II, culminated in 300 pages and extended over 10 years.

Stories are important to Emmanuel, from the copious novels he read as a child to the scripts he writes for the hugely popular *Sardine in Outer Space* series, also published by First Second. *Alan's War* quietly reveals the personality of one soldier dealing with the trials and challenges of day-to-day existence during a war. Emmanuel reveals the origins of this story in a chance meeting with an elderly expatriate American living in France, and the stories he told Emmanuel over many years about his wartime experiences. "I was

fascinated by the simplicity of what he was telling me and the capacity of these simple words to create very vivid images in my mind. This was the fuel for the very first drawings."

Emmanuel's intuitive inclination to turn the testimony of his friend Alan into a graphic novel launched him on a journey of documentation revealing the connection between author and subject that so powerfully infuses the book; it is the force of this connection, not the subject of war itself, that was the catalyst for his novel. "He could look at a life that was rich in feelings," Emmanuel recounts fondly. "It was a blessing to meet such a person, with the burden of age and all that implies, but who had the strength to face the future. This is the kind of nutrient I wanted to put into my books and to share. I deeply think that's important. They feed you, you should feed others."

Within his graphic novels he sees no distinction between fiction, such as *The Professor's Daughter* (1st English edition, First Second, 2007) written by his long-term collaborator Joann Sfar, and documentary narrative, explaining, "It's always fiction. I'm inventing, I'm recreating the past, but it's as close to fiction as it can be." From the slow journey of *The Photographer* across the harsh Afghan landscapes to the sometimes banal moments of Alan's life, the entertainment in Emmanuel's work comes neither from high drama nor revelation nor suspense.

His lavish, diary-like publications *Le Pavé de Paris*, *Japonais* and *La Campagne à la mer* (all published by Futuropolis), each bursting with observed drawings of their locations, reveal a curiosity about people and place as well as a mastery of media. These direct observations share the same function and process as fictional work; the content of the drawings is always carefully selected and his interpretation thoughtfully revealed through a well-crafted image. The reader always has space to make their own reading of the narrative. Emmanuel acknowledges that some of his readers may find his books too quiet, but that for him "there is a kind of hypnosis" in their creation. As he reflects, "Maybe I'm too easily charmed by stories about human beings, but for me that's what life is about."

OPPOSITE PAGE:
Visuals for *The Professor's Daughter.*

Cover, *The Professor's Daughter*,
published by First Second, 2007.

THIS PAGE:
Drawings from *Japonais*,
published by Futuropolis, 2008.

Portrait and studio photography by
Paul Duerinckx.

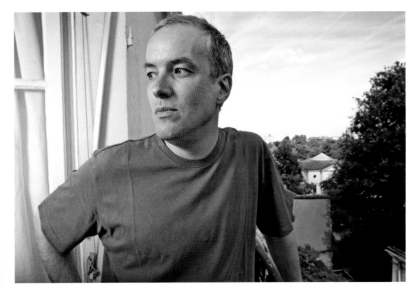

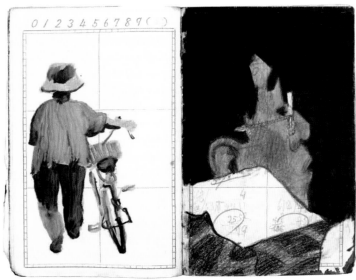

EMMANUEL GUIBERT

Emmanuel is not tied to one medium or approach. The search for a visual language to realise *Alan's Story*, for example, culminated in the discovery of the remarkable 'drawing with water' approach, a precarious process involving drawing onto watercolour paper with a water-filled pipette, which he domesticated by adding ink so that the grainy line magically appears – an approach metaphorically parallel to that of giving memories a tangible form. This is underpinned by a supreme confidence in both the visualising and composing of images, gained by a lifetime of observing and drawing in sketchbooks, as seen in his Paris, Japan and Normandy publications. *Alan's War* and *The Photographer* are works of documentary fiction, but they draw completely upon this skill in observation and the confidence in editing, selection and description that comes through extensive and continual drawing from life.

Emmanuel is careful not to let the sometimes necessary use of photographic reference, mainly for historical or technical accuracy, intrude upon or disrupt the flow of reading, and restricts the visual clues he provides to convince the reader. He explains, "I'm searching for details to give myself, first of all, and then the reader the sense that I'm in the right period at the right moment, to create reality and truth. The rest I invent – people and places." He reflects on the construction of imagined reality, stating, "That's one of the privileges of comics. In the movies they're actors, they pretend to die. In comics when they die, they die!"

He works systematically within his biographies, creating a transcript of interviews. These become the foundation of a book, evolving into a script with dialogue and captions. He compartmentalises each process, being sure not to regulate or inhibit the text because of any demands this may place upon him later in his role as an illustrator. "I prevent myself from drawing when I write. I don't want to have any idea of the problems I will face before I draw." He draws pages in the order they will appear in the book because he

"wants to have a feeling of accumulating experience", revealing that "it would confuse me to know the end before the middle".

OPPOSITE:
(top row and bottom left)
Artwork from *La Campagne à
la Mer, Guilbert en Normandie,*
published by Futuropolis, 2007.

(centre and bottom right)
Drawings from *Japonais,*
published by Futuropolis, 2008.

THIS PAGE
Cover image: *The Photographer*
published by First Second, 2009.

From *Alan's War*, published by
First Second, 2008.

Emmanuel's search for the ideal way of presenting a sequence to the viewer – "I have to find it" – results in pages of carefully considered compositions and viewpoints, of which only some make it to the final novel. His ultimate aim, to convey the narrative compellingly whilst balancing one frame against another pictorially, is achieved by fastidious quality control. "The process of learning the job of a graphic novelist is learning to put more sheets of drawing into the rubbish and not being afraid of doing so, and digging more and more into the images until I find what I imagine to be the best for what I'm trying to say."

He says that some drawings are "given to me", but that mostly "I'm always ready to follow my hand when it brings me unexpectedly good surprises, leading me far from the original idea. That fortunately happens quite often." He only moves in a forward direction, saying, "The only reasonable thing you can do is your best at each stage, knowing that at the end there shouldn't be any unbearable drawings – unbearable according to your own standards. Some unbearable drawings can make the authors cry tears of blood and be perfectly fine for the reader, and vice versa!"

The stories Emmanuel turns into novels are multilayered; their humour, pathos, joy, sadness and tenderness reflect the warmth of a man whose great perception and skill as a storyteller and an artist will endure. "If you receive a commission editorially or even for a children's book, you know it will be soon finished. When it's a graphic novel it's a longer journey. You may have thought about it for years, although that's not always the case. It's both exciting and scary. I know that every day, rain or shine, I have to do my best. I like being this way, with the responsibility of knowing there's a craft waiting for me.'

Emmanuel Guibert was born in Paris, France. He continues to live and work in the city.

TANYA LING

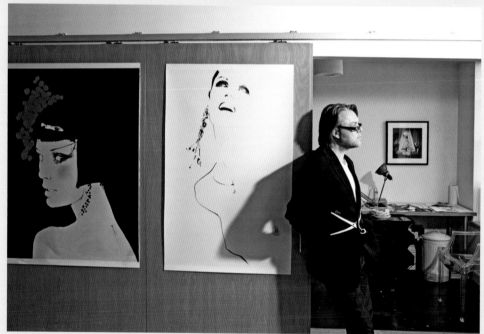

DAVID DOWNTON

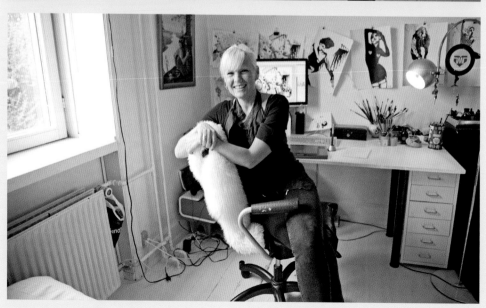

NAJA CONRAD-HANSEN

Fashion Illustration

Fashion can be depicted by illustration. Through its application to clothing and artefacts it can also contribute to fashion.

The client's perspective: Abraham Thomas - Curator, Designs, Word & Image Department, Victoria and Albert Museum.

The power of fashion illustration has always been rooted in its profound ability to carve out a 'space inbetween', to bring form and definition to those thoughts, gestures and moments occupying the gaps left unexplored by the premeditated shutter releases of the photographer's camera.

Drawing offers a freedom to examine texture, detail, colour and materiality in a way that photography often cannot. Illustrators tasked with recording a catwalk presentation rarely complete their drawings during the event itself, often scribbling down what details they can in the form of rough sketches before working them up afterwards into finished drawings. One might argue that this inherent layering of the creative process, the gestation time between that initial snatched glimpse and the final interpretation, offers the illustrator valuable space in which to pause, breathe and allow for a period of contemplation and filtering. Through a process of subjective yet judicious recollection, the drawing is allowed to align itself with those subtle inferences and suggestions inherent in both the garment itself and the overall vision of the designer. These are qualities which can sometimes be lost in the instantaneous 'click' of the camera shutter.

In the context of the atelier presentation, the relatively simple apparatus surrounding an illustrator – paper, easel and drawing materials – invokes a sense of intimacy and immediacy which is often impossible to attain when dealing with the bulky equipment and set-up times required for a traditional photo shoot. As opposed to the photographer who finds him or herself trapped behind the viewfinder of a camera, the illustrator has the luxury of maintaining direct eye contact with the model, without worrying about any such physical barriers, and is thus able to initiate a dialogue and relationship with the sitter which brings out the delicacy, grace and poise that characterise the greatest examples of fashion illustration.

Of course, illustration shares many values with the nuts and bolts of the design process within fashion. Through the act of drawing, a designer embarks upon those tentative explorations into the early stages of a new collection. The common skill of draughtsmanship allows both designer and illustrator to follow similar lines of enquiry. With today's focus on the overall brand of a designer, rather than simply the details of form and cut, perhaps it is illustration's ability to subtly delve beneath the surface, to meditate upon the implicit qualities of a designer's message, that will drive the medium forward in a world dominated by more instantaneous forms of image-making.

ABOVE:
Portrait by Derek Brazell.

LEFT:
Photography by Andrea Liggins,
except David Downton by Paul Duerinckx.

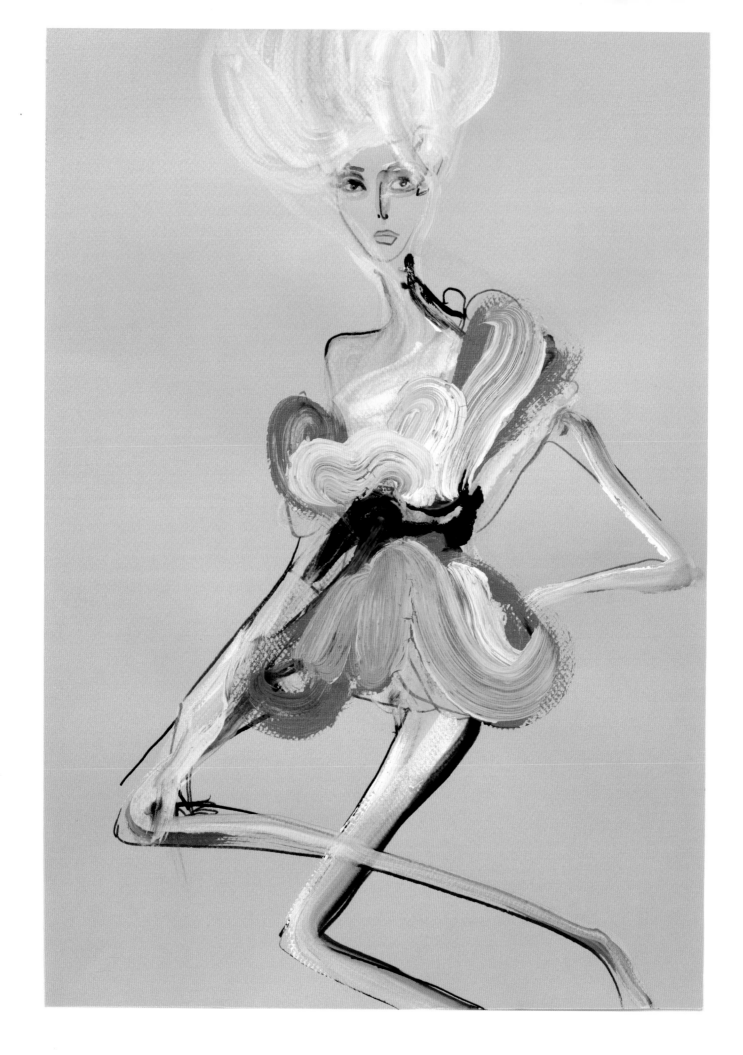

Tanya Ling

LONDON | UK

"I draw so much and so often, and my work's not conceptual — it is very intuitive, and I just go into automatic."

With a distinctive exuberant line, Tanya Ling has painted and drawn for fashion, beauty and portraiture, even painting directly on to dresses, whilst also creating works for gallery shows and designing womenswear for her own line and collections for the Veryta Foundation. Pale ink wash may be employed to produce minimal, sometimes androgynous imagery, or paint used for more dramatic, sultry and playful pictures. Many fashion houses, including Louis Vuitton, Yves Saint Laurent and Jil Sander, have engaged her to bring an additional aesthetic to presentations of their collections and products.

OPPOSITE:
International Ready to Wear Series, Lanvin Ready to Wear Spring/Summer collection, 2010. Mixed media on paper, January, 2010.

ABOVE:
Painting created at House of Viktor & Rolf exhibition, Barbican Gallery, London, UK, 2008.

As an only child in a family that frequently moved around, Tanya started drawing people for company, forming characters with their own ongoing stories. "It was a comfort thing," she says, "and then in the end it became what it still is now, like a visual diary. It became the way I express myself." Visiting exhibitions and museums as an older child she realised she was attracted to the clothing, while music culture and its attendant dress codes influenced her as a teenager. "I've always liked extremes of high and low culture," she says.

Having announced that she would like to study fashion, Tanya's father researched the best college to go to, "because he thought it was a bit of a silly thing to do and thought it must be a bit tough to do it". College emphasised that designing was about ideas and that these should be expressed in an articulate way. "The quickest way to do that is obviously to be able to draw it down." In life drawing, students were encouraged to draw a classically long figure, and Tanya's angular, elongated figures developed through this into her intuitive style of drawing, though she emphasises she has always been intrigued by the person's character — the face and eyes.

After graduating, Tanya designed for a period for Dorothée Bis and Christian Lacroix in Paris, before returning to Britain to raise her young children. However, she continued to draw every day in sketchbooks "that piled up in the corner of a room, just like if you're a writer, you keep a journal". Work then created on loose sheets was exhibited in London in 1996, prompting *Vogue* to ask if she'd consider doing some fashion illustration for the magazine. Though not having contemplated illustration as an option during her work in fashion, Tanya said yes, not thinking that it would become a full-time career, but once further offers started coming in she found she had a passion for the work.

Her images do not represent the perfect woman and avoid the archetypal fashion look. She describes the women she depicts as quietly powerful characters that offer a combination of "cheekiness mixed with

157

TANYA LING

THIS PAGE:
International ready to wear series,
Louis Vuitton, 2009. Medium: acrylic
paint and ink on paper.

Portrait and studio photography
by Andrea Liggins.

melancholy". She is not necessarily looking to fashion to inspire fashion imagery. "It's everything else that's going on. I love meeting different people, and you always learn something from everyone you meet." She will observe people and what they are wearing, though not in any systematic way, allowing inspirations in the work to arise organically, trusting that it will "still hopefully have my poetry in there. It's all a bit of a mess how I do things." She's happy to work in complete chaos in her garden studio, with pens and papers everywhere, but she's still in control, always knowing if something's been moved. Visually aware of her working environment, she says, "It almost becomes like a landscape."

Tanya produces her work rapidly, using a deft line, not looking at the image much during its creation, but she will return later to assess the piece, sometimes turning the work upside down to check the balance. Artwork will be started with whatever is to hand – ink, watercolour or acrylics – and she does not plan how the figure will look, nor work out backgrounds; characters just develop under her hand. There is a quirkiness to her women, usually revealed face on, languid limbs bent and folded, gazing directly at the viewer, with hair an important accessory, expressing the characters' moods and feelings.

Reference or models are not required. "I don't physically need somebody there," she says, believing that when observing her characters' faces, viewers may be able to discern that she is originally Indian, but trained in the West. For fashion assignments, Tanya will either be sent the clothes, go to draw the garments on a model, or be directed to images online – she does not have a preference.

A good art director, having chosen her to do the commission, will ideally let her "do my thing", and she certainly feels that overdirection can be a negative factor. The art director's biggest decision is to select the right illustrator for the job, "a bit like when a casting director chooses a model, I guess, or when a stylist is hired." She listens to the client, hears "what their dream is, and what they want it to be like. Then normally I'm given the go-ahead to just do it. Sometimes it will be more graphic and sometimes more abstract." The client may indicate that they require a minimal line image, or one of her more intense painterly illustrations, depending on what the artwork will be used for, but clients often seek to capture a mood, a character, a person, an expression with her work. If they refer to previous work, Tanya will make a point of emphasising that the resulting imagery will not be the same as anything else she has done, and that they need to respect that.

THIS PAGE:
(above)
Design drawings, 2010.
(below)
Created for and reproduced in the *Elle Trend Report* Spring/Summer, 2001. Executed: 2000.

When commissioned, whatever she starts will be the finished piece – "I don't do roughs, everything's a rough! It is just what it is" – and if the client is unsure of the result she will rarely work over or erase elements, but instead redo the artwork. When painting or drawing her own work she may keep working at a piece she is not satisfied with, but can reach a point where it is torn up or even walked on. "I can get very aggressive very quickly, and just chuck loads of work away. I'm learning to give it a bit more of a chance."

Commissioned to develop a print consisting of lines of paint for Louis Vuitton's Cruise collection in 2009, she was subsequently asked to capture the atmosphere of the collection in images which were blown up onto canvases to accompany the press launches around the world. "I was given carte blanche just to be Tanya, and that was wonderful, because they completely got it. Therefore the clothing itself wasn't technically correct, in a way that a draughtsperson would do it right – it was obviously what it was, and nothing else. They were paintings really." This is what she loves about being a fashion illustrator, being the photographer, the model, the hair and makeup artist, having the entire visual entrusted to her.

Drawing live is an invigorating experience for Tanya, and in 2009 she documented a model changing into many outfits on stage at a Victoria & Albert Museum event celebrating the 25th anniversary of London Fashion Week. "I enjoyed that. You really know that you're alive," she says, likening it to being an actress, street artist or busker. The speed of execution required did not phase her. "I like it on the brink of disaster, that 'if you don't get it done now' sort of thing." She has also made works at a Viktor & Rolf show at the Barbican Art Gallery in London, where she laid out her own personal space with easel, paints and pots, "and then just got stuck into it, like I would in my studio". This adrenalising live work puts her in a zone where observers will not distract her, and her spontaneous approach works well in this context, with the resulting images displaying drips and fast brushwork.

Veryta, a non-profit foundation set up by Yves Saint Laurent Creative Director Stefano Pilati, along with Filippo Binaghi, CEO and Designer of Italian silk-weaving company Lorma, approached Tanya to be their Creative Director and design collections for them, a percentage of sales from which would go to the foundation. In addition to designing the clothing, Tanya took her artistic expression a step further and painted directly onto 20 of the simple silk dresses, daubing, dotting and forming abstract shapes, making a canvas of the garment. Many would be daunted applying to such a surface, but "There I was, painting on the most beautiful fabric in the world – I just loved it. That's my thing," Tanya says, laughing, "making a mess that doesn't look like a mess in the end!" pointing out, with her easy candour, that one combination of colours looks like vomit, "but does still look very elegant".

Creativity is an essential part of her life, and Tanya draws constantly. She aims to continue painting large-scale personal pieces (which she may exhibit) alongside illustrating and designing. She values the emotion and spontaneity in her mark-making, and although aware that not everyone will understand her work, she appreciates that those who do (and her impressive list of fashion clients testify that there's many who do) very much enjoy her novel characters and the attitudes they convey.

Tanya Ling was born in Calcutta, and spent her childhood in America, Africa and England. She now lives in London in the UK.

OPPOSITE:
Nars Face Chart. Ink on paper, 2009.

ABOVE:
Veryta Collection, painted dress in Tanya's studio, 2010.
Photograph by Andrea Liggins.

Veryta Collection, painted dress, 2010.
Photograph courtesy of the artist.

David Downton

BRIGHTON | UK

"Working as a fashion illustrator has totally changed my life. Wherever I go and whatever I do, I think, 'This is where drawing got me.'"

It is easy to picture the successful freelance career working for magazines, publishing, design, with a contented professional lifestyle, "wagging my tail every time the phone rang", when out of the blue comes a momentous commission to draw at an haute couture show in Paris. This changed the life of David Downton, launching him without preparation into the rarefied world of fashion illustration. "I thought it was a one-off," he recalls, "that I'd come back with good dinner-party stories." Instead he is now well respected for drawings that report with verve and panache on the glamour behind the velvet curtain. He describes the experience as daunting, "like being on Mars", but also intoxicating, thrilling, invigorating, exotic. "Drawing at fashion shows is like going behind enemy lines. It's stressful and difficult. You have to learn about the hierarchy and the rules. You wait for an hour and a half for the show, and it's over in 10 minutes. The culture is one of 'Hurry up and wait'."

This commission was the lightning bolt awaking in him a new ambition. Attitudinally and aesthetically a new career was launched. "I became focused and fearless. Everything came into alignment because I had something to work towards." The impact of this invigorating opportunity is evident in subsequent commissions that have sent him around the world to produce art depicting the world's most beautiful women. It is not an understatement to say he loves his work, the people he draws and the world of couture. He continues to be enthralled and fascinated by the spectacle, rhythm and tensions of the fashion show.

"It would be disingenuous to say I knew nothing about fashion," he reveals, although he is honest in admitting that he isn't interested in fashion per se. He recalls an incident when after a show he was brought a garment on a hanger to observe more closely. He laughs about the irony of this, revealing that "to me it looked like curtains", before adding that, "Couture is art. Lacroix makes garments which are

ABOVE:
Dita von Teese for *Pourquoi Pas?* 2008,
(a journal of fashion illustration).

OPPOSITE:
Portrait photograph by Paul Duerinckx.

163

LEFT:
Betty Jackson, preparatory sketches, 2008.

BELOW LEFT:
Final image for *Betty Jackson*
for Debenhams, 2008.

BELOW RIGHT & OPPOSITE:
Sketchbook drawing,
Paris couture, July 2009.

Photograph of David Downton
and Jo Davies in artist's studio
by Paul Duerinckx.

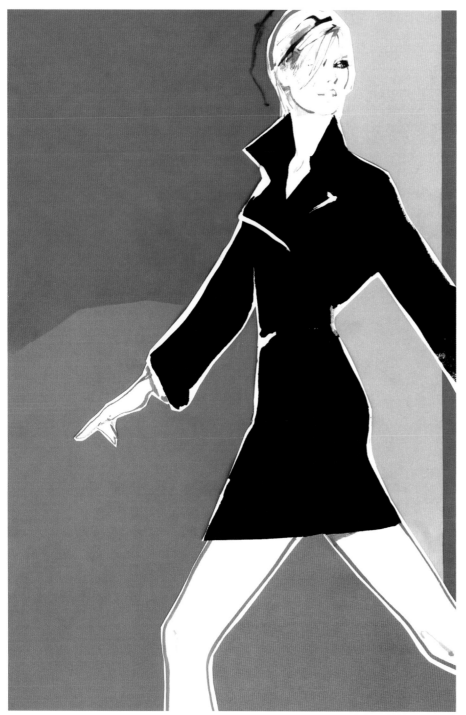

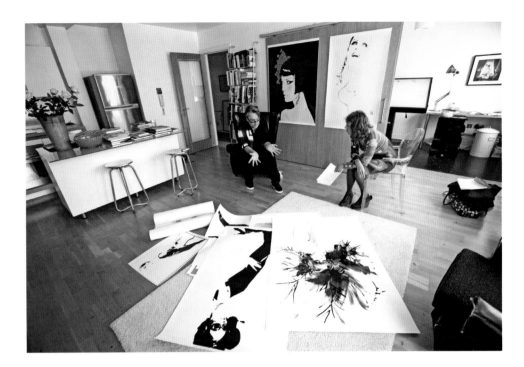

subtle and beautifully crafted, like pieces of sculpture, but for me it's how the garment reacts with the person and the body."

These people and their bodies are extraordinary, but progressively they have become part of David's normal life, which has led to him making some distinguished images epitomising the glamour and finesse of fashion. They don't pretend to be fashion drawings and equally they depict the beauty of an individual without being portraits. "That environment made my work what it is. If you are lucky enough to draw Erin O'Connor, then half the work is done for you. She's such an arrangement of shapes and angles, it's as though someone made her up. When I first saw her I thought, 'She looks the way I want my drawings to look.'"

It is fair to say that the couture show freed David up. Without the constraining commissions that had become his professional norm he began to work on a bigger scale, allowing the largesse of the subject to dictate the scale of his drawings. "This was fantasy. It couldn't be too over the top."

His briefs now come in from all around the world and are varied in their objectives. Sometimes it's the story of a model, at other times a round-up of a fashion show or a focus on the collection of a particular designer. He rarely draws at the shows, preferring to work in a sketchbook and to take photos as back-up work, drawing later in his calm and airy Brighton studio. He works fluidly with line, often choosing Rotring ink for its dense, solid, deep black. "I love the first flash of black on white. Black is so forceful it makes you decide. You can't just tickle it in." His drawings are calligraphic, as exhilarating as the shows themselves. Lines are seemingly gestural but deceptively controlled, conveying what he describes as an illusion of "controlled spontaneity", an attempt to instil the energy and thrill of a first drawing even though it is thoughtfully refined. He rarely does sketches for a client, striving instead to get it right for himself, admitting that this means, "I get a drawing that is successful and a drawer full of drawings that I don't like."

David's drawings of Cate Blanchett for the covers of Australian *Vogue*'s 50th anniversary issue were seminal, marking a triumph of illustration in a context that has long been the stronghold of photography. This work is reminiscent of a golden age in fashion illustration that David respects. Although portraits are a natural extension of his fashion work, David is nervous of the label. "Lucien Freud is a portrait painter. With me it's a lightning thing. I get one chance. I can't begin to understand the person in two hours.

165

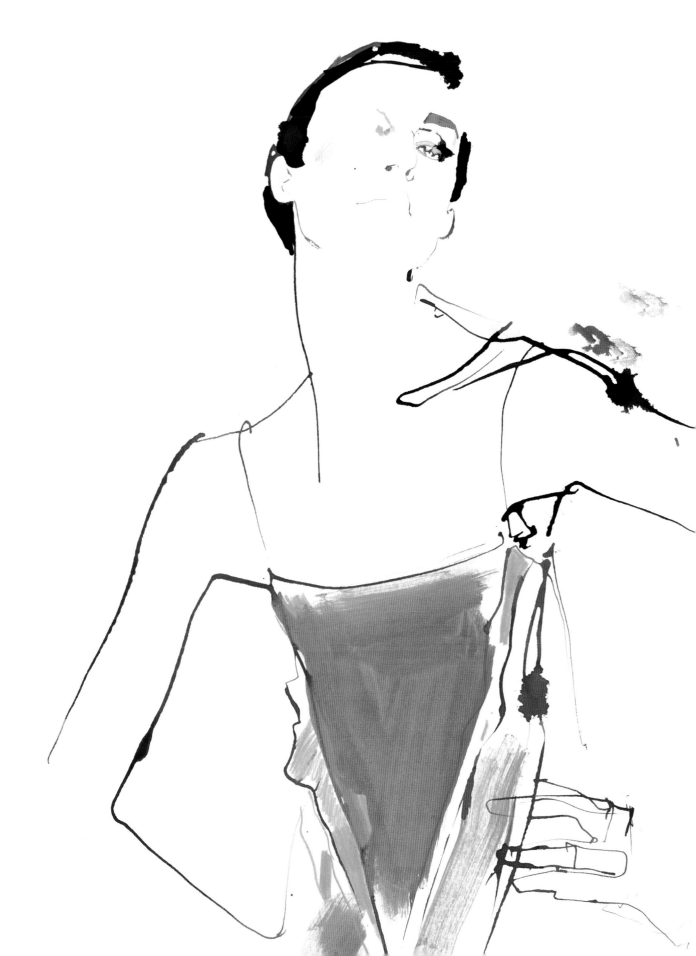

ABOVE:
Cover featuring Cate Blanchett for
Vogue, Australia, 2009.

OPPOSITE:
Erin O'Connor for Top Shop, Atelier, 2004.

That would be an insult to them. If you're Freud you work with them for a year." In common with his antecedents in the job he idealises his sitters, revealing what he refers to as "the varnished truth", drawings which stress the positive, making tangible his interpretation and perception of their appearance. "Beauty is much harder to draw because you have less to work with. W.H. Auden would have been a complete gift," he says, laughing. "That's the sort of thing I don't do much, but perhaps it's around the corner, beauty in a way that I've not done it before."

David wants his drawings to stay fresh, seeking the surprise of using new materials and continuing to work to achieve a precision in the economy of his mark-making. His approach to media and his systematic direction is dictated by the essence of the subject that he wants to convey pictorially. He may use watercolour for a more romantic Lacroix piece or adopt a more graphic stance for a bolder Gaultier piece. In same way as one of his heroes, "the genius" René Grauau, he is conscious of the framing within his drawings, often anchoring them to the page with solid areas of denser colour.

As well as his pictorial skills, David believes confidence is one of the most important contributing factors in the success he now enjoys. His confidence diminished during his art-school education and this impacted upon his rather reticent early career. "I had it knocked out of me, but now I'm more confident with my decisions, I don't prevaricate over things by wondering, 'Will it work?' Of course they don't always work and my confidence is misplaced, but I'm confident enough not to let that worry me and to do it again."

There's a romantic dimension to David's work, a sure sense that beauty has a supreme presence and power. In the context of contemporary fashion illustration this is an anachronistic quality. "I used to think of it as damming when people referred to my work as classic," he observes, "but I suppose it's true. My heroes all worked with an illusion of effortlessness that I'm also trying to convey. I'm not interested in pastiche, but someone called what I do 'contemporary nostalgia' and I love that description."

His magazine *Pourquoi Pas?* and his recent book *Masters of Fashion Illustration* (Laurence King, 2010) celebrating the history of fashion drawing, pay homage to the great artists whose lives were dedicated to the subject of fashion. "The past of fashion has resonance. It existed on an epic scale and I've loved celebrating that." These publications exist as an important archive of both the changing fashions of more than a century and the intertwined fashions of illustration.

David provocatively confirms that he has witnessed wonderful things "behind the velvet curtain", describing the highs of his involvement with couture shows as "fascinating" and revealing that eating cheesy chips with supermodels in his local pub is a "perk of the job". Through David's work we have a brush with the pure glamour of fashion. "When you see an amazing show it transports you. You don't have to know anything about fashion. It's just another world."

David Downton was born in Kent in the UK and now lives and works in Brighton. He is a visiting professor at the London College of Fashion, and in April 2009 received an honorary doctorate from the Academy of Art University, San Francisco.

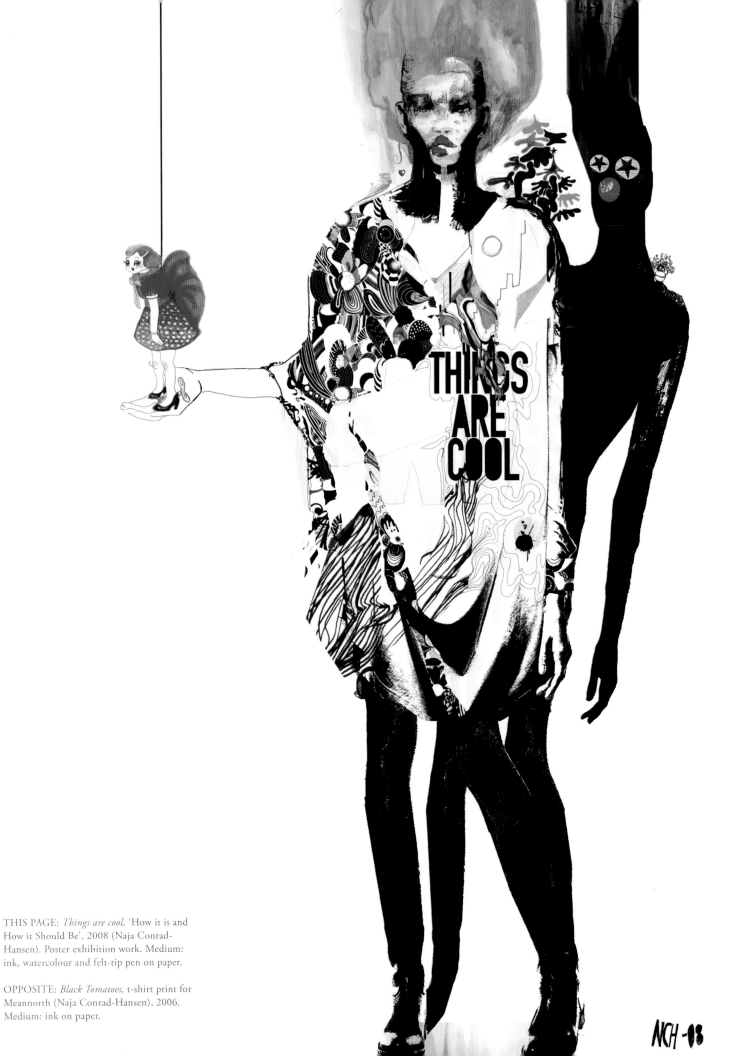

THIS PAGE: *Things are cool*, 'How it is and How it Should Be', 2008 (Naja Conrad-Hansen). Poster exhibition work. Medium: ink, watercolour and felt-tip pen on paper.

OPPOSITE: *Black Tomatoes*, t-shirt print for Meannorth (Naja Conrad-Hansen), 2006. Medium: ink on paper.

Naja Conrad-Hansen

COPENHAGEN | DENMARK

"In fashion I'm not interested in the clothes. It's more about the attitude and the themes of the designers, the ideas in the fashion. When I'm asked to do it for commission I translate their view of what they want, but this never gets in the way of creativity."

The impression one gets from the long-legged ladies striding and prowling across the picture planes is that they are in charge. Latently fierce they glare, sirens beckoning you into their world, enticing you with a dangerous sensuality. For fashion illustrator Naja Conrad-Hansen, living and working in suburban Copenhagen, these images are the epitome of her interesting life and have a genesis in her childhood when her favourite activity was drawing women wearing leopard-skin trousers, red lipstick and leading Dalmatian dogs. She laughs. "My passion was not for Barbie dolls but other kinds of dolls."

Despite her reluctance to follow in the footsteps of her mother, a successful painter in Finland, Naja has always made art that reflects her own life experiences. The seeds of her current work were sewn when she worked in an unfettered way as a fine artist in Berlin before the wall came down. "A significant period," she recalls, "it was an inspiring time. I was living rough in a caravan. There were great underground bars, a great creative scene. I was particularly fascinated by the '20s and I love *Cabaret*, which is set in Berlin – it has something elegant, enchanting and starry-eyed." The latter description matches her current work.

With agents in Berlin, Italy and the UK, Naja now works commercially for editorial, fashion and beauty-related clients, and exhibits her large art paintings. The distinctive, decorative images are populated with feisty, dominant women – archetypal in many ways – who could easily be cast in leading roles for a Bob Fosse production. They are potent extensions of Naja. She is also strong enough to achieve such success in a competitive market, absorbed in her work whilst keeping a balance of family and professional life. She laughs. "I don't think I'd admit that," she says. "I'm a double personality – in charge, the captain – and then I'm insecure about the world, especially during the process of making work. The double thing is an exciting part of it. I give my women strong attitude so that they're not only sweet. I like the fact that they reflect that women have the choice of also being powerful in their lives."

169

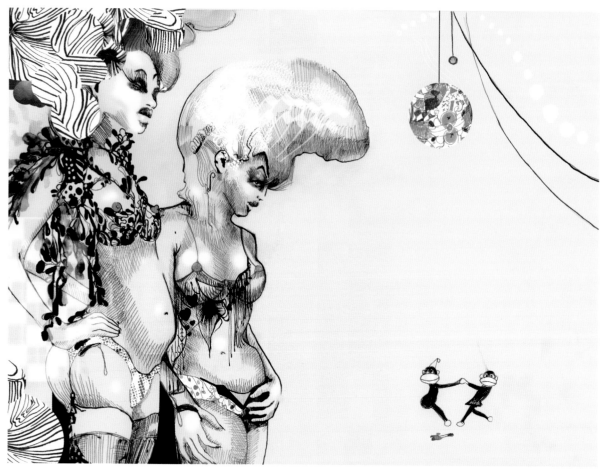

THIS PAGE:
LEFT:
Rock Me Amadeus 1, published by Grafuck Books, 2007. Medium: ink, watercolour and pencil on paper.

BELOW:
Portrait photograph by Andrea Liggins.

OPPOSITE:
Working process 1–4.
Photographs courtesy of the artist.

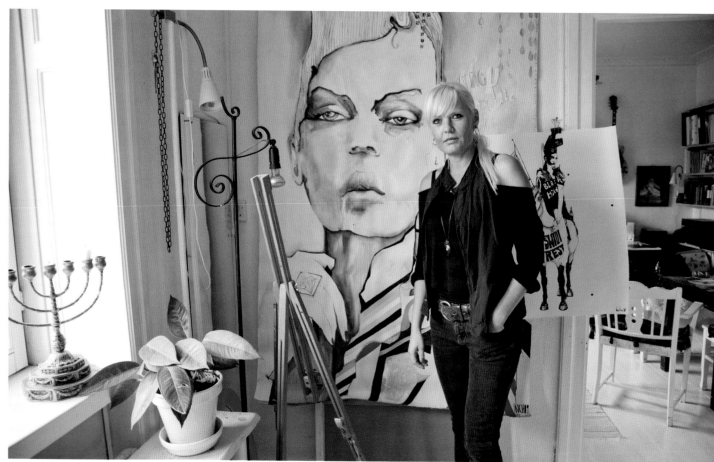

Sometimes her images are of monumental women, sometimes simply a highly decorated face. There are figures in circus poses, often dripping with a watercolour bleed. The illustrations are reminiscent of the Vienna Secession, combined with 1970s Op Art, with a flavour of *Bizarre* magazine. They are often edgy and taut with drama, and this oddness can largely be attributed to the distortion within the figures. During her early career Naja used pieces of collage to construct characters with mismatched, exaggerated features, and these became the basis for her illustrations. "Now it's not conscious," she explains. "My characters draw themselves. They just want to look like that." They are invented and seldom based on people she knows. In the early days she did a lot of figure drawing, but she now draws entirely from her imagination or uses photos as reference. "They start their own life off when I draw them. They start to look at me and they just become unique, independent people. Sometimes they have their own way too." She often talks about her work in this way, as though it has an existence independent of her, a magical quality that it is her job to harness and respect. "When I'm most enjoying working it feeds me," she says. "It's like a conversation."

Despite her success for high-end clients like Max Mara and Fiorucci, the impetus for Naja's work continues to be provided by the reality of the everyday, rather than the unreality of a fantasy world of clothes. "I'm fascinated by fashion but it's not about that," she clarifies. "It may not always reflect in what I do, but I need to feel a part of what is happening now, and also what is coming next. It's trying to look into the future to see how the world will develop how the occurrences of the news feed into it. I try to bring that through my pictures."

Naja has a firm foundation of drawing skills and media understanding which she uses to describe her creative vision. She also enjoys the physicality of the technical processes. "I love using my hands." When she studied at the Danish Design School in Copenhagen following the birth of her daughter in Berlin, she benefited from the opportunity to explore printmaking, textiles and surface pattern. The process of exploring is important and ongoing.

Many of her canvases, large-scale oil paintings, fulfil a different objective from that of the delicate A4 pencil drawings on her work desk. In her work as a whole, colour is used strategically and confidently, but black is the predominant ingredient in her images. Solid areas sometimes lie alongside fluid lines, interwoven with areas of dense tone made from built-up line. "My grandfather was a Finn who used to do posters for the cinema," she explains. "I was fascinated by his work as a child. He always used a lot of black in them. I love black. It holds magic for me." Through the beauty of opulent gold paintings, lavish decorative surfaces, and controlled but sumptuous watercolour washes, Naja reveals her enjoyment of materials. She revels in the tactile quality of a large piece of watercolour paper, which she says, "makes you fight with it".

However her work is defined – either by her technical approach, the content, the function or the client who commissioned it – the magic it embodies is a thread tying it together. Sometimes the images are

awkward or mysterious, with their repeated symbols, such as the incongruous monkey who brings a sense of odd disquiet. She laughs at this suggestion. "The monkey is a comment about being human, how ridiculous things are, how unnecessarily serious things become. When I become too self-conscious I put him in. It's a way of making fun of strong attitudes." The use of text is another feature of her more graphic work, and she refers to Saul Bass as an important early inspiration. Naja keeps a sketchbook and reveals that it is full of words. Unlike Bass she sees her words as purely pictorial elements – shapes and textures that marry with the other content in the image. "Sometimes there may be a line of text in my work but I hide it so that you don't know it's there." She laughs provocatively, saying, "Maybe a secret poem."

One of the categories on her website is Fashion Fiction, and this succinctly describes the personal work she produces, using characters to play out subtle narratives. She says she loves reading, and that "Stories are fantastic because they give you pictures for free." It could be that the excitement of the crime genre she enjoys permeates into her images. "They can become the basis for things," Naja admits. "It goes in, so it's got to come out somewhere." There can also be a dramatic stillness – a tension between the elements – which suggests something is about to happen. She reflects that this may be a consequence of her love of black and white film, which contradicts itself with its drama and what she describes as "the empty rooms between the black and white".

Although Naja has never drawn for couture shows, the majority of her work reflects fashion and she enjoys working commercially within the genre. "It's my dream job," she says. The global nature of commissioning means that Naja is chosen for particular work that suits her. Although, as she points out, "Clients know what they want but they don't always know what they can get," she sees working to briefs as a part of her ongoing development. "You can get blinded when you do work for yourself. Clients sometimes see other things – you can put something new in, better than you may have thought of yourself." Although she is aware of the danger of "burning out", not running out of ideas but becoming worn out in a physical sense, she always tries to "give a bit extra" to commercial work. In the early days she would often present two versions, one that satisfied the brief and an alternative version containing more of herself.

Reflecting on the career to which she gives so much she says, "It is more than a job, it is my obsession," adding, "Horrible when you think about it, but wonderful when it works."

Naja Conrad-Hansen lives and works in her native Copenhagen.

LAURA CARLIN

OLIVIER KUGLER

MATTHEW COOK

Topographical/Reportage Illustration

Despite the facility of lens-based technology, illustration continues to be valued as a way of providing visual documentary. Describing a sense of place is central to the practice of these illustrators.

The client's perspective:
Martin Harrison,
Senior Designer, The Times, *UK*

An illustrator who is able to cover a live event quickly and accurately, especially one in a foreign conflict that might be full of danger, is rare. Throw in the pressure of newspaper deadlines and editors' quirks and you are looking at a very small pool of specialists.

Of course, the pressure of these situations can also be a sharp reminder of the true value of the illustrator's art. Drawing the truth can become the reason for living, as Ronald Searle discovered when he documented the most hellish aspects of Japanese prisoner-of-war camps, and his fellow prisoners' hourly fight for life.

The Times newspaper's association with particular war artists has sometimes developed from an earlier commission recording the production of the paper. But it has been through these 'safe' commissions, which nevertheless require sharp observation and quick reactions, that one can spot an illustrator who can not only draw well but has an eye for a story.

In the 1980s Linda Kitson boldly caught in pencil the energy of producing *The Times* in the days of hot metal. As a result of this she covered the Falklands conflict for the Imperial War Museum. Matthew Cook undertook a project documenting daily life on *The Times* in 1997. This was so successful that the paper sent him to follow the coalition forces into Iraq in 2003.

But you don't need a war to produce exciting foreign reportage illustration. The travel pages can be a challenging and rewarding subject for the artist-reporter. I sent Matthew to walk the coastal path of Cornwall and to record the architecture of rural Tuscany; Jane Webster accepted a commission in Marrakesh to draw its markets, vibrant street life and labyrinthine souk.

From 2009 until mid-2010 I supported the brave endeavour of a very talented young reportage artist, George Butler, who drove from London to Libreville in Gabon, Africa. Editorial space in the paper is very restricted, so George posted a live illustrated blog at *Times Online*. George has had his share of dangers too: he managed to escape a serious kidnap attempt on the Algerian/Mali border. The drawing he posted of his escape was full of drama and intensity.

Photographs may be fantastic at capturing the moment, but a reportage illustrator can put something more into his news image: information that might have escaped the photographer's frame can be easily incorporated. Writing can form part of the image, explaining what is happening and identifying characters. And the drawing itself can capture the essence, or spirit, of an unfolding situation. And because we are so used to seeing photography, a drawing can be very arresting. It can surprise readers – even shock them. All of this contributes to the added dimension that a reportage illustration has, and that a photograph, too often, does not.

ABOVE:
Portrait by Derek Brazell.

LEFT:
Photography by Sylvan Grey, except
Matthew Cook by Andrea Liggins.

Illustrators may get downhearted about the lack of space given to drawing in newspapers and magazines these days. But the internet is global and immediate. George had a healthy following on *The Times* website. In a world dominated by agency photography, eyewitness reportage illustration may have a valuable role in 21st-century media.

175

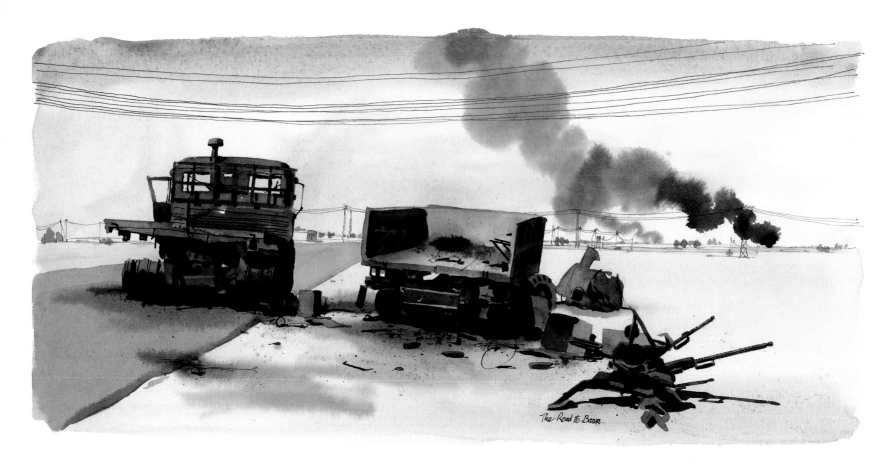

The Road to Basra

Matthew Cook

LONDON | UK

"Drawing under gunfire? At the time it seemed the most natural thing. It's only now that it seems the most bizarre thing to do. You have to be slightly obsessed to do these drawings."

Most illustrators value sketchbooks and will fill them with drawings from either their imagination or what's in front of them, but it is more rare for images from sketchbooks to be placed on the front page of newspapers or in gallery shows. However, this is where you may have seen Matthew Cook's reportage work from Iraq and Afghanistan, which has put him at the frontline of representing these conflicts. This reportage work has been an integral part of his life since he was four years old, introduced to drawing on location by his father. "Didn't matter if it was sun or wind or rain," remembers Matthew, "we'd go out sketching. And that introduced sitting down and drawing on location – regardless of the weather."

Matthew's commercial work has depicted picturesque English towns and countryside, sporting events, busy newsrooms, industry and portraiture, all created with his fluid use of watercolour, inks and line, and a distinctive approach to white space. His atmospheric use of light and skilful capturing of the movement and stance of people have contributed to a strong body of work that has been further enhanced by his reportage from conflict zones. Matthew takes the same approach to covering a game at Lord's cricket ground to that used to depict destroyed anti-aircraft guns on the dangerous road to Basra. "It's still finding something interesting, composing it in your mind, looking for a juxtaposition of figures or something quirky or funny."

Although he does not actively search for it, hindsight may reveal a narrative in a series of images, and individual pictures often hold a strong sense of place: those from Iraq and Afghanistan, for example, often capture the underlying tensions of a scene. Although Matthew reveals, "I've got to admit I'm the sort of person who goes out and draws frantically, and I don't give it any thought, I just don't have the time. Just get on with it." However, his years of experience have patently given him a built-in sense that enables concise observation.

THIS PAGE:
*ISAF (International Security
Assistance Force) mounted patrol
in Kabul, Afghanistan*, 2010.
Medium: watercolour inks.

Portrait photograph
by Andrea Liggins.

OPPOSITE PAGE:
*Destroyed trucks and anti-aircraft
guns south of al-Zubayr*, Iraq, 2003.
Medium: watercolour inks.

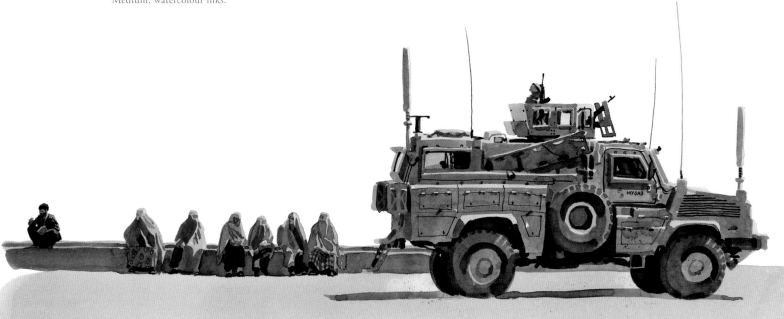

177

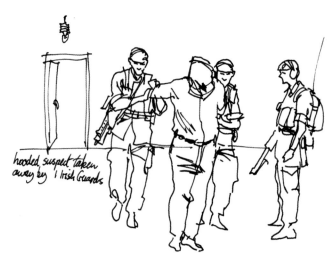

The Times first asked him to travel to Iraq in March 2003 to cover the invasion (he returned less than a year later as a mobilised soldier with the volunteer British Territorial Army), and subsequently he has travelled to Afghanistan in 2006, 2009 and 2010. His drawings and paintings from these trips reveal life on the ground for the soldiers in both countries, as well as for the citizens of Iraq, with whom he was able to mix before it became too dangerous for him to travel alone. Sending images back to *The Times* from Iraq involved a convoluted daily process of scanning into a laptop using his hire car's cigarette-lighter socket, and sending through a similarly powered satellite phone connected to a dish on the car roof – a potentially dangerous scenario to be caught in for a lone traveller. As a soldier Matthew found his choice of locations was more restricted, a source of frustration when compared with the freedom of driving around in a hire car, and going wherever there seemed to be something happening.

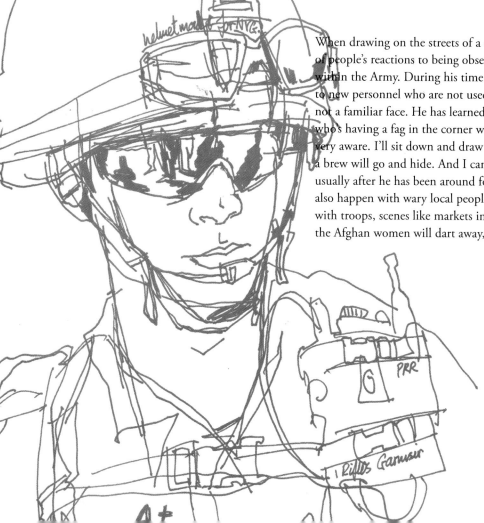

When drawing on the streets of a country with a foreign military presence, Matthew has to be conscious of people's reactions to being observed as they go about their business. This also applies when working within the Army. During his time in a country he is moved around from place to place, being introduced to new personnel who are not used to him, and soldiers and Army crew can be very self-conscious if he is not a familiar face. He has learned not to start by using a camera. "If they're working on aircraft, someone who's having a fag in the corner will go, 'Oh God, I can't smoke here, he's taking photographs.' So I'm very aware. I'll sit down and draw first, everyone will be a bit stiff, a bit self-conscious. Someone having a brew will go and hide. And I can just see them thinking, 'Oh shit, I'd better be working.'" However, usually after he has been around for a while, just drawing, people relax. The same self-consciousness can also happen with wary local people, who may disappear if they spot Matthew sketching them. If he is with troops, scenes like markets in places such as Afghanistan can be hard to capture naturalistically as the Afghan women will dart away, leaving just the men and inquisitive children.

THIS PAGE:
Irish Guards searching suspect's bedroom, Basra, Iraq, 2003. Medium: pen.

Suspect being taken for questioning, Basra, Iraq, 2003. Medium: pen.

Platoon commander in Garmsir, Afghanistan, 2010. Medium: pen.

OPPOSITE PAGE:
Checkpoint on the Jalalabad Road, Kabul, Afghanistan, 2006. Medium: pen and watercolour.

Afghan elder at a shura (consultation), Malmul, Afghanistan, 2006. Medium: pen.

Creating artwork on the move can be a challenge, and his four- or five-minute line sketches in black pen are those images that best capture the immediacy of a moment – for instance, soldiers searching a room or returning fire during an attack (on one occasion Matthew sheltering in a ditch with them, still drawing). "Yes," he says, "I was aware my hands were shaking, and so was everyone else." Such situations require a rapid response, with events recorded quickly, then it's back into the armoured car and off somewhere else. For painting he'll carry just the primary colours, and where water rationing has been in place he's occasionally had to resort to urinating in a bottle for diluting paints - "It got quite basic!"

With art supplies being difficult to come by Matthew will double up on materials required: "two sets of watercolour inks, two sets of brushes, two sets of pens". He will use a white correction pen for adding writing on signage, enjoying the graphic look of Arabic script on signs or graffiti. Sketchbooks need to fit into a compact rucksack, and he'll use anything from tiny ones up to A3 size in the field. He will do a very rough sketch to position the image on the page prior to painting, indicating where a figure may go, but wind and heat means that liquid dries very rapidly, limiting the size of paintings.

These works capture light and atmosphere in a remarkably effective way, from a glowing torch at dusk to recreating the effect of looking into the direction of the sun, a viewpoint that increasingly interests him, as it can allow for heightened drama in the painting and the speedy creation of silhouetted figures.

His medium can still frustrate. "It's still a challenge, it still goes muddy, it still goes wrong. I don't think you ever become a master of it – it's a battle, you can't tell how a picture's going to come out, if it's a hit or miss." And he's aware of the potential interpretation of watercolours. "If there's a pretty row of cottages, I'll still like the electricity pylons behind. I'll like the two together. Never like anything that's too twee. Unless there's a real brief from a client, I'll still put in vapour trails and stuff going on around." As with most users of paint, splats will inevitably appear on artwork, and he does not try and stop that happening (though clients may remove them on occasions); sometimes he will use them for texture, adding to the grain of a wall or to indicate debris and dust.

On sketches Matthew will make notes about colour or the direction of light should he come to redraw it, and on the paintings he'll add notations almost as captions: "I like writing, it becomes part of the image. It looks a bit formal to me, a painting without some scratchy writing." He will also use photography for back-up reference, aware that some of the situations he is in are very fleeting, that he may never go there again. "It's a one-off glimpse, so draw, sketch, photograph, do everything you can – it keeps all of those options open."

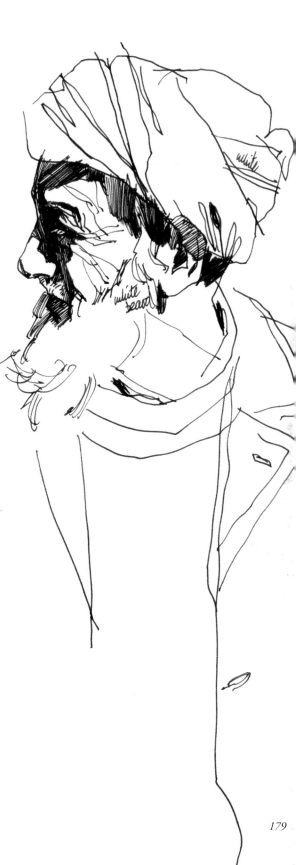

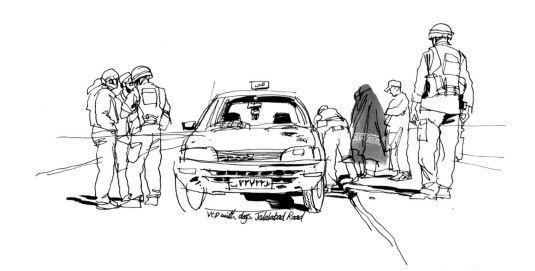

VCP with dogs, Jalalabad Road

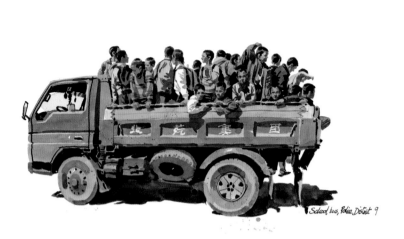

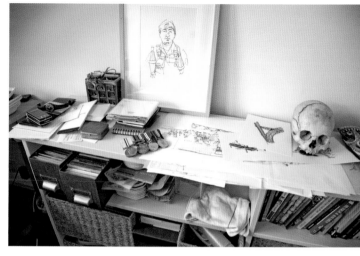

THIS PAGE:
School bus in Kabul, Afghanistan,
2010. Medium: watercolour inks.

Studio photograph by Andrea Liggins.

The Blue Mosque, Mazar-e-Sharif,
Afghanistan, 2006.
Medium: watercolour inks and collage.

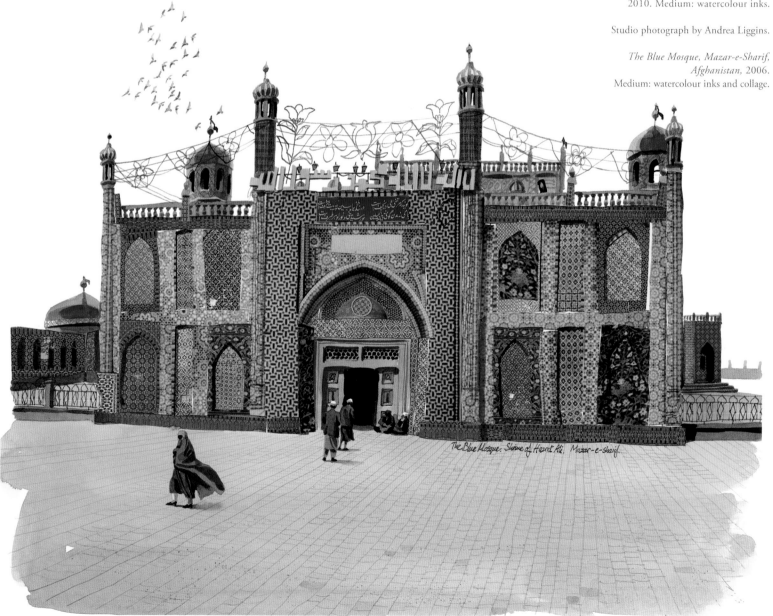

180

Matthew drops a subtle use of collage into many of his watercolours, using snippets from newspapers or other printed material – "they are tucked in all over the place" – to add another layer. *The Blue Mosque* is largely constructed from photographic images of patterned Islamic tiling, ultimately used as a solution to rendering a good likeness of the building. "I didn't know how to tackle it. I did some drawings on the spot, just samples of the intricate tiles. Really wanted to draw it, but it was so fiddly." This was solved back home in his rooftop studio with reference to the internet, resulting in a striking image of the mosque.

As with most artists, composition of an image can be flexible, though Matthew understands the importance of accuracy when he's reporting on a conflict. And with the National Army Museum having purchased over 30 of his paintings, historians will be looking at them in years to come, just as they do now with Crimean paintings. For reportage work and commissions he will search out an intriguing compositional viewpoint either to enliven a potentially mundane subject or to expand the scene, climbing onto roofs to take in the view from an elevated position. As he often leaves out backgrounds when composing from his usual eye-level view, this can offer an opportunity to expand landscape or architectural elements: "If I can get a different view, I'll always take it."

Though now used to tearing work from his sketchbooks, Matthew admits it's still a wrench selling some of his work. Even though he can be frustrated that his artworks may never turn out as they originally appear in his mind, having exhibited images from both the Iraq and Afghanistan conflicts, he's aware that any purchaser of a work will not have the memories that connect him to the artwork. This close association with what he is observing brings an intimacy to Matthew's reportage drawing and painting which places his audience directly in the situation, and gives them an opportunity to feel how life is for the soldiers and citizens during a military conflict.

Matthew Cook was born in Epsom in the UK and now lives in London.

BELOW:
*Urinals next to perimeter wall at FOB
(Forward Operating Base) Argyle,
Nad e-Ali, Helmand,* 2009.
Medium: watercolour inks.

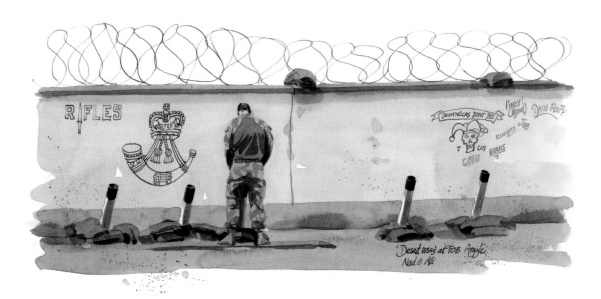

Laura Carlin

LONDON | UK

"I create my own version of reality. I learned to put my personality into things. I enjoy that I could be looking at exactly the same scene as someone else but that they're seeing it in a different way to me."

London provides the comfort of anonymity for Laura Carlin. The bustle of the crowded trains, pubs and streets of the capital city is an extension to her studio. This is the environment she often chooses to explore her ideas, tapping into its energy and witnessing the lives of its richly distinctive characters.

Although not specifically documentary illustration, Laura's award-winning work across a range of subject matter is grounded firmly upon the drawings she has created through a process of direct, objective observation of people and places. Whilst thrilled and stimulated by opportunities to visit and respond to, such exotic places as Tokyo, resulting in her first book, *Ten Days in Tokyo*, the landmarks and events she generally seeks are rarely monumental. Instead she gravitates intuitively towards mundane environments, in particular towards people in public spaces. The aim is often to encounter "either a real cross section of society or a particular type – the observation of a melancholic dimension of humanity". She reflects that "I probably take solace and courage from a bit of the sadness of other people. I find the way other humans interact with each other really fascinating, whether it's a jarring thing, or their lack of comfort or awkwardness." Using these real, observed characters to populate images gives her pictures an emotional quality, a lyrical charm which makes them appealing to commissioners across the industry, and in particular within publishing.

Books have always been important to Laura. A prolific reader since childhood she acknowledges that she has always skim-read, filling the gaps imaginatively. This reflects in the approach she now brings to illustrating fiction. "I love immersing myself in someone else's character or life or to see something in someone else's point of view." She describes how this is reflected in her process of deciding where to focus in a text: "I tend to choose either a pivotal or slow moment, and always prefer to exaggerate a feeling or emotion rather than being too literal."

Laura describes her work as being "darkly nostalgic", this being a reflection of her empathy for the gentle tragedy of everyday life. She clarifies this position. "There's a sense that life may not live up to how you thought it was going to be. Maybe that's why I choose to draw sad people. It's like life's not entirely wonderful, but it can also be charming and funny, and my work reflects that too."

Laura does not celebrate or seek out what she describes as an "old worldliness", but her work, despite its clear contemporary edge, is imbued with a sense of nostalgia. This was nurtured by growing up

OPPOSITE:
(top) Editorial piece for *Vision* magazine.
Published 2009.

(below) Sketchbook drawing.

THIS PAGE:
Sketchbook drawing.

LEFT:
The contact scandal (on the subject of child abuse), editorial piece for G2, *The Guardian* newspaper, 2006.

in a household with many references to the past: books, maps and textiles which she says were "old-fashioned". She both embraces and is repelled by the new. "It's a contradiction, there's a fight within me. I love the 1950s – the writer Richard Yates, for example – but I enjoy vulgar new things. I'm amazed, disgusted and appalled by new technology, but also perversely drawn to it, and want to comment on that in my illustration."

Laura asserts that her work is about meaning rather than description, but it is also more a case of editing what she witnesses in the world, rather than inventing. She chooses the components within her images because they contribute to the message, or feeling, she wants to convey. Whatever the brief, typically her process will entail consulting sketchbooks at the early stages and being out in the world. She returns to public places such as buses, pubs and tubes to explore ideas through prolific thumbnail sketches, seeking transience. "I just enjoy the stimulation of an external environment," she enthuses. "At home, surrounded by my favourite artists and illustrators, I can feel distracted, I'm in a world of Laura – and I enjoy being out of that. In a busy café I'm invisible and often concentrate more."

In common with many artists and filmmakers the stance she takes in whatever activity she is recording is to be at the heart of it rather than distanced from it as a voyeur. However, she is also conscious of the need to be anonymous and to that end cherishes inconspicuousness. "The idea of making someone feel uncomfortable would make me unhappy, so I prefer not to intrude. That's why I stay hidden." This reflects her philosophy as an illustrator, which obliges her to seek the most naturalistic viewpoint. There are parallels here between the process of location drawing and responding to a text. "Whether location or text you have to remove yourself to get an essence of something." Paradoxically, both require a distance and immersion. Both depend upon visual discernment and selection, choosing the best moment. Outside the studio Laura records the moment in the most expedient way: photography, drawing or words. She is pulled towards whatever is visually interesting. Whatever the experience, bringing sensitivity to her individual interpretation of it is paramount. "I sometimes think my sense of humour can verge upon sounding patronising or condescending, and it's awful to think my illustration could do the same."

Whether on location, or in the studio, Laura sees editing as an important objective, and over her career has become more assured in the act of visual decision-making. "I take a lot of things out before I even put pen to paper," she says. As well as elimination, she is very deliberate in her addition of elements to her illustrations, while always regarding them as being secondary to the figures. Laura clarifies that

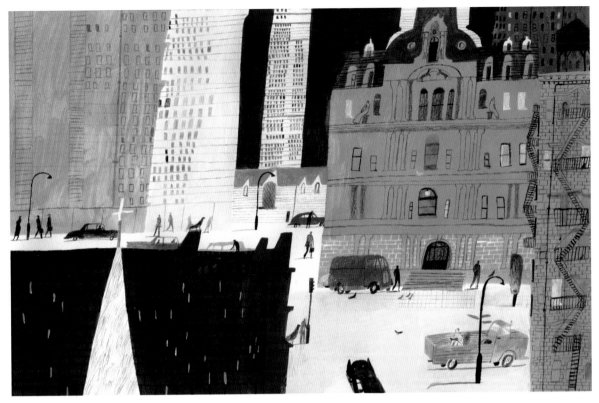

THIS PAGE:
(top)
Cover for *Closing Time* by Joe Queenan,
published by Macmillan, 2009.

(bottom)
Illustrations for *The Collected Stories* by
Anton Chekhov, published by The Folio
Society, 2010.

"Often it's not the environment at all, but the young boy with his Nan, for example, the man walking past. That's important. Architecture, often secondary to people, is about the excitement of placement. The building often reflects the personality of the person or exaggerates a really dark sky. I try and use them in the character's favour."

In her studio she deliberately fends off "preciousness", which can diminish the sense of vitality and the immediacy of direct observation, by choosing from a random array of materials accumulated throughout her lifetime. The acrylic paints she uses for her subtle washes are the "cheapest in the art shop", and the coloured line is added with pencils she has owned since she was six years old. She often works simultaneously on different versions of the same image, so as to stay relaxed and avoid becoming overly conscious about the finish. It's an organic approach that often involves drawing on a small scale with a brush, enjoying lines that are "wonky and temperamental" and relishing the uncertainty of how it will translate when enlarged.

Like many great illustrators, Laura is highly motivated and constantly in the driving seat of her own creative journey. Excursions into new media such as ceramics are about more than conquering materials and exploring new commercial possibilities; they are instrumental in her mission to avoid becoming stale under the pressure of commercial constraints. "I'm terrified of getting lazy. It's great to gain experience and wisdom, but I'd have to become complacent and churn things out. It's not that I'm interested in the technical dimension, what materials to use. I'm more driven by what comes out." The use of a new medium such as ceramics or textiles forces her to pare down her imagery even more. Such economy is seemingly a key objective within her practice.

THIS PAGE:
(top)
Visual for *The contact scandal* (on the subject of child abuse), editorial piece for G2, *The Guardian* newspaper, 2006.

(bottom)
Personal work.

OPPOSITE PAGE:
Portrait photograph by Sylvan Grey.

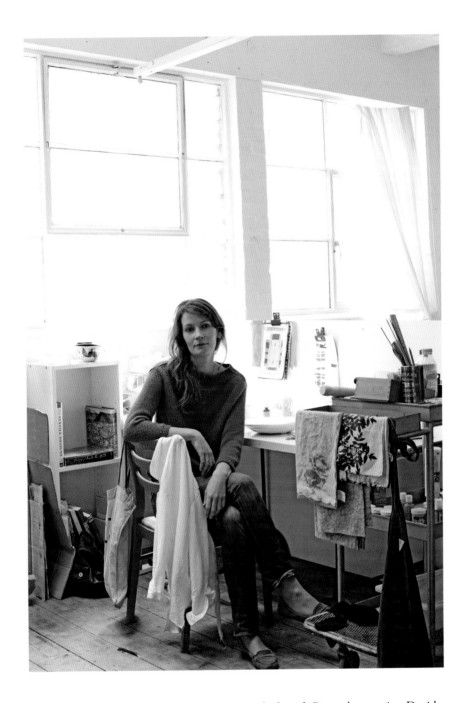

Laura is drawn eclectically towards artists from across the board: Picasso's ceramics, David Hockney, Edward Bawden, the American folk artist Clementine Hunter, maps, filmmakers. She finds inspiration in reference books with old illustrations which need an imagination to bring them to life. In common with many of her influences she is keen to use her work to share her own visual perspective, to reveal her own viewpoint. "I'm hard on the subject of illustration. Making images which are just aesthetically pleasing as opposed to having any gut reaction or integrity terrifies me."

Laura Carlin lives and works in London, UK. She was winner of the V&A Illustration Awards 2011, in the Best Illustrated Book category.

Olivier Kugler

LONDON | UK

"When I do my drawings, I never make up things – I only draw what I see."

THIS PAGE:
Lighthouse, James Town, Accra, Ghana, 2007. Medium: pencil and digital.

OPPOSITE:
Drawing from *The Frying Pan* boat series, personal work, 2001. Medium: pencil and digital.

Clean line and flat colour bring an apparent simplicity to Olivier Kugler's drawings, but with selective visual editing he adds elements of detail which reveal an observer's interest in structure and shape. The eye is led around his expansive images, resting at points where he's chosen to concentrate line or colour. Often commissioned for reportage and portrait work, Olivier has also diligently recorded his travels, taking a sketchbook, or latterly a camera, to capture the scenes around him, adding text as an additional layer of information.

Olivier will put as much detail as he can into a drawing, starting with the main focus, or a smaller element that he's drawn to, such as a shop sign, and then expanding the image to include what is happening around it. As with many image makers, decisions are made unconsciously – whether certain elements are added or left out depends on how important they may be within the drawing.

As a fan of comic books, and of Tintin in particular, Olivier has always preferred line. "I always did line drawings. I never liked to shade my drawings, and at the beginning I never really liked to add colour, so colour came later." Describing his style as "kind of realistic", interpreting what's before him but not overly precisely, he drew only from life for a substantial part of his career, believing this was the only way he could make images. Latterly, all those years of location sketchbook drawing have given him the confidence to start using his own photographs as reference.

This shift has freed up his time when travelling. "If you're travelling for four weeks, you want to see stuff. You don't want to just sit in one place and draw the mosque all day and not see anything else." Now he enjoys drawing from location photographs as, having taken it himself, the image pulls him back to the time when it was taken and he is able to record all the detail he'll need for future drawings. High-resolution photographs also reveal detail that can be zoomed in on, allowing for close observation in the drawing.

ABOVE:
Photograph of pencil drawing by Sylvan Grey.
Studio photograph by Andrea Liggins.

BELOW:
Portrait photograph by Sylvan Grey.
Tattoo Parlour New York, sketch USA, 1990s.
Medium: pencil.

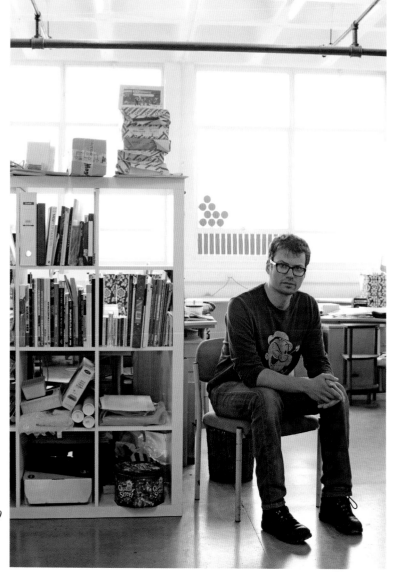

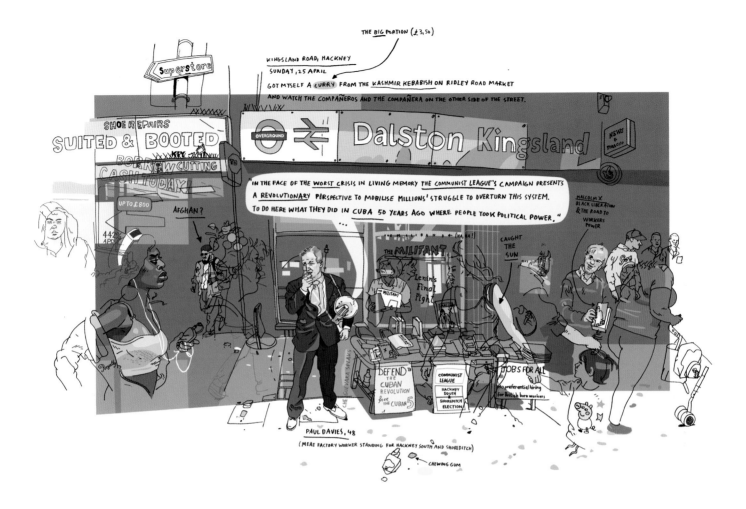

ABOVE:
General Election Campaign
(detail), for *The Guardian*
2010. Medium: pencil
and digital.

Ten years ago he was using an A4 sketchbook, but as his desire to include more detail has increased, so have the paper dimensions. "The longer I draw, the larger my drawings get," he says, "Now if I'm doing a drawing that's printed around A4, the original drawing is probably four times the size. And this is one of the reasons I'm using high-resolution photographic reference, so they have a lot of detail in them." A disadvantage, as an illustrator, is that it can take a long time to create an image. Olivier will use up all the time available for a commission, right up to the deadline, but is still tempted to look at the end result, thinking, "If I had another hour, I could have done some more."

Use of handwritten text is a constant and identifiable part of Olivier's images. Ranging from a couple of lines to areas that will make up a significant part of the work (even a few speech bubbles appear occasionally), he began incorporating text when studying in America in the early 2000s. "You're sitting in a coffee shop drawing someone, they start to talk, and you think, 'This is really funny' – or hearing lyrics of songs that are playing on the radio. I quite like that." He believes it is an important thing to do as an illustrator, "because you're creating your own stories. As soon as you can do that, you're not dependent upon a client to commission you to do a drawing for someone else's text."

This narrative element makes Olivier's images work successfully within an editorial context, and has led to storytelling on a more extended level, with a comic-book commission based on a cross-country journey travelling with an Iranian truck driver. This grew from a personal project which, like others he's undertaken, he hopes may find an audience through sale to a newspaper or magazine. Although he'd pursue it anyway, Olivier will present this type of project to an editor before setting out to see if there is any interest in publishing the resulting work. The ideal situation for him is to be paid for work that has a strong personal connection, but with stories which will engage a readership.

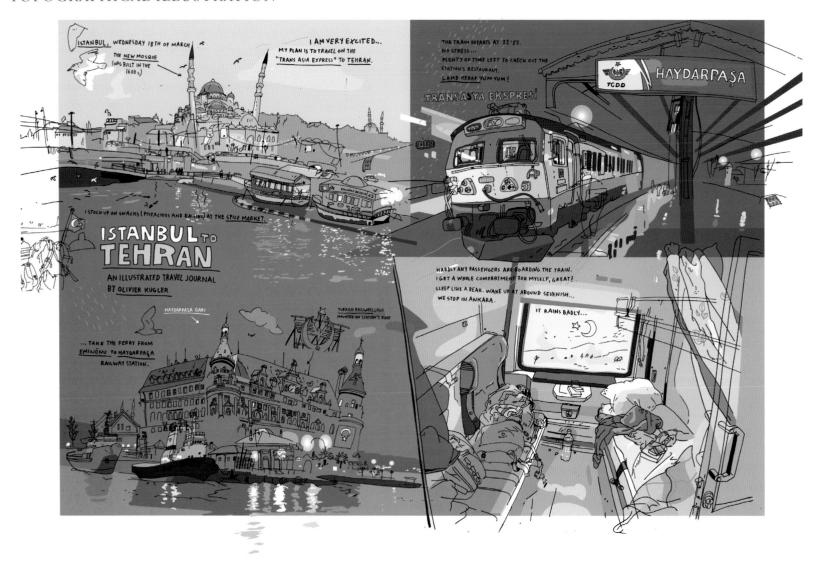

ABOVE:
Istanbul to Tehran travel journal, for *Jazeera* magazine, 2009. Medium: pencil and digital.

He doesn't take a political angle with his reportage work. "My work is about people, and the places I see, the way they treat me." But opinions can still be present in the final work if he notes down comments that people might make to him. The text in his drawing of Esfahan in Iran includes quoting a thinly veiled criticism of President Ahmadinejad which a man he met had made to him. As Olivier recognises, "It's a gift, a reward that you get on location. When you do your own research, people will approach you. It depends a bit on luck, too, when someone comes along and says something like that. You need to put it in the drawing as it makes the drawing work much, much better."

Olivier welcomes the unforeseen opportunities which just walking around can bring. "I could be drawing one thing and then something else happens, like an improvisation." And he's not unduly concerned about people watching him draw, having become used to it over time. He says he is fairly shy, but saying that he is producing a drawing gives him the confidence to approach strangers. "I can imagine people may be more prepared to pose for a portrait with a drawing than with a photograph. I had to do a drawing of a prostitute in Germany, and she told me that if it was a drawing it was fine, but she wouldn't like to see her photograph in a newspaper."

Once a drawing is scanned in he rarely removes any elements, but moves it around within the required layout, giving him an idea of what may need to be added. He rarely does preparatory sketches. Additional drawings can be added to create the image he wants, an activity Olivier likens to a kid playing with a Playmobil: "maybe a castle – you've got one thing and you add something else, like a pirate ship, then you add little figures. When I'm working I'm thinking quite often about being a child again, playing with the Playmobil."

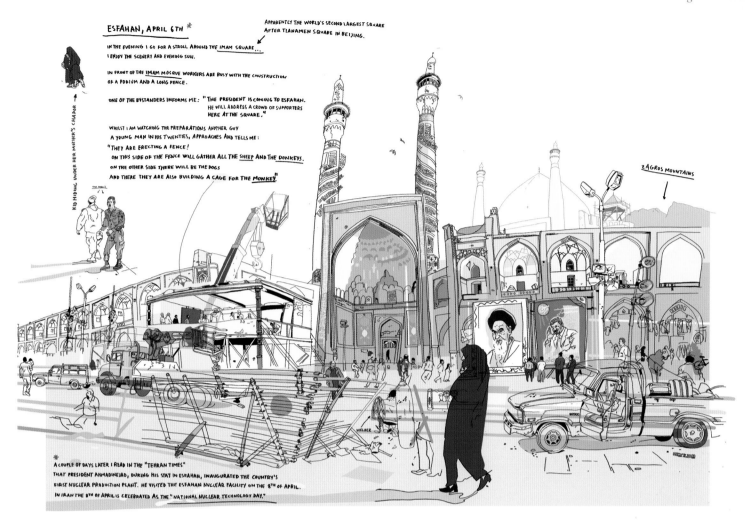

OLIVIER KUGLER

He likes to allow the drawing to develop, with a mind open to the possibilities of a changing composition. Colour is added on the computer rather than the line drawing, allowing flexibility within the layout to move or omit, but he will try to keep colour as accurate as possible to the original reference. He's never been satisfied with the process of producing colour on paper, "There's something in the way my brain works – when I look at things I can see the colours, but I can't mix them with my hands. But I can mix them on the computer, that's no problem."

ABOVE:
Esfahan, personal work 2009. Medium: pencil and digital.

The location portrait work he is commissioned to do highlights some of the interesting sketchbook-like qualities of this work. Having drawn people over long periods of time in bars, barbers' shops and tattoo parlours, he overcame the issue of capturing a person who doesn't stay still for long by continuing to add to the drawing as they moved; showing in a single image that the subject is doing different things like smoking a cigarette and drinking, with their hands, for example, in many positions. "It brings a sense of movement, and the drawing is not as static – it's much more like life." This multi-viewpoint element has been continued in work referenced through photography, with poses selected from the many photographs of a specific location or event, and including the subject's surroundings.

Olivier takes landscapes and portraits equally seriously, but his favourite thing? "I love to draw old ships and junkyards – the rustier things are the better," he says with a glint in his eye. "And old, derelict industrial landscapes – that's my favourite."

193

Olivier Kugler was born in Stuttgart in Germany and now lives in London in the UK. He was awarded Best Editorial Illustration and Overall prizewinner at the V&A Illustration Awards, 2011.

JEAN- PHILIPPE
DELHOMME

ROB RYAN

PAUL DAVIS

Authorial Practice

Labels become defunct. Writer, artist, illustrator, publisher, these creative people define their own practice finding opportunities for self-publishing, artworks, books and artefacts.

The client's perspective:
Adrian Shaughnessy,
*Designer, Writer
and Publisher at
Unit Editions*

ABOVE:
Portrait by Derek Brazell.

LEFT:
Photography by Andrea Liggins.

Amongst graphic design's chattering classes, authorship has been a hot topic for a decade or more. In the 1990s, when American academics, radical designers and commentators first raised the notion of the designer as author, design's traditionalists dismissed it as heresy. Designers were not authors, they said. Designers were anonymous conveyors of other people's messages and information: like a good journalist, the designer should never become part of the story.

Radical designers acknowledged that many practitioners were happy to use their skills purely to serve their clients' needs; it's called being professional. But they also pointed out that another group had an urge to use these same skills – and their creative sensibilities – to make their own unique and self-driven statements.

This argument rumbles on. In the design schools the notion of the designer as author still has currency; so much so that in my view it has created a problem. We now have a generation of designers who think and act like authors. Yet not every design student has the talent or sensibility to be an author in the full sense of the word – that is, someone capable of working in an entirely self-directed capacity. If we are going to encourage every student designer to think of himself or herself as an author, we have to be sure that they have the authorial instinct in them.

But of course this debate has not troubled illustrators to anything like the same degree. Yes, there are vast numbers of commercial jobbing image-makers who are content to sit and wait for a client to call them with a brief. Absolutely nothing wrong with this; it is called being professional. But genuine personal authorship has always been possible in illustration.

In an interview in the illustration magazine *Varoom* the American designer Ed Fella noted, 'Whereas graphic design is more anonymous, all illustration is sold for its particular and individual style.' In other words, illustrators have always been 'allowed' to have their own voice – and what could be more necessary for authorship than the possession of a 'voice'?

Today it is routine to see illustrators who have produced self-directed work: books, comics, and saleable goods such as clothes, posters and assorted objects. These outcomes have no direct clients, and rely instead on the urge for authorship amongst illustrators. In these times of dwindling budgets, clip art and the decline in editorial commissions, the authorial instinct is no longer a choice for illustrators – it is a necessity.

BARNEYS
NEWYORK

Her suit by Barneys New York,
sandals by Henry Beguelin.
His suit by Ronaldus Shamask
for Barneys New York,
shirt, tie and sandals by
Barneys New York.

Valerie was leading Burt into an ingenious trap.

Jean·Philippe Delhomme

PARIS & NEW YORK

"I don't like to define myself as an illustrator, but that's often the easiest way. I do different things. Sometimes I write, sometimes I do drawings, sometimes I paint. I like to go from one thing to another."

Jean-Philippe Delhomme seems to have an astute sense of what may be perceived as absurd within the realms of style, fashion and culture. "I love everything regarding culture and the visual translation of that. That is my favourite subject." Whilst drinking coffee, attending a couture fashion show or visiting an art exhibition he is "receptive to whatever is going on", and uses his painterly approach to chronicle his observations, often alongside text. His resultant witty, creative output has a distinctive tongue-in-cheek personality, a firmly ironic voice.

Jean-Philippe is a published novelist and often language will be central to his process, as an artist, of creating a visual narrative. As an author, in all senses of the word, he has carved an individual niche for himself as both an illustrator working commercially and an autonomous practitioner, often combining text and images for books, exhibitions and his blog. "Drawing and writing are for me the same thing. I often start writing first – a sentence, an idea in words, and then a drawing. It's rarely the other way round." Clients are important because they provide vehicles for these narratives: "In a way I don't know who is using who," he says, laughing. "I work for the clients to fulfil the brief but can also show something else or tell another story, maybe even show things in a slightly more poetic way."

Throughout his career the clients he has attracted have been receptive to his sardonic narrative stance, those "great jobs" where he has "been able to work with as much freedom as possible without being too tied up by an idea". Inspired by the advertising posters of *affichistes* like Raymond Savignac, seen in his childhood in the 1960s but truly discovered in books and exhibitions when a student in the early 1980s he has, since the beginning of his career, aspired towards creating imagery that "would be painted and seen as part of everyday life – paintings on the street". High-profile advertising campaigns in Europe and the USA, (Barneys New York, Saab, The Mark), commissions for Parisian department store Le Bon Marché, and editorials for *Glamour* magazine (France) have allowed him such exposure.

OPPOSITE:
From an advertising campaign for Barneys,
New York 1993–95.

THIS PAGE:
Coyote, from www.unknownhipster.com, 2010.

JEAN-PHILIPPE DELHOMME

At the other end of the authorial spectrum, Jean-Philippe's blog (www.unknownhipster.com), is a channel for his entirely self-instigated work. Here, through his diarist postings of both images and text, he reveals journalistically his perspective on life in Manhattan, where he has been a resident for more than ten years. "In some ways this could be seen as classical drawing," he explains, "where the inclination is to draw what I see – people, landscapes, anything – not academically or formally, but trying not to change them." As with his commissioned work, this involves an intuitive process of editing, arising from his preference for drawing from memory in order to focus on the details that matter. "I see what I see," he says, "but there will always be just a couple of things that I remember. It's easy to focus. It's about doing the things I know I'm going to express well."

Although he says he "never planned to be a fashion guru", early commissions for publications such as *Vogue* in the UK and *Glamour* in France, positioned him firmly on the radar, and within his multifaceted career he is recognised in this genre. Jean-Philippe makes no distinction between work undertaken in a commercial context, where fashion is observed, documented and often promoted, and the more sardonic pieces that comment on the contrivances of the subject. The link he identifies is his objective to describe and express what he has observed about the people who inhabit designed environments. "Fashion is just a subject," he says. "If it's not clothes it could be chairs or architecture or furniture. Anything."

A humorous approach would be inappropriate to a fashion brief. "Drawing from a couture show is more like classical painting, like in the 19th century when a subject was posed in a dress in a formal way. That's what I have in mind when I do fashion drawings." These images often capture and distil the pose, action or attitude of the person in the garments so that they become identifiable. In the foreword to Jean-Philippe's book *The Cultivated Life* (Rizzoli, 2009), Glenn O'Brien, the former Creative Advertising Director of Barneys, New York, reveals how 'the semi-abstract figure with a head resembling a baked potato covered with sour cream and bacon bits' (the figure Jean-Philippe depicted wearing the new fashion range for New York store Barneys) contributed to a surge in garment sales because customers were readily able to relate to them.

Rather than use sketchbooks, Jean-Philippe takes photos to record precise details that he will need later to inform his paintings in the studio. Although exact in his choice of subject and use of reference, he also suppresses some details, "to convey maximum information with minimum content". He explains, "I try not to change too much. I want to make the images as simple or honest as I can without putting too much of myself in the drawing."

Spontaneity and freedom to express an idea are also important to Jean-Philippe and consequently the most enjoyable commissions are those which mimic the processes central to his self-initiated work. "People with less ideas than you asking you to do something is never the best way forward." This freedom extends to the physical properties of a piece, and Jean-Philippe says that he enjoys "looking at paintings where you can see they've been painted". The gestural qualities of his own paintings could be attributed to his childhood in Paris, where he was raised in a culture of Impressionism and influenced by a grandfather who was a painter and also Creative Director for Lancôme from the start of the company until the early 1970s – he designed most of the bottles and ads – and a surgeon father. He recalls how alien the more formal, constrained paintings of early art-school peers seemed, and how liberating it was to see the work of David Hockney, who was exhibiting in Paris at this time. "There was so much freedom in those paintings," he recalls. "There were no rules. It gave me the sense that I could do whatever I wanted."

Jean-Philippe often produces lots of sketches around his subject, sometimes taking these to quite a
198 resolved stage before choosing one that will be successful either to use as the artwork or to be fully developed. Commercially he works to a small format, often around A4, or intended reproduction size,

OPPOSITE PAGE:
(top left)
Coyote, from www.unknownhipster.com, 2010.

(top right)
From an advertising campaign for Le Bon Marché (department store), Rive Gauche.

(bottom right)
Chelsea, from www.unknownhipster.com, 2010.

(bottom left)
Studio photograph by Andrea Liggins.

ABOVE:
Dries Van Noten, Winter, 2008.

Davantage qu'une cuisine, c'est un atelier d'artiste !

Now that we have redecorated for the art, I'm considering slightly modifying the view.

Our new kitchen is so slick, it's hard to tell the fridge from the stove!

Our friends are amazed that we put the Marcel Duchamp in the bathroom.

As a viewer, I always feel guilty if I don't succeed in constructing meaning out of a piece of art.

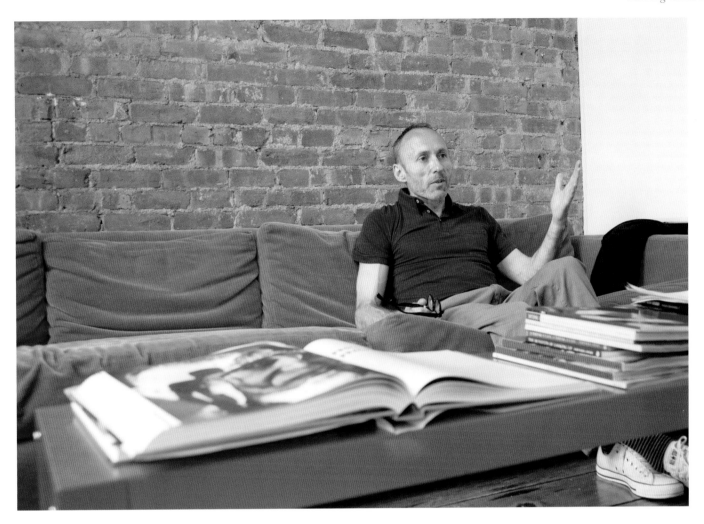

THIS PAGE:
Portrait photograph by
Andrea Liggins.

OPPOSITE:
© Jean-Philippe Delhomme
from *The Cultivated Life*,
published by Rizzoli,
New York, 2009.

the expedience of scale allowing him to work quickly and spontaneously on a tabletop. With their subtle colour ranges, either gouache or acrylic on paper or board, these paintings are crafted with a flourish which he says is intuitive. The metre-square oil-pastel drawings on the walls of his studio, depicting barges in New York, reveal an openness to investigating new directions, both technically and in content, as well as an enjoyment of the physical challenges of making an image when removed from the limits of a brief.

Like a set dresser for a film, Jean-Philippe stages his images, often aiming to reflect what is contemporary in his choice of costume, accessories and props. Of course, this may be wasted on the audience: "Most people think of a drawing as an object. Not many know how to read the details. They are mostly read in a fast way: 'Is it a happy drawing? Is it a sad drawing?' When you go into the details, you are speaking to a lesser number of people. I'm fine with that. I think it's funny even if fewer people notice it."

Although immersed on a daily basis in a stylish environment, close to the milieu he is commenting on and maybe even part of it, Jean-Philippe nevertheless dispels the notion that he could become inured to its more ludicrous aspects. Of his life in fashion he comments, "I'm never too close. I never melt into a particular crowd of people. I always stay slightly on the side."

This combination of currency and autonomy ensures that as both commentator and recorder Jean-Philippe Delhomme contributes to and also encapsulates the more ironic aspects of 21st-century Western culture.

Jean-Philippe Delhomme was born in France, and now lives and works in Paris and New York. Visit his blog: www.unknownhipster.com

OUR ADVENTURE IS ABOUT TO BEGIN

202

THIS PAGE:
Our Adventure, papercut, 2010.

OPPOSITE:
My Only Home is in Your Arms,
edition print, 2010.

Rob Ryan

LONDON | UK

"I don't see myself as an illustrator. I see myself as someone who produces my own work with other people. It's a collaborative thing where we work together and try to make something new."

There is something anachronistic about the exquisite papercuts for which Rob Ryan is known. With their distinctive motifs of birds, trees, buildings and natural forms, often interwoven with words, these delicate artefacts with their bittersweet messages possess a stillness redolent of time gone by. Rob is resolutely forward-looking. A post-punk education in the 1980s instilled what he describes as a "get off your arse and do it" mentality which has culminated in the success he now enjoys, both as a recognised illustrator and as an autonomous practitioner. His images are seen in a vast array of commercial applications, anything from window displays to Sloggi underpants, but in spite of this undisputed midlife success he seems determined to maintain a firmly independent cultural direction. "I guess it's my work and I'm going to do what I want!" he says, and this culminates in both exhibitions and independent merchandising through Ryantown, his shop, where textiles, laser-cuts and ceramics are available in limited editions.

Rob reflects on the dilemma of being a recognisable brand in popular demand within a commercial arena, with an acknowledged potential to make a product endure through being associated with his images, and the pitfalls of being perceived as a commodity. "I always see myself as a fine artist. I do editorial work, book jackets, children's books, textiles – whatever I end up doing it's a broad practice. I can't sign that away to anybody. I have to have control over what I'm doing. If I don't, I may as well stop now."

Although Rob says, laughing, "In some ways I haven't got a clue what I'm doing, things aren't massively planned," there is an obvious command of the meticulous process of creating artwork, and with that in mind he has pragmatically engineered a distinctive working environment to facilitate his practice. In his studio several assistants deal industriously with some of the technical dimensions of making artwork, which both frees up precious time Rob needs to invest in creating artwork, and provides much-appreciated social interaction. "I'm not solitary like the archetypal fine artist who's alone in the studio all day without a phone, just painting all day," he says, laughing affably. "I would pay them just to talk to me!"

Equally, Rob has enjoyed the stimulation of external challenges, acknowledging that the involvement and intervention of some clients has been rewarding, saying positively, "I've loved the work I've done

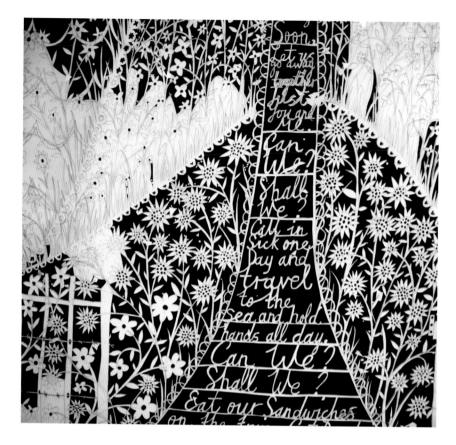

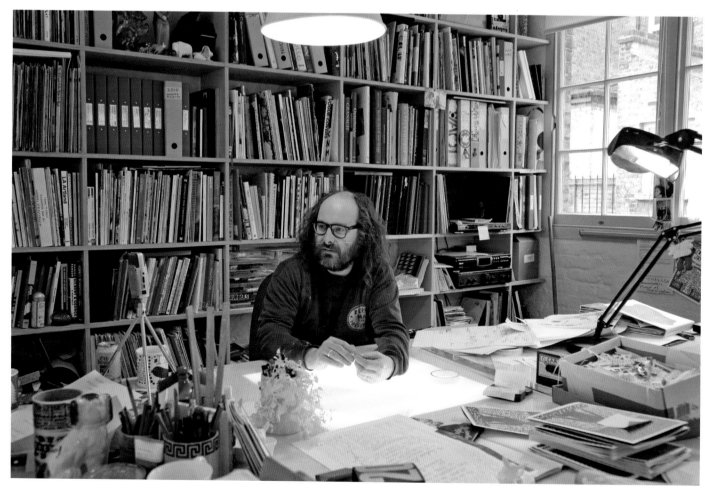

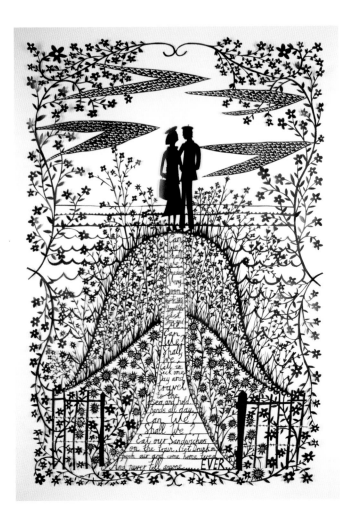

OPPOSITE PAGE:
Spreads from working notebook.

Can We Shall We, papercut in
progress (detail), 2010.

Portrait photograph by Andrea Liggins.

THIS PAGE
Can We Shall We, papercut, 2010.

(top right)
Studio photograph by Andrea Liggins.

All other photographs supplied
courtesy of the artist.

with other people." The potential volume of this, however, has led to Rob being measured about the commissions he now accepts, and although he appreciates the financial stability which commercial success has brought, saying he felt "tortured" when he first turned down a commission. Preserving his integrity is paramount. Rob reflects on his consequent decision to ensure that a large proportion of his work is self-generated. "What makes my work mine is my life, what I feel about things – on many levels it's incredibly personal."

It seems that as his life continues to evolve and his career builds momentum, there is a danger of disconnection from the authentic inner voice articulated through his work. He reflects on this. "I have to keep the unconfident person alive inside me (even though I'm more confident than I used to be), to try and bring work from that part of myself."

With their sometimes wistful messages, reflected in works such as *Since I have been alone time goes by slow,* and their overt emotional content, his lyrical images have been described as sentimental. Rob is conscious of this perception. "Sentimentality has negative connotations. The word has been hijacked to imply someone who is affected by something but too ineffectual to do anything about it. If someone describes my work as sentimental, I see that as a rave review!" he says, laughing.

Rob clearly sees the message as the nucleus of his images. Although he is less exact about the source of individual ideas, these are ever abundant. He jots down thoughts prolifically in notebooks, instructions such as 'Do a picture about not resisting change.' As he further explains, "Some ideas you can't do a

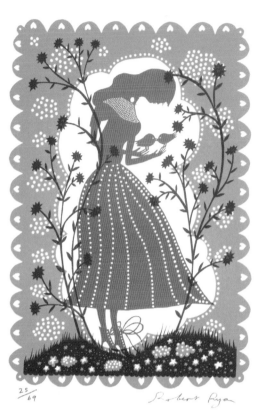

LEFT:
Fragile tape, limited-edition merchandise from Ryantown.

Birdlady, limited-edition screenprint, 2010.

BELOW:
Please Smell Us, limited-edition merchandise from Ryantown.

Photographs supplied courtesy of the artist.

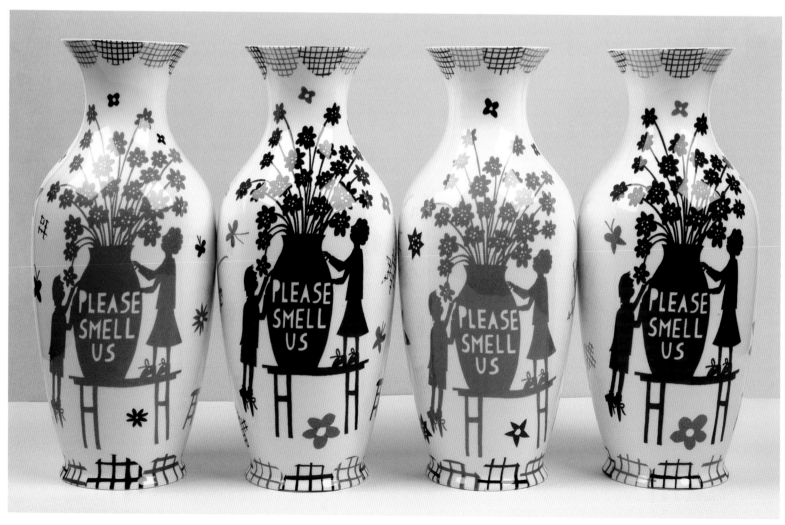

sketch for. You have to write them down and then find a way of representing them later in pictorial form. Sometimes there are drawings I have in sketchbooks which I can develop."

It was the need to filter these ideas that led to Rob switching from his paintings to the more edited visual process of paper-cutting for which he is now recognised. This entails reducing the image to a single plane, consciously limiting colour and eliminating detail, whilst introducing words to add other nuances to the message or to make it more concrete. He elaborates upon this methodology. "I decided to limit the number of decisions I have to make within one image. I could be like outsider artists who put everything in their work," he says, laughing. "I stop myself from being completely insane. It's like outsider art by someone who isn't mad."

The process of marrying the conceptual, aesthetic and technical properties intrinsic to his imagery is a complex one. The sketches and notes to which he constantly refers are developed into highly detailed drawings, which for commercial purposes become the client visual and are the template from which the artwork is cut. The technical restrictions inherent in the cutting process both constrain and influence the eventual content and form of the image. Its disparate yet interconnected elements have to work coherently as a whole. It's this authority over what Rob describes as "a bit of a complicated puzzle" which has culminated in his distinctive visual language. As he explains, "The separate strands weave together, words hang from strings. These are devices I use to help the physical construction and mechanics of the picture – literally how it holds together." Parts of his routine are handed to his assistants, and although he explains that "there isn't much subtlety in the cutting, nothing can really go wrong," he prefers to take over for the elements that require more subtlety, such as figures. The cut may then be sprayed one colour or scanned as a template for a laser-cut or design to be applied to an object or textile.

Of his craft Rob says, "I never see myself as being at the forefront of paper-cutting. It's not about the skill to me. I'm much more interested in the idea and what I have to say." Although pragmatic in this respect, Rob recognises that the exquisiteness of the detail and the aesthetic of this medium is part of the allure, reflecting, "People love things that have been painstakingly crafted. It can be spellbinding even if they don't like art."

The cutting of images is a natural evolution from the cutting of stencils for screenprinting, which was a major aspect of Rob's earlier practice, and although he joins a lineage of paper-cutters whose images have conveyed narrative and evoked drama, such as Lotte Reiniger, it is in the context of a wider spectrum of art with which he feels an affinity. He recognises "a connection to a broader kind of art which includes you in it," citing the observation of American illustrator Maira Kalman: 'In my work I'm trying to work out two things: how to live and how to die.'

Although the links to Romantic painters such as Adolf Menzel and Caspar David Friedrich are less overt, the same themes are considered. "It's about the wonder and scale of a vast and sometimes overwhelming landscape."

Rob Ryan was born in Cyprus and now lives and works in London. He studied fine art at Trent Polytechnic in Nottingham in the UK, and later printmaking at The Royal College of Art in London.

ROB RYAN

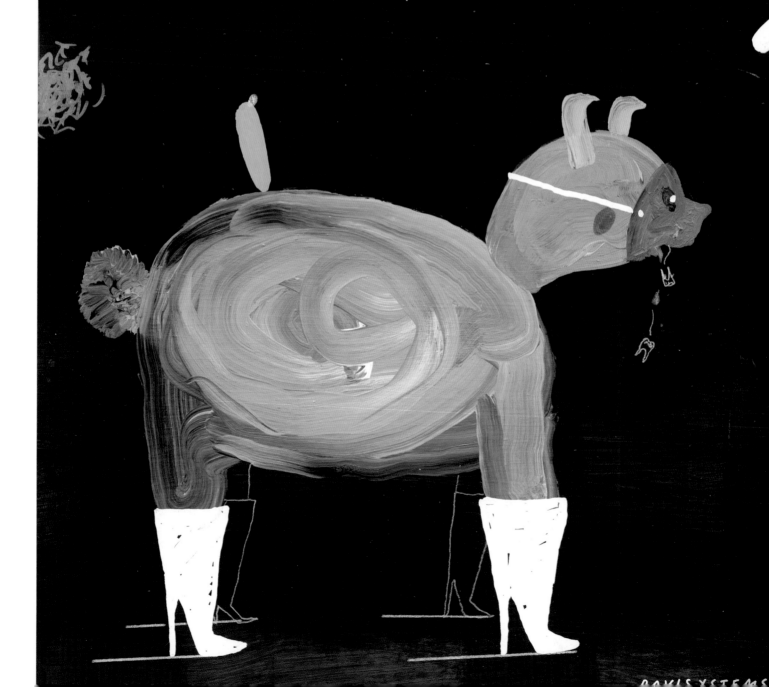

Paul Davis

LONDON | UK

"I'm just trying to understand what the hell is going on."

"I don't care what people think of my personal work," says Paul. "I just have to do it or I'll go insane." This is a big statement backed up by the intensity of his prolific drawing output. Self-generated projects, ideas for books and gallery shows spring from the point where he wakes up each morning thinking, "What shall I do?"

His books include *Us & Them*, the result of posing the question "What do you think of the Americans?" to the British, and vice versa, and *Blame Everyone Else*, which includes some of his mammoth series of drawings on Post-it notes.

Paul draws every day, stimulated by the attitudes and ignorance he encounters. Through his drawings he challenges pretension, bigotry and human behaviour, offering the viewer something to think about and, crucially, laugh about. "I'm a romantic," he says. "I don't want people to be homophobic or racist or sexist – I don't get it." The mundane does not escape comment either, with modern speech and promotional wording placed in a different context for all their bland absurdities to be recognised. His images can be like something seen out of the corner of an eye, and where most of us move on, Paul stops, listens and observes, but even as his drawings peel back the subjects' veneer you are aware of a certain sympathy – the targets are mocked but not despised. This can equally apply to himself, as some of his personal work does not shy away from surveying his own life. "It's very autobiographical without being wanky. As long as it makes people smile, that's the main thing." This desire to engage through humour carries though to commissioned illustration. "So you read the brief, and you can't help reacting to it in your own way. It is subjective, but you objectively know it has to communicate, to educate."

Text, whether collected from interviews, overheard, teased from inane advertising, or coming directly from his own head, has an important presence in his work. He wants to communicate, but doesn't necessarily want to make it easy. Text can wilfully contradict the image – "It's the Magritte thing, *Ceci n'est pas une pipe*" – but may be placed after the image has been completed, producing juxtapositions which suggest a new meaning for what was first placed on the paper (a goldfish floating above the word 'Jubilant', for example). He will work at finding the right construction for an image, in *Us & Them*, for instance, swapping quotes from a portrait of the actual speaker to another character who may suit the words better.

THE INDISCREET EVOLUTION MODEL

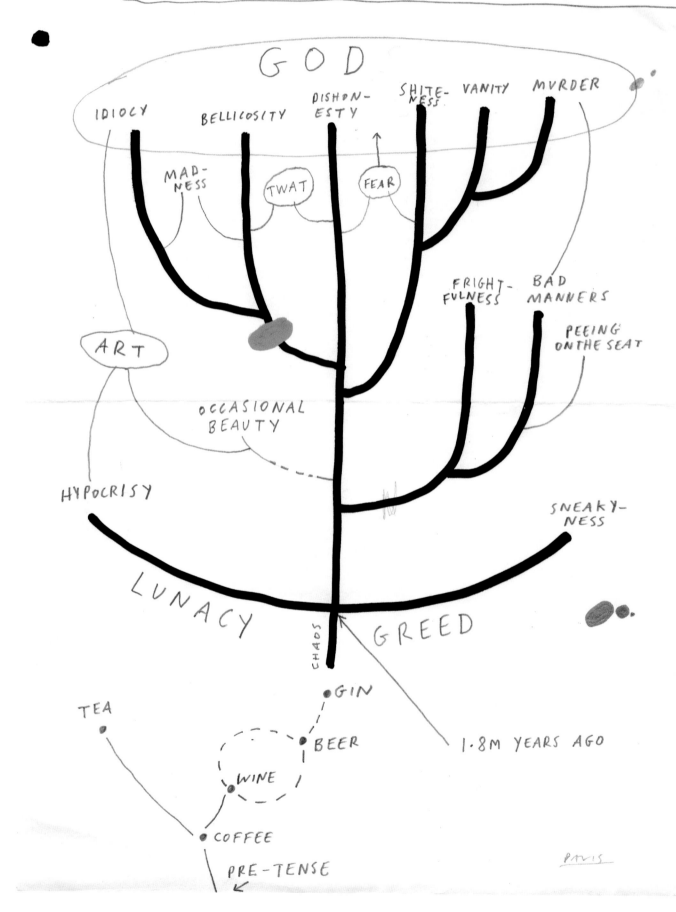

GOD

IDIOCY BELLICOSITY DISHON-ESTY SHITE-NESS VANITY MURDER

MAD-NESS TWAT FEAR

FRIGHT-FULNESS BAD MANNERS

ART

PEEING ON THE SEAT

OCCASIONAL BEAUTY

HYPOCRISY

SNEAKY-NESS

LUNACY CHAOS GREED

GIN

TEA

BEER

1.8M YEARS AGO

WINE

COFFEE

PRE-TENSE

DAVIS

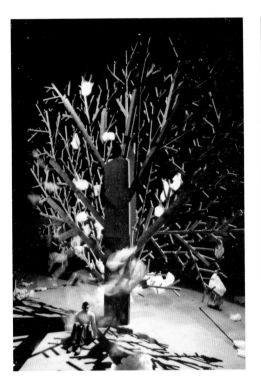

The works don't always require a representational image. Paul's handwritten text is also integral to the flow-diagram drawings he has done since childhood. Words are important to him, and he's not afraid to use them. Lunacy, greed, laboriousness, bellicosity, chaos, numbness, nihilism – they are all there. If they don't fit, they are crossed out, but left visible. The diagrams are darkly funny, leading you through overlapping shapes and along arrows, and if you weren't left smiling you might feel slightly depressed at the universal truths being presented: the awful fear of not being invited; underlying relationship tensions; our tendency to self-obsession. "I think they're beautiful, but then you start reading them, and it generally ends in pain and death," says Paul, smiling. "I think that's funny too. I'm confronting it because I'm scared shitless. It helps me – it's my therapy."

Paul revels in undercutting the corporate ideal. Awkward logos, real or imagined (Prada toilet roll anyone?), will be roughly drawn, stripped of the tightly polished presentation so coveted by consumers everywhere. A series of drawings inspired by Yellow Pages box adverts are now reworked to sound worse than they already are, now promoting 'DAVISYSTEMS' with an ironic "terrible-on-purpose" logo, "deeply ironic to the extent that it almost un-ironises itself", he says, laughing. "I'm not sure if that's a word!"

Humour is a constant presence in his work. "It's funny. It *is* funny, and people who don't have a sense of humour I can't be bothered with. How can you not have a sense of humour in this ridiculous world? I'm laughing and shouting all the time – that's all I do!"

Paul will not reveal artwork he is not satisfied with. Work remains in storage, to be assessed years later, discarded or reused. "I'll just paint over them. When things go wrong, recycle!" he says. He'll willingly follow happy accidents, such as when a picture is torn up but lands next to another section, revealing an interesting clash. Out comes the scalpel and tape, and a new piece may be the result. "I'm thoroughly open-minded," he says. He also enjoys the process of creating a layered base for images, sometimes taking primed paper, adding gesso and lines, then painting over that to form a background. "I love that process of doing things."

Drawing on different papers is usually the result of reaching for what is closest to hand: hotel notelets, a page torn from a reporter's pad, or some graph paper. "I just think it looks interesting. It's not a case of wanting to be known as a well-seasoned traveller – 'Look at this paper, it's plastic and I'm in Japan!' – I might have insomnia, jetlag, can't be bothered to get out of bed for the Moleskine, so reach for the paper from the bureau next to the bed. It's the veracity, the realness of it, that's quite nice. It's a bit forced, but not pretentious. And people seem to like it."

Images are generally created in line or paint, with tone rarely utilised, as Paul considers the idea to be the focus and he wants to get on with it. He'll appreciate the beauty of everyday objects, drawing an electrical plug or forgotten household objects from cupboards, but claims, "I don't think I'm that skilful when it comes to actually drawing – I could draw you eventually, but I'd sooner draw you without looking, I'd find that more exciting." Taking his ideas into three dimensions has been successful, with a huge tree constructed from pieces of wood, and entangled by blowing plastic bags, filling one gallery space in the mixed-media show It's Not About You (2005). He is also planning a pulsing brain sculpture constructed from decorative light ropes representing the synapses. "I'm obsessed with thought and how incredibly complex the brain is," he says.

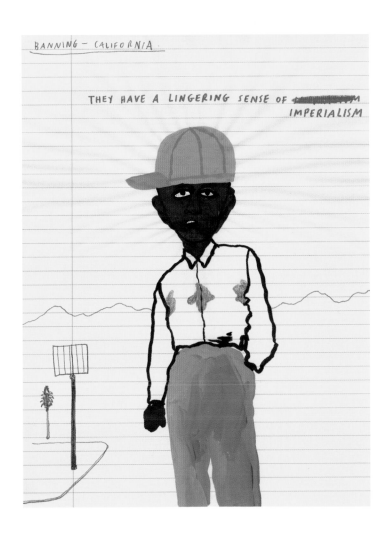

ABOVE:
They Have a Lingering Sense of Imperialism, from *Us & Them – What the British Think of The Americans; What The Americans Think of The British,* published by Laurence King, 2004.

Brick Lane View, Print magazine, 2009.

OPPOSITE:
Portrait photograph by Andrea Liggins.

For personal work, perhaps reproduced as a print, the computer is utilised to adjust colour or maybe invert the entire image, but if he intends to frame it as an original then no adjustments are made. Although he considers sketching to be "one of the most honest things you can do", Paul sometimes incorporates photography, though does not consider himself a photographer. "I'm a recorder of what's there, and I take photographs the way that I draw. It's the medium that's different. I like pushing it. I want to have fun with stuff. I don't want to get bogged down."

Authorial work is used to generate commissions, with new images sent out in PDF form to potential clients – used as a tool to get work, but not initially created for that purpose. If clients look at it and go, "Wow, this is different," then it has done a job. He is constantly exploring new ways of delivering his work to an audience, whether through exhibitions, self-published books or occasional unpaid commissions. In common with many others, he's not happy that illustrators are often treated with little respect, and has created some highly amusing work on that theme. Images for *Studio Culture*, by Adrian Shaughnessy and Tony Brook (Unit Editions, 2009), reveal a simmering anger which questions the entertaining surface. "I really feel that within illustration we are being patronised," he states, and though there is an ambiguity to much of Paul's artwork, it's clear that he has an opinion to express, and the viewer may find that disturbing.

Paul Davis was born in Somerset in the UK and now lives in London.

The Photography

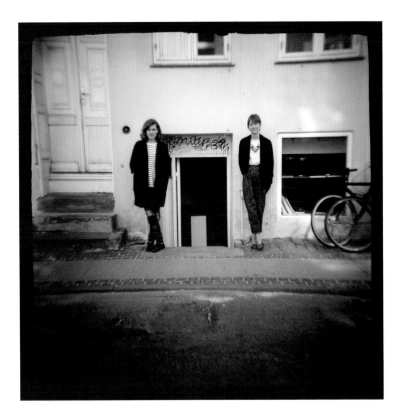

As this is a book about illustration, not photography, our aim was to produce images that have an intimacy and a quiet informality; that sit comfortably on the page.

These images can be viewed as documentary portraits, made not in the traditional sense by a neutral observer but by an insider; the aim was to portray familiarity, inclusivity and happenstance, and to create a sensation of place rather than its description. The studios and surroundings were not composed, nor staged, but reflect the portraits. It was intended that the photographs would have a naturalness of lighting, and if lit artificially that light should emanate from the lamps used every day in the illustrators' studios. The photographs in the book are digital, but as I normally work with film, I also photographed some of the illustrators in outside spaces (as above) or their gardens, with my usual 'landscape' camera. This 1960s cheap, plastic-lens camera, allows me to discover worlds within worlds, set apart yet somehow complete in themselves. The images from this camera help the reader enter these worlds and not view them from an outsider's position. I tried to reproduce these qualities in the images for the book, to do justice to the wonderful creativity and individuality of every one of the illustrators I visited.

Andrea Liggins
www.swansea-metro.academia.edu/AndreaLiggins

One of the key motivations for many photographers is a fascination with people, whether observing them candidly in the street or, as with this project, closely in their studios. Much of my practice is concerned with the former but most of my experience as a working photographer has involved the latter. Ultimately, the purpose of the photography is to make the illustrators depicted seem visually, on the printed page, as fascinating as we found the experience of meeting and photographing them.

Paul Duerinckx
www.swansea-metro.academia.edu/PaulDuerinckx

Additional portrait and studio photography supplied by Sylvan Grey and Mac Premo.
www.sylvangreystudios.com
www.macpremo.com

Index

ANTOINE+MANUEL 56
Decorative Illustration and
Merchandising
www.antoineetmanuel.com

LAURA CARLIN 182
Topographical Illustration
www.heartagency.com/artist/LauraCarlin

MARIAN BANTJES 108
Typographical Illustration
www.bantjes.com

NAJA CONRAD-HANSEN 168
Fashion Illustration
www.meannorth.com

QUENTIN BLAKE 122
Children's Publishing
www.quentinblake.com

MATTHEW COOK 176
Topographical Illustration
www.matthewcookillustrator.co.uk

KITTY CROWTHER 128
Children's Publishing
www.ecoledesloisirs.fr

EMMA DIBBEN 28
Design and Advertising
www.emmadibben.com

PAUL DAVIS 208
Authorial Practice
www.copyrightdavis.com

DAVID DOWNTON 162
Fashion Illustration
www.daviddownton.com

JEAN-PHILIPPE DELHOMME 196
Authorial Practice
www.jphdelhomme.com

CATALINA ESTRADA 62
Decorative Illustration and
Merchandising
www.katika.net

JEFF FISHER 36
Fiction
www.centralillustration.com/
artists/Jeff-Fisher/

PETE FOWLER 68
Decorative Illustration and
Merchandising
www.monsterism.net

DOMINIQUE GOBLET 142
Graphic Literature
www.dominique-goblet.be

GRANDPEOPLE 102
Typographical Illustration
www.grandpeople.no

EMMANUEL GUIBERT 148
Graphic Literature
www.firstsecondbooks.com/guibert.html

HVASS&HANNIBAL 22
Design and Advertising
www.hvasshannibal.dk

MATTHEW RICHARDSON 48
Fiction
www.matthewxrichardson.com

RALPH STEADMAN 88
Editorial and Political Illustration
www.ralphsteadman.com

ROB RYAN 202
Authorial Practice
www.misterrob.co.uk

YUKO SHIMIZU 42
Fiction
www.yukoart.com

RONALD SEARLE 76
Editorial and Political Illustration
www.ronaldsearle.com

ALEX TROCHUT 96
Typographical Illustration
www.alextrochut.com

The Authors

Derek Brazell and Jo Davies have been working together since the late 1990's when as council members of the Association of Illustrators (AOI) keen to create a platform for discussion and investigation into the subject of illustration they developed the journal *which they edited collaboratively until their subsequent launch of the award-winning and internationally acclaimed* Varoom *magazine in 2006, to which they still contribute as writers.*

JO DAVIES

As a freelance illustrator Jo has worked since the late 1980s for major clients across advertising and design as well as for publishers such as Barefoot Books, Scholastic, Weidenfeld and Nicholson, Heinemann and Macmillan. She is a published author who has exhibited her artwork internationally in the USA and Europe, receiving awards from Korea and Italy. She has many times been included in *Images – The Best of British Illustration*. Her ongoing interest and practice in drawing involved her in a major research project, which culminated in the publication of the book *Drawing – The Process* (Intellect, 2005) which she co-edited alongside the curation of a major touring exhibition.

Her career as writer and illustrator has been combined with work in education at all levels and she is currently Associate Professor in Illustration at the University of Plymouth and represents the AOI on several national committees in education.

Jo continues to be experimental in her work, curious about the world of illustration and determined to assert the value of illustration as an important cultural force.

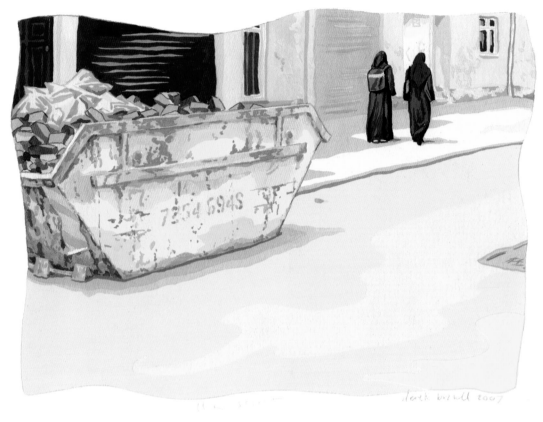

THIS PAGE:
UK Street by Derek Brazell,
2007. Medium: gouache
and pencil.

OPPOSITE PAGE:
Reaching high by Jo Davies.
To advertise distance learning
degree courses for the Open
College of the Arts, 2010.
Medium: gouache and pencil.

Portrait photographs:
Jo Davies by Mike Heneghan,
Derek Brazell by Sabine Reimer.

DEREK BRAZELL

Derek has been immersed in the illustration world for many years and is known for a successful series of children's books, including *Cleversticks* for Harper Collins, which has been in print since 1992. Other illustration clients include Liber, Mantra Lingua, Next, the Post Office and Scholastic, for whom he illustrated several long running book series. He has also been involved with schools' creative partnerships, as well as lecturing on careers and ethical issues in illustration for universities. He has participated in many exhibitions, including *Images - The Best of British Illustration*.

His involvement in *the journal* and *Varoom* magazine includes editing and writing and he believes that illustration will continue to be increasingly recognised for its cultural contributions, especially though expansion of writing on the subject.

Derek has closely supported illustrators in all areas of their careers through his Project Manager role at the Association of Illustrators, has spoken on illustrators rights at the Bologna Children's Book Fair and campaigned for creators rights through his work with the Pro-Action visual artists group and the European Illustrators Forum. He was invited to join the Creator's Council of the Design and Artists Copyright Society in 2007 and became Director for Visual Arts on the British Copyright Council Board in 2009.